# INTRODUCTION TO ROCK ART RESEARCH

David S. Whitley

**Left Coast Press** Inc.

Walnut Creek, California

## LEFT COAST PRESS, INC.

1630 North Main Street, #400
Walnut Creek, CA 94596
http://www.LCoastPress.com

**Left Coast
Press Inc.**

Copyright © 2005 by Left Coast Press, Inc.

ISBN 1-59874-000-8 (hardcover)
ISBN 1-59874-001-6 (paperback)

Library of Congress Control Number 2005928676

*Printed in the United States of America*

 The paper used in this publication meets the minimum requirements of
American National Standard for Information Sciences—Permanence of
Paper for Printed Library Materials, ANSI/NISO Z39.48–1992.

Design and production services: Detta Penna, Penna Design, Abbotsford, BC
Cover design: Joanna Ebenstein

05 06 07 08 09 10    5 4 3 2 1

*Cover photo: Head of Sinbad site, Utah, a Barrier Canyon style site dating to the
Archaic period.*

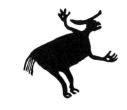

# CONTENTS

*To my Guatemalan friends and colleagues*
*Lucky de Batres,*
*Marlen Garnica,*
*and Edgar Carpio*

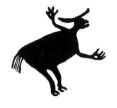

# PREFACE

I was twelve years old when I decided that I would spend my professional career studying rock art. (I had already determined, as a three-year-old, that I would be an archaeologist "when I grew up," causing me to wonder, ever since, whether it was a wise age to make a major career choice.) What tilted me toward rock art was a somewhat serendipitous visit on my first trip to Europe to the cave of Niaux, France, with its remarkable corpus of Paleolithic art. (I knew about the caves near Les Eyzies and had planned to visit them with my parents on this trip, but we unexpectedly encountered Niaux in the Ariege first, before we got to the better-known Dordogne.) I remember being transfixed by the Pleistocene images on the walls of this impressive cave, and I recall spending much of the next year reading everything I could find about Paleolithic art—which (as these things tend to go) wasn't much. Little did I know, at that time, that rock art research was a marginalized topic in Anglophone archaeological research, or that I would eventually become a colleague and friend of the primary researcher at Niaux, Jean Clottes (e.g., Clottes 1995), our leading authority on Paleolithic art (e.g., see also Clottes 1997a, 1998, 2003; Clottes et al. 2005). Sometimes youth and innocence can be blessings, if not portents.

By the time I began to prepare for my Ph.D. dissertation (with

the kind encouragement and support of Clem Meighan at UCLA), I realized that, to study rock art seriously, I had to figure out for myself how rock art research should be conducted. There was no manual or guide or handbook available in English in 1980. Indeed, rock art research was not then taught in American universities; nor was rock art research included in books on archaeological theory, methods, or field techniques; nor was the topic even included in histories of the discipline. And, although the history of French rock art research differs dramatically from the American case (Whitley and Clottes 2005), the history for the remainder of the Anglophone archaeological world appears to parallel the American example, not the French: rock art was ignored, not just in America but in much of the English-speaking world. In 1980, in fact, there were pathetically few good empirical studies in the Anglophone world upon which a rock art research project could be modeled. The result has been a career that, for better of worse, has tacked from theory, to method, to analytical technique, to field work, to empirical case studies, all directed toward understanding the prehistoric images left on rock and cave surfaces.

Luckily (or, again, serendipitously) my interest in rock art research developed at the same time as that of a series of other archaeologists worldwide. Indeed, I am privileged to have worked during what I predict one day will be termed a golden age for rock art studies, marked by major interpretive advances, the development of important new techniques, and groundbreaking discoveries. In addition to my friendship with Jean Clottes, who has provided international leadership in rock art research during this period, I have benefited greatly from my work with David Lewis-Williams (e.g., 2002, 2003), who is responsible for elevating rock art research from little more than a descriptive activity to a theoretically sophisticated research domain, and my collaborations with Ron Dorn (e.g., 1998a, 2001), who is the creative genius behind the chronometric dating revolution in rock art research. I am encouraged by the fact that each of these three researchers has received widespread professional acclaim for their contributions and studies (e.g., Jean Clottes was inducted into the French Legion of Honor; David Lewis-Williams

was awarded the Society for American Archaeology Excellence in Archaeological Analysis Award; and Ron Dorn received a Presidential Young Investigators Award, among numerous other honors.)

In addition to these three key figures, my work has been enriched by a series of other colleagues and good friends who have influenced my thinking in a variety of ways. They are: Jean Auel, Todd Bostwick, Carolyn Boyd, Kevin Callahan, Phil Cash Cash, Niccole Cerveny, Duane Christian, Meg Conkey, Thor Conway, Elisabeth Culley, Phil Dering, Carol Diaz-Granados, Julie Francis, Hector Franco, Kelley Hays-Gilpin, Don Hann, Russ Kaldenberg, Jim Keyser, Larry Loendorf, Jannie Loubser, Peter Nabokov, Jim Pearson, Peter Pilles, Eric Ritter, Marvin Rowe, Linda Schele, Richard Shepard, Dimitri Shimkin, Joe Simon, Linea Sundstrom, Solveig Turpin, Peter Welsh, Tamy Whitley (well, more than a colleague and friend), and Michael Winkelman in the United States; Richard Bradley, Chris Chippindale, Paul Devereux, Marga Diaz-Andreu, Thomas Dowson, Bob Layton, Peter Jordan, and George Nash in England; Knut Helskog in Norway; Ulf Bertillson, Åke Hultkrantz, and Neil Price in Sweden; Mike Morwood, Claire Smith, and Paul Taçon in Australia; Geoff Blundell, Janette Deacon, Tom Huffman, Sven Ouzman, Johnie Parkington, and Ben Smith in South Africa; Norbert Aujoulat, Dominique Baffier, Valérie Féruglio, Carole Fritz, Yanik LeGuillou, Michel-Alain Garcia, Jean-Michel Geneste, and Gilles Tosselo—"Team Chauvet"—in France; Angelo Fossati in Italy; Manolo Gonzales Morales in Spain; and Andy Rozwadowski in Poland. I owe them all considerable thanks.

Many of the examples used in this book result from research and management projects that I have conducted on public lands in California with Joe Simon and Jannie Loubser, two very talented friends. I am grateful to the Commander, China Lake Naval Air Weapons Station for permission to work in the Coso Range; the Bureau of Land Management for support in the California Desert and especially the Carrizo Plain National Monument; the National Park Service at the Lava Beds National Monument; and Mike McIntyre and Doug Milburn with the Angeles National Forest. I also thank the Little Lake Duck Club.

The last two decades have witnessed a revolution in rock art research. This is partly due to the people just mentioned, who (among others, and like me) have spent considerable time working on better ways to record, analyze, date, and interpret rock art. In part, too, it can be attributed to one of the (rare) beneficial effects of postmodernism: a revived archaeological interest in art, symbolism, and belief. But it also has been influenced by the increasing prominence of heritage management or, as it is labeled in the United States, *cultural resource management*. While archaeological research conducted under the guise of an explicit research design has the luxury of ignoring aspects of the archaeological record that fall outside its narrow intellectual purview, resource managers have no such option. They are responsible for the archaeological record in its entirety and must exercise concern for all of it, including rock art sites. As much as anything else, this management demand has helped bring rock art into the archaeological mainstream. Moreover, it guarantees that it will continue to be important: while research interests may shift over time, management requirements are, literally, codified in law and are for this reason less prone to change. The simple fact is that rock art research has experienced great growth in the recent past.

This growth may be particularly evident in English-speaking countries like South Africa, Australia, and the United States. But it is not limited to them. One region where rock art research has also blossomed is Latin America, where numerous researchers are now conducting studies and national organizations and yearly meetings are flourishing. A good example of this is provided by Guatemala. Although rightly renowned as the focus of Classic Maya civilization and famous for an archaeological record that is rich in ruined cities, soaring temples, and complex hieroglyphic texts, archaeologists from the Universidad de San Carlos alone are currently conducting three separate rock art field projects; the government Instituto de Antropologia e Historia (IDEAH) has recently created a Rock Art Section within its Department of Prehispanic and Colonial Monuments; and, in 2005, Guatemalan archaeologists organized their sixth international rock art colloquium. No example better illustrates the growth of rock art research, worldwide, than Guatemala.

But growth, including academic growth, requires training, re-sources, and infrastructure. Fundamental to these is an introductory text, intended for college students but also useful to professional ar-chaeologists and resource managers who, at some point in their ca-reer, develop an interest in or need to study or protect rock art sites. This book has been written to serve that purpose, but its origin lies as much in the growth of Central American as in North American rock art research.

I was contacted by Lucretia de Batres, a Guatemalan archaeolo-gist associated with San Carlos, to teach a short introductory course in rock art research at that university in 2004. To do so, I realized that I had to prepare an introductory text. This short book is the result. It is intended as a starting point for students and archaeolo-gists interested in rock art research (and is not meant to be the final word on how this research must be conducted). As is to be expected, it reflects my own experience, interests, agendas, and biases. Chief among these is the fact that I work primarily in western North Amer-ica, studying shamanistic hunter-gatherer cultures where substantial ethnography is available to aid interpretation. But, in my defense, I have also conducted various kinds of archaeological research in Guatemala, off and on from 1977 to 1987 (including the recording, with Ed Shook, of the Olmec pictograph at Amatitlan, in 1977); have worked for two years in southern Africa at the University of the Wit-watersrand; have spent considerable time looking at and reading and thinking about western European rock art; and have benefited from large network of international colleagues. I brought this additional background and experience, and these international experiences and resources, to bear in preparing this book, although I am sure that in-ternational readers will still find it largely American in tone.

The underlying theme of this book is that rock art research re-quires an integrated effort that is equal—or at least roughly equal—parts theory, method, fieldwork, analytical techniques, and interpre-tation. Rock art research is, simply, one approach directed towards understanding or explaining the prehistoric past, and for this rea-son it is best conducted in conjunction with or within the context of broader archaeological research and information. And, in the

twenty-first century, it is a kind of research that must always be framed by long-term site management and conservation concerns and goals.

This book reflects these attitudes and concerns. Avowedly, it is not just a manual for rock art fieldwork, although it does contain a chapter on this important topic. In hindsight I recognize that, traditionally at least, an introduction to rock art probably would have been conceptualized solely in terms of just such a field manual. Some readers may have come to this volume expecting this kind of emphasis. My intent, instead, is to provide a guide for the minimum level of field recording, balanced against the numerous other issues of rock art research. The message here is simple: professional fieldwork cannot be divorced from all of the other commitments and tasks related to research. (Anyone who still thinks that rock art research is just fieldwork, in my opinion, is not conducting research.) There is information on rock art field techniques here, but it is simply one component of a much more involved, multifaceted kind of archaeology.

This warrants a few explanatory comments.

First, while I believe that our theoretical presuppositions are embedded in all of our professional work, and that they need to be kept explicit whenever possible, the book does not contain a discussion of theory per se. There are a number of reasons for this exclusion, but the main ones are that such a broad topic is beyond the scope of this short text; that theory in rock art research necessarily needs be linked to the theoretical issues in archaeology more generally, not isolated as a stand-alone topic; and that books on archaeological theory are readily available (e.g., Preucel and Hodder 1996; Whitley 1998c). Instead, I have focused on the topics that are unique or particularly important to the study of rock art, with one key exception.

Second, this exception is scientific method—that is, the means that we use to select a preferred interpretation or explanation from possible alternatives. I believe that, for a variety of reasons, scientific method has been widely misunderstood, ignored, or overlooked by archaeologists. Perhaps the most recent example of this has been the post-modernism (or, in archaeology, post-processualism) of the 1980s and 1990s, which presented a strong critique of science. One

PREFACE

result of this critique was the disavowal of "scientific" research by many archaeologists. I have already presented my opinions on this topic (Whitley 1992a, 1998a) and they don't need reiteration. Suffice it to note that the *concept* of science involves many things: a body of knowledge; a Western intellectual tradition; a series of laboratory and field techniques; a technological complex; a set of value-based goals and agendas; specific philosophical commitments and beliefs; and a variety of competing methods. These different aspects of the concept of science traditionally have been conflated into Science (with a capital S) as an all-or-nothing proposition. But anyone can use scientific method in their decision-making processes, regardless of their interest in or commitment to other aspects of Science—just as a post-modernist can use the Internet and a home computer to rail against the evils of the Science that produced the innovations for expressing those same opinions. Scientific method, in other words, is powerful approach to intellectual decision-making, and rock art research conducted with an eye toward this method will always be stronger because of it, regardless of our commitments to, or interests in, other aspects of a scientific agenda or approach.

Even when researchers conceive of themselves as historians or humanists, I believe they can use scientific method to improve the strength of their conclusions. This particular section of the book is directed towards that aim.

Third, I had intended to "borrow" sections of this book from some of my other publications, where appropriate, since I saw no great value in rewriting discussions simply for the sake of creating a false kind of originality. This is not a presentation of new research conclusions, after all, but a road map to conducting rock art research. As the book turned out, however, there were only two consequential repeats, and even these were modified in various ways. One involves the section on chronometric techniques, which is derived from a discussion I wrote in the *Handbook of Archaeological Method and Theory* that I jointly authored with Larry Loendorf. The second involves the discussion of scientific method and the related review of Heizer and Baumhoff's (1962) Great Basin study, portions of which were also presented at the Seventh Oxford Conference on Archaeoastronomy, in 2005.

xiii

Despite this and other minor derivations, this book ultimately has its origins in Guatemala. I am thus particularly indebted to Lucky de Batres and Marlen Garnica, head of the archaeology program at San Carlos, who, ultimately, set the events in motion that resulted in its writing. I also thank the Escuela de Historia at the Universidad de San Carlos and, also at the university, my good friend Edgar Carpio; as well as the Guatemalan *Instituto de Antropologia e Historia* and, at the *IDEAH*, Manuel Colon and Ramiro Martinez—the newly formed Rock Art Section—and Tomas Lacayo, conservator. I am indebted to Ida Heckenbach and Carmen de Foncea, in the Cultural Affairs section of the U.S. Embassy in Guatemala; and the Fulbright Senior Specialist Grant program, which gave me the opportunity to teach and work again in Central America. Mitch Allen is due significant thanks for encouraging this book and bringing it out in his new press. I am also grateful to Judy Johnstone and Detta Penna, who edited and designed this book, for their valuable contributions and the pleasant camaraderie they both brought to these usually tedious tasks. Joanna Ebenstein artfully composed the cover; Héctor Lavoe ("el rey de la puntualidad") pulled together the index. Jean Clottes, Jannie Loubser, Ron Dorn, Joe Simon, and Mike Taylor have generously provided me with some of the illustrations used here; Dean Snow and Suzanne Villeneuve graciously provided copies of their unpublished research. Finally, I thank Tamy, Carmen, and Margaret Whitley, who managed to keep busy (mostly by *salsa* dancing and riding mules) while I was busy writing, when we were all in Guatemala. All of these individuals were important catalysts in the appearance of this short book.

*Antigua de Guatemala*
*August 2004*

# INTRODUCTION

Rock art is an archaeological phenomenon found in many regions of the world. Despite this fact, and for a complicated series of historical reasons, it has long been ignored by most Anglophone archaeologists, whether working in the Americas, Africa, Europe, or Australia (e.g., see Whitley and Clottes 2005). The status of rock art research has started to change, however, with recent studies showing its importance in reconstructing symbolic and religious systems (e.g., Lewis-Williams 1981, 2002; Lewis-Williams and Dowson 1989; Lewis-Williams and Pearce 2004; Layton 1992; Rajnovich 1994; Garlake 1995; Bradley 1997; Keyser and Klassen 2001; Boyd 2003; Rozwadowski 2004), defining gender relations in societies (e.g., Hays-Gilpin 2004), identifying cultural boundaries (e.g., Francis and Loendorf 2002) and cultural change (e.g., David 2002), and studying the origins of art and belief (e.g., Clottes and Lewis-Williams 1998; Clottes 2003; Lewis-Williams 2003)—among other topics.

Rock art sites are also highly valued by indigenous peoples, who generally view them both as sacred and as important components of their cultural patrimony (e.g., see Utemara with Vinnicombe 1992). The art has captivating aesthetic qualities, causing it to be highly regarded—and exploited—by the general public in ways that the dirt archaeological record cannot match (indeed, rock art T-shirts are as

common today as rock band T-shirts). Rock art sites may be attractive for cultural tourism and thus contribute to the economic health of a community or region. All of these are reasons for studying, managing, and preserving rock art, although its inherent fragility sometimes makes this a difficult task.

This book presents an introduction for archaeologists, cultural resource managers, and students interested in studying, managing, and preserving rock art and rock art sites. Such a book is necessary because, even while rock art research is a sub-discipline within archaeology (e.g., see Morwood 2002), it requires different techniques, addresses slightly different analytical problems, and has its own specialized body of literature. Moreover, American archaeology students do not usually receive any formal training in rock art research. My purpose in this short book is to provide a bridge into rock art research and its literature in order to encourage the study and preservation of this important aspect of the archaeological record.

This chapter introduces some basic definitions and a brief look at rock art production techniques. (For a more detailed analysis of rock art techniques, see GRAPP 1993.) Chapter 2 presents an introduction to rock art fieldwork, which differs in important ways from the standard archaeological techniques used in excavation and regional surveying.

Chapter 3 addresses the important analytical problem of classification. This problem, as you will see, has vexed rock art research for the last century, yet it is always the starting point for analysis. Classification is followed in Chapter 4 by a discussion of approaches to dating. Chronology has been a difficult issue for rock art researchers and, while chronometric rock art techniques still require much basic research, there is nonetheless cause for substantial optimism about our ability to date rock art.

A series of related chapters then set forth the topic of rock art interpretation. My premise in writing these chapters—as in conducting my own rock art research—is that our interpretations must adhere to scientific method, whether we are concerned with reconstructing a symbolic system in its own terms or with explaining the part a symbolic system may play in adaptation to the environment. Chapter 5

thus begins with a brief description of scientific method (that is, an approach to selecting a preferred hypothesis from a series of competitors) before considering rock art interpretations in terms of two broad categories, as suggested by Taçon and Chippindale (1998): informed and formal methods.

*Informed methods,* outlined in Chapter 6, emphasize ethnography and symbolic analysis, and thus aim to provide an insider's understanding of the art—that is, an interpretation identical or similar to that of the art's creator. *Formal methods,* in contrast, concern outsider's perspectives. These are considered in two sections: Chapter 7 describes neuropsychological analyses, whereas Chapter 8 considers quantitative, landscape, archaeoastronomical, and other approaches to rock art interpretation. Chapter 9 turns to site management and conservation, a topic important to all who study rock art. I conclude this book with some brief comments on the future of rock art research.

## DEFINING ROCK ART

Rock art is *landscape art* (Whitley 1998b). It consists of pictures, motifs, and designs placed on natural surfaces such as cliff and boulder faces, cave walls and ceilings, and the groundsurface. Rock art is also sometimes referred to as cave art or *parietal* (wall) art. Regardless of appellative, the defining characteristic of rock art is its placement on natural rock surfaces, thereby distinguishing it from murals on constructed walls, paintings or carvings on canvas, wood, ceramics, or other surfaces, and free-standing sculptures.

Rock art includes *pictographs* (paintings and drawings), *petroglyphs* (engravings and carvings) and *earth figures* (intaglios, geoglyphs, or earthforms). Some researchers also include pecked *pits and grooves,* sometimes called cups and rings or *cupules,* as another form of rock art. Pictographs and petroglyphs are found on rock art *panels.* These are approximately flat surfaces that are the fracture or weathering planes of a natural rock outcrop.

Although there are occasional exceptions, most rock art made by traditional, non-Western cultures was created during rituals of some kind. Rock art research for this reason is a kind of archaeology of

religion (Lewis-Williams 1995; Whitley 2001; 2005a). Some researchers object to the inclusion of the term *art* in "rock art," implicitly or explicitly arguing that the western concept of art is not appropriate for traditional, non-Western cultures. They hold that the use of the term *rock art* is an essentialist projection on the past, a way of applying our own contemporary cultural conceptions inappropriately to others. They suggest, as alternatives, terms like *rock graphics* or the hyphenated *rock-art*. I prefer the old, unhyphenated term *rock art* for a variety of reasons, not least of which is my interest in continuing reasonable and long-standing archaeological traditions. As an archaeologist, my concern is with preserving the past. This necessarily includes archaeological traditions, unless they are convincingly shown to be pernicious or simply wrong.

More important, it is clear both that our Western artistic tradition includes the kinds of performative and religious art found in rock art created by non-Western, traditional cultures, *and that* these same non-Western cultures are capable of appreciating the aesthetic qualities that are (for some) the hallmarks of Western art. As Sven Ouzman (2003) has sagely observed, the argument that the term *rock art* is somehow inappropriate for traditional non-Western cultures necessarily implies that "we" create "art," whereas traditional cultures create something else—and something less. This seems unreasonable. Accordingly, I use this term without apology throughout this book.

## PICTOGRAPHS

Pictographs are paintings or drawings made, worldwide, with common mineral earths and other natural compounds. Red, a frequently used color, typically is made from ground ochre; black is usually made from charcoal, but sometimes from other minerals (e.g., manganese); white is from natural chalk, kaolinite clay, or diatomaceous earth. Other, rarer, colors are also made from naturally occurring mineral or plant sources.

Regardless of source, the pigments are usually ground and then mixed with a liquid, such as water, animal blood, urine, or egg yolk, and applied as a kind of wet paint (Fig. 1-1). Or, they may be dry-

**FIGURE 1-1A** Pictograph created with wet paint. This example, a grid, is from the "Antilope Well" site in Lava Beds National Monument, California. It was made with a highly liquid black paint (probably charcoal and water), and runs of paint can be seen along the line margins.

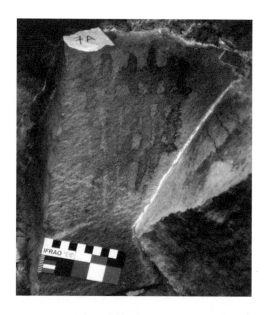

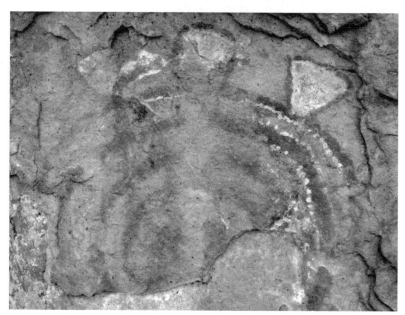

**FIGURE 1-1B** Most wet paint is more viscous, causing it to pool or puddle across minor rock surface irregularities. This painting, of a Pacific Pond turtle, is typical. It is from Saucito Rocks, Carrizo Plain National Monument, California, and is painted in red, white, and blue-black.

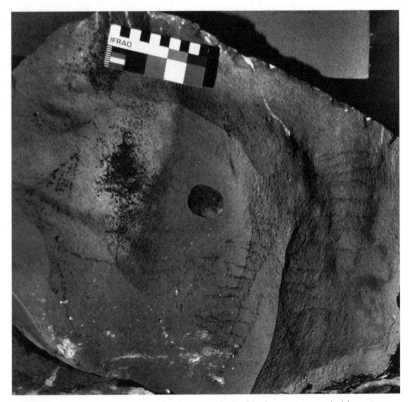

**FIGURE 1-2** Geometric pictographs drawn with dry black pigment, probably a piece of charcoal. Note natural hole or vesicle in center of basalt panel; charcoal has been rubbed on panel, creating a "blur," at center left. Symbol Bridge site, Lava Beds National Monument, California.

applied as a kind of "chalk" or pencil (Fig. 1-2). A simple piece of charcoal, for example, works very well for drawing on a rock surface.

Pictographs can thus be divided into wet-applied paintings and dry-applied drawings. Wet-applied paints are continuous, even over a rough rock surface; dry-applied drawings often show concentrations of pigment on high spots on the rock face. Drawn lines thus may be discontinuous when examined with a hand lens.

Wet-painted pictographs may be placed on a rock surface using a brush, the fingers, or a stamp. Brushes were usually made from the tip of the tail of a small animal, or from shredded and bound plant

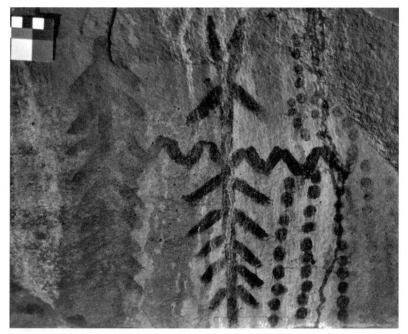

**FIGURE 1-3** Black finger dots arranged into a geometric pattern, along with rectilinear geometric motifs finger-painted onto panel. Symbol Bridge site, Lava Beds National Monument, California.

material (e.g., agave fiber). It is relatively easy to tell whether paint was applied with a brush or with the fingers based on the thickness and consistency of the lines. Finger-painted motifs are "cruder." Finger-dots are particularly common in some areas (Fig. 1-3). Sometimes these dots are arranged into motif patterns. At the famous site of Lascaux, a kind of stamp was employed in some cases to apply pigment; it was probably made of fur or plant material (Aujoulat 2004, Geneste et al. 2004).

Two special categories of pictographs also exist. One of these is hand-prints (Fig. 1-4). These may not be universal to all rock art–producing cultures but they are quite common in the Americas, in southern Africa, in Australia, and in Western Europe. There are three kinds of hand-prints. Standard hand-prints involved coating the hand with wet paint and then pressing the hand against the rock

**FIGURE 1-4** Handprints and geometric motifs in red, from the Puberty Rock (CA-RIV-19), near Perris, California. This historic site, like others in the region, was created by young girls at the culmination of their puberty initiations. Most of the geometric designs are zigzags, diamond-chains, or combination and variations thereof. These were said to represent the rattlesnake, which was the preferred spirit helper that girls received during their initiations.

surface. Alternatively, a design (e.g., a spiral) could be drawn on the coated hand before pressing it against the rock, creating a hand-print with an internal pattern.

The third kind of hand-print involves an entirely different approach to painting. This uses dry pigment blown onto a rock surface through a tube—a kind of air-brush or spray-painting. For hand-prints, this involves placing the hand on the rock surface and then blowing the paint onto it. The result is a negative print of the hand in outline, usefully referred to as a "stencil" in Australia (e.g., Layton 1992).

Rarely, air-brush painting has been used for more than negative hand-prints. At the site of Pech-Merle, in Upper Paleolithic France, an air-brush–like painting technique was used to create the famous pictographs of spotted horses (Lorblanchet 1991, 1993a). At Pech-Merle, helpers apparently placed their hands in specific spots to assist in shaping the outline of the animals as the pigment was blown on by the artist.

Australian aborigines also used an air brush technique to make much more than hand stencils, producing feet, boomerangs, axes, and geometric patterns; in the last case, twigs and leaves may have been used to create a composite image (Walsh 1979, 1983).

Evidence for air-brush painting in North America is also seen in the Barrier Canyon pictographs (Fig. 1-5) found in the state of Utah and dating to the Archaic Period (roughly 3000 years ago). According to professional artist Charles Huckeba, the evidence indicates that the ancient artists were blowing the pigment out of their tubes with a pressure of about 40 pounds per square inch, which is equal to a modern pressurized air-brush system.

We usually think of paint as an economic or technological resource, something manufactured and traded. It is true that paint has these qualities, but it is important to recognize that, in some ritual contexts, the paint itself could also have important symbolic and religious values and meanings. In parts of Native California, for example, pigment was traded only by shamans, the ritual officials for the hunter-gatherers in that region. In other parts of North America, the Indian word for *paint* was the same as the word for supernatural spirit,

**FIGURE 1-5** Human-like figures from Barrier Canyon site, Utah. The creation of these Archaic pictographs involved the preparation of the panel by smoothing and then the use of blown-on pigment.

showing the close association between the two (Hann et al. n.d.). (Rock art in these regions was said to portray the spirits.) In southern Africa, among the San (or Bushmen), the blood of the eland antelope was mixed with the dry pigment because this blood was thought to be supernaturally powerful—as were the paintings themselves (Lewis-Williams 1986). We find bedrock mortars, used for grinding pigment, at many rock art sites in California. This suggests that even the making of the paint was part of the rituals conducted at these sacred sites.

While recognizing the symbolic importance of pictographs (and petroglyphs), it is important to realize that the symbolism of the rock art may involve much more than the iconography. The paint itself may be important to understanding the ritual and beliefs of the prehistoric culture that created the art.

## PETROGLYPHS

Petroglyphs are *rock engravings* or (as they are called in Scandinavia) *rock carvings* (Figs. 1-6 and 1-7; see Feruglio 1993). Usually they are made with a hammerstone that is directly battered against the rock panel surface. Almost any rock of appropriate size will work as a hammerstone; for example, a fist-sized basalt hammerstone will work very well for engraving a basalt rock surface.

In the California deserts, however, petroglyphs were engraved with quartz hammerstones. Quartz is a hard mineral that works very well for pecking motifs in basalt, but it is easy to make engravings with many kinds of stone. Quartz was selected in this case for ritual reasons: the art was made by shamans, and quartz was an important component of the shaman's ritual paraphernalia in this region. This was tied to the triboluminescent qualities of quartz—the fact that quartz will generate light when mechanically shocked (e.g., by rubbing two quartz cobbles together)—which was itself thought a visible manifestation of supernatural power (Whitley et al. 1999a). Even the choice of the hammerstone, in this case, was based on religious beliefs.

Pecked rock art could also be made through indirect percussion: using one rock as a hammerstone to pound against another, placed on the panel face as a kind of chisel (Keyser and Rabiega 1999).

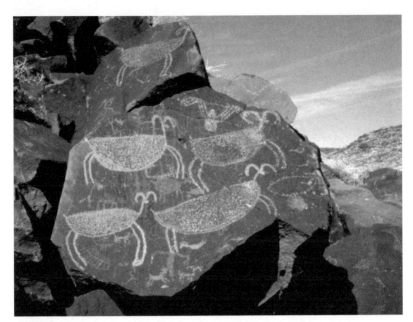

**FIGURE 1-6** Bighorn sheep petroglyphs from Big Petroglyph Canyon, Coso Range, eastern California

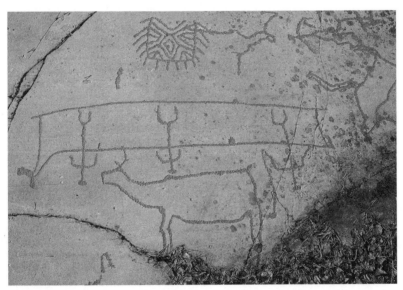

**FIGURE 1-7** Scandinavian "rock carvings," from Alta, Norway. These motifs are typically engraved on glacially smoothed bedrock. Because the motifs are very difficult to see, except in raking light, they are infilled with red paint at sites open for visitation. Shown here are a moose or reindeer, a moose-headed boat with three humans, and a complex geometric design, in addition to other figures at top right. The panel is horizontal and at ground level, hence there is no natural or obvious orientation, with different engraving episodes oriented in contrasting directions.

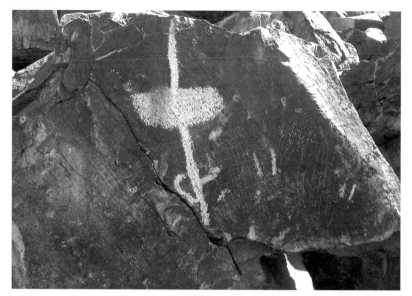

**FIGURE 1-8** Scratched or incised motifs are common in far western North America, although they are sometimes overlooked or (wrongly) dismissed as graffiti. This example, grid designs to the right of the unvarnished engraving, are from the Little Lake site, in the Coso Range of eastern California.

Another less-common type of petroglyph is *incised* or scratched into a rock face (Fig. 1-8). These fine-line motifs are often difficult to see except in raking light. Incised art was probably made with a lithic flake or blade or, during the historic period, with a metal knife.

Just as engraved petroglyph manufacture was symbolically charged (in western North America) through the use of quartz hammerstones, the creation of scratched art (in at least some cases) also had symbolic importance. On the Columbia Plateau, at least, scratched art was related to ritual mutilation and bleeding that was part of shamanistic vision questing (Taylor and Keyser 2003). Recalling the use of eland blood in the pigment of the southern African San, we see that the technology of rock art production is best understood not so much as technological manufacture but as ritual action. The creation of rock art was a ritual act, and its associated symbolism involved much more than the graphic image, which is the remnant archaeological record of this ritual behavior.

# EARTH FIGURES

Large designs and motifs, created on the groundsurface, are called *earth figures* generically, and they occur in many regions of the world. They can be categorized by their method of manufacture (von Werlhof 1987, 2004). *Intaglios* are created in desert pavements (groundsurfaces covered by pebbles and cobbles) by scraping away the pavement to leave a negative image on the ground (Fig. 1-9). The Nazca Lines of Peru are probably the most famous intaglios, but intaglios occur in other desert regions, including California and Arizona. *Geoglyphs* are rock alignments (sometimes also called *petroforms* or *earthforms*). These are created by piling cobbles and small boulders into a pattern on the groundsurface, thereby creating a positive image (Fig. 1-10). Rock alignments are also found in western North America and Australia (e.g., Gould 1969:145), among other places.

Regardless of the kind of rock art present in a region, one circumstance usually needs to be kept in mind. Most rock art is, by its very nature, a multifaceted aspect of the archaeological record. It is

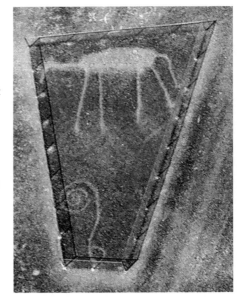

**FIGURE 1-9** Intaglios or geoglyphs, from Blythe, California, made by scraping desert pavement away to expose the lighter soil underneath. These figure are a mountain lion and a double spiral. They are said to represent the spirit helper of the Mojave creator deity, Mastamho, and a mythic incident in which Mastamho caused the flood waters of the nearby Colorado River to recede (Von Werlhof 2004). These figures are fenced for protection; the mountain lion is about 30 feet long.

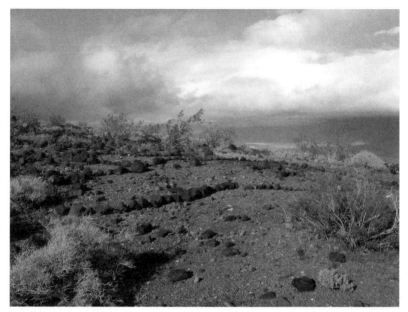

**FIGURE 1-10** A rock alignment, consisting of cobbles arrayed in an irregular geometric pattern, from the Slate Range, in the Coso region of eastern California. This area has the heaviest known concentration of rock alignments in North America and is immediately adjacent to the densest petroglyph concentration, in the Cosos. Based on ethnographic analogy with the Columbia Plateau, the alignments are believed to be the product of the same vision quests that resulted in the creation of the petroglyphs.

usually symbolic and related to ritual, but it may also have a technological side in terms of its mode of manufacture, and may even have economic implications (e.g., if pigment is traded). Thus there are a variety of ways rock art can be studied, with implications for a number of archaeological problems.

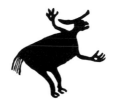

# ROCK ART
# FIELDWORK

Archaeologists might assume that rock art research, like other types of archaeological work, begins with fieldwork. In fact, this is not exactly correct. Any work we conduct is partly (if not largely) predetermined by the individual interests, theoretical concerns and biases, and methodological approaches we bring to our research. For example, someone interested in reconstructing prehistoric diet might choose only to analyze animal bones, consciously ignoring stone tool technology. This selectivity demonstrates that our explicit and implicit biases and interests determine what we record. Indeed, this fact is no better demonstrated than by rock art itself, which was too often ignored by previous generations of researchers.

The kinds of archaeological data that represent a complete and adequate documentation of any kind of site, including rock art sites, are not necessarily obvious. Rock art recording, like all archaeological fieldwork, is always selective (Loubser 2001). The choice of data that are important to record for adequate documentation of a site depends upon research interests, site conditions, and other goals and agendas. Indeed, in recording a site, the attention of a *rock art conservator* (a professional trained in the techniques for preserving and

protecting the art) will most likely focus on the condition of the motifs, including such details as weathering on the panel face, mineral and crystal growths on the art, lichen, and vandalism or graffiti. An archaeologist conducting a wide-ranging regional study, on the other hand, might be primarily interested in motif associations on specific panels, and an archaeologist interested in symbolic analysis and interpretation of one site alone might be concerned with the relationship of the motifs to natural features (such as cracks) on this same panel face. Meanwhile, neither of these archaeologists may pay attention to the kinds of data that are of greatest interest to the conservator—yet all of these interests, concerns, and forms of data are legitimate, useful, and important.

There are two implications of this kind of selectivity. The first is that no rock art documentation is value-neutral, in the sense of providing a complete and objective record of all of the site data (Lewis-Williams 1990). Whether conscious or not, all documentation involves choices about what is important to record and what may reasonably be left out, given real-world constraints like time and money. These choices should be made as explicit as possible, and are ideally defined by an overarching research or site management problem that guides the fieldwork. The need to define the problem or objective clearly cannot be overemphasized.

The second implication is that it is essentially impossible to outline a *complete* guide to rock art fieldwork and data collection. Thus, this chapter is an *introduction* to fieldwork that covers the basic data collection techniques and will result in a minimum level of recording—that is, recording that is adequate for many (but not all) research and management purposes, and that provides baseline data potentially useful for subsequent conservation assessments.

Rock art data collection can be considered in terms of three primary tasks: site mapping, narrative recording of the art and its condition and context, and graphic documentation of the art itself (cf. Aujoulat 1993a; Loendorf 2001). I will discuss these tasks as well as other types of archaeological research conducted in conjunction with rock art recording. But before turning to these topics it is worthwhile to identify what I have omitted here, and why.

There is no discussion about the recording of earth figures. This is because their documentation is accomplished through the standard archaeological procedures for mapping and documenting structural remains at open-air sites. I also omit discussion of typological tabulations at sites—that is, counting the number of motifs present at the site, at the site locus, or on individual panels, per a specified motif typology. In fact, this approach can be useful—especially in large regional research projects (e.g., Grant 1968; Lewis-Williams 1972, 1974), where it may be the only practical technique for a wide-ranging study. Usually, however, motif typology is inadequate for site-specific documentation (especially for management or conservation purposes) because it provides such general and potentially subjective results. This is partly because motif typology is itself a complex topic in rock art research (see Chapter 3).

In sum, we are concerned here with the most widely applicable and appropriate *general* field recording techniques. These must always be gauged against the specific goals and conditions of a particular project and adjusted as necessary.

## SITE MAPPING

Pictograph and petroglyph sites differ in important ways from open-air archaeological sites, where most archaeological mapping is conducted (and where most archaeologists receive their primary training in mapping). These differences relate partly to physical settings: caves, rockshelters, and talus (or scree) slopes are very different from open-air middens, pueblos, walled-fields, or plazas with mounds (cf. Rouzaud 1993). But the mapping difference also involves the nature of the data collection unit. For open-air sites, archaeologists commonly map topography, features (such as structures), and excavation pits or trenches as their data collection units. Rock art research also maps topography (and structures, if present). But the data collection unit is typically the *rock art panel,* a relatively flat natural fracture or weathering plane. Rock art panels may be vertical or horizontal, and, often enough, on the ceiling of a shelter. The locations and orientations of our data collection units complicate rock art site mapping

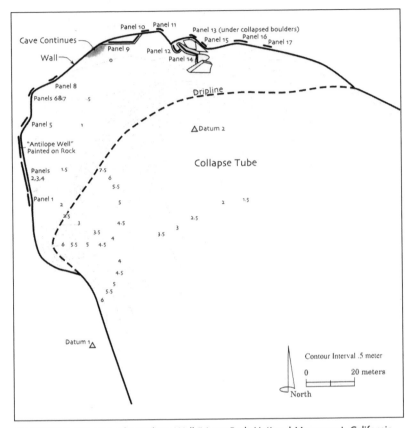

**FIGURE 2-1** Site map of "Antilope Well," Lava Beds National Monument, California (Loubser and Whitley 1999). The site is in a lava tube collapse, thereby combining the problems of mapping on a boulder-strewn talus slope with mapping on caves walls. Note that only boulders with pictograph panels are illustrated, and that an effort has been made to depict the shape and relative size of these, along with the orientation of the panels themselves. *Map compiled and drawn by Jannie Loubser.*

and the depiction of our collection units on the resulting map, as does the topographical setting of many sites.

For caves and rockshelters, many of which are relatively small, most of the mapping can be completed with a carpenter's level and measuring tapes. Mapping should include vertical and horizontal sections of the cave, if this is possible. For larger caves, transit and stadia (or, commonly now, a Total Station™ or laser level) can be employed. Boulder fields and talus slopes can present a series of

**FIGURE2-2** A second example of mapping within a lava tube collapse, here the Symbol Cave and Copper Rock Cavern sites (Loubser and Whitley 1999), Lava Beds National Monument, California. *Map compiled and drawn by Jannie Loubser.*

additional, more difficult, problems resulting from the fact that the topography in these contexts is very complex. The locations of panels (and thus data collection units) in talus slopes vary on both the horizontal and vertical plane, and also with regard to aspect.

Figures 2-1 and 2-2 present two rock art site maps that were made by Tony Greiner and Jannie Loubser, using a Total Station™, during a project we conducted in Lava Beds National Monument, California, a few years ago (Loubser and Whitley 1999; Whitley et al. 2004). In each case the sites are in large collapsed lava tubes or depressions. For this reason they combine the aspects—and problems—of mapping in rockshelters and caves with those of talus slope sites. Greiner and Loubser first mapped only those panels and boulders with art, ignoring the "noise" of the undecorated boulders and

rock faces. Second, they attempted to depict graphically the relative size and shape of each mapped boulder and the orientation of the panel. These maps illustrate a series of approaches to reducing and depicting the mapped data in graphic form.

A relatively quick and simple approach to mapping a talus slope with rock art boulders has been provided by Wallace and Holmlund (1986). They took a black-and-white photo of their site, enlarged it, and then, while in the field, mapped each individual boulder/panel on the photo. Although this does not provide a true planimetric site map, it is an accurate guide to panel locations that serves most research and management purposes.

Some rock art localities may consist of a series of discrete rock-shelters or caves clustered in a relatively restricted area. Rocky Hill, a Yokuts site in the southern Sierra Nevada of California, is one example of this kind of rock art mapping problem. It is probably best described as a mountainside covered by piles of granite boulders, roughly two dozen of which contain rock art sites that individually may contain one or more painted panels. Another is provided by the famous Hueco Tanks locality near El Paso, Texas. Bob Mark and Evelyn Billo have mapped both localities using a state-of-the-art global positioning system (GPS). In these two cases, the mapping units consisted of the individual sites (or *loci*), rather than specific panels with art. Clearly it is a relatively easy step to move from these loci on the locality as a whole to individual maps that depict each panel.

A series of high-tech approaches could potentially be used, and either have not yet been tried or are in the experimental stages. One of these involves low-level aerial photography of a site (e.g., from a tethered balloon) or, alternatively, a large boom (circa 20 meters in height) holding a remotely controlled camera. If stereo photographic pairs of a site are taken, these can be scanned and digitized and, with existing off-the-shelf computer software (e.g., Surfer™), turned into a true and detailed topographic map.

The next revolution in mapping and site recording appears to involve 3-D laser scanning systems. Thad Waslewicz and I have been

using a 3-D laser scanner to map the Little Lake site in the Coso Range of eastern California (Waslewicz et al. 2005). This site is in an extremely complex (and unstable) basalt scree slope, resulting in a very difficult mapping problem. Margarita Diaz-Andreu, in contrast, is using a similar system to document, in great detail, individual cup-and-ring petroglyphs in England (Simpson et al. 2004; Barnett et al. 2005). The first implication of both (ongoing) studies is that the laser scanning system not only can provide a detailed 3-D map of the site but it can also accurately record, in three dimensions, engraved rock art panels. Indeed, in an initial experiment, Waslewicz and I found that the 3-D laser scanner could also record some painted motifs, whereas Diaz-Andreu has shown how the technique can be used to monitor subtle variations in site erosion.

The second implication is that the laser scanner can be used digitally to recreate the complex internal topography of a cave in three dimensions, and rock art can easily be added into such a digital model. This will greatly facilitate more thorough documentation of the archaeological contexts of rock art. Computer models created in this fashion will allow for virtual, fly-through visits to sites. They will also improve our ability to recreate rare sites for visitation (e.g., so-called Lascaux II, which is a replication down to the surfaces of the cave walls of the famous but very fragile Paleolithic site).

## NARRATIVE RECORDING
## OF THE SITE

By *narrative recording* I mean the written documentation of the site, its panels and their condition, and the art on the panels. While small sites, with just a few motifs and/or panels, may be documented with descriptive fieldnotes written by a single individual, standardized forms work best for larger sites, especially when working with field crews. Not only do standard forms expedite the note-taking process but they also guarantee consistency in the data recorded. (Appendix A includes basic examples of these forms. They should be appropriately modified for specific sites, projects, and field conditions.)

## GENERIC SITE RECORDS

Narrative recording involves two levels of detail. The first is the site as a whole, and this starts with the *generic site record* itself. It is important that rock art sites be recorded using the same site forms that, in a given region and for a particular project or for a specific government agency, are used for all types of archaeological sites. This ensures that all of the general data (e.g., locational information) are consistent from one site to the next. It also ensures that rock art sites will be included in larger compilations of regional data and will be identified using the same site numbering or ordering system.

It is often useful to augment the generic site record form, used for all kinds of sites, with one that details the nature of the art present. The *rock art site record* is essentially a rock art summary for the site as a whole. It is particularly valuable for regional projects involving multiple rock art sites. These forms can also be a great aid for projects at individual sites, because they can be used to organize and cross-check panel designations and other data tabulations. This form is usually further augmented by a *photographic record*. This provides details about each photographic frame taken at a site, including the panel photographed, direction of view, dimensions of scale (if included in the photo), film used, and exposure setting.

## PANEL RECORDING FORMS

The second level of detail is found in the *panel recording form*. This is generally tailored to the specific project, reflecting the conditions and concerns of the site in question. (For example, there is no reason to include information about the nature of painting on the form if the site only has petroglyphs, and vice versa.) That said, this form should include basic kinds of data for all panels. It serves as the critical link between the mapping data for the site and the graphic documentation of the imagery itself (discussed below). The panel recording form also carries the written notes for the graphic documentation, and it should explain any conditions or circumstances that are present but that may not be entirely clear in the graphic documentation

itself. Here it is useful to think of a researcher who is reviewing your site data twenty years in the future. Will that archaeologist fully understand all aspects of panel status and condition from the graphic documentation without written explanation? In most circumstances the answer would probably be "No, not completely." The panel recording form is intended to fill in the gaps.

Some of the key kinds of information to include in the panel recording form then are:

- Aspect (which direction the panel faces) and orientation (whether it is vertical, horizontal, or somewhere in-between)

- Presence or absence of superpositioning among the motifs

- Presence of cracks and other natural rock irregularities and features, and their relationship to the art, if any

- Condition of the art

- Condition of the panel generally

While we will discuss assessment of site conditions later, it is worthwhile to emphasize the final point listed. A panel may have graffiti or mineral encrustations present, for example, but if these are not on, or immediately adjacent to, the motifs, their presence may not be included on the graphic documentation of the panel. Twenty years later it may be very important to know whether the graffiti or encrustations then present are a new development or whether they have been on the panel for decades.

These forms, in this sense, make explicit what is recorded on a particular panel and, equally important, what is *not* recorded. Systematic use of the same form across a site ensures consistency in the recording of all of the panels.

## GRAPHIC DOCUMENTATION

The *graphic documentation* of the rock art site is the heart of the recording process. Indeed, some (perhaps too many!) rock art researchers take this task to be the only step in field research. Certain

research interests or problems may in fact require only the graphic documentation of one or a few motifs or panels at a site. (For example, a rock art dating project justifiably documents only those motifs that are sampled for dating.) But adequate site recording requires more than just the collection of images of the art, as the above discussion implies.

Four points should be kept in mind when considering the graphic documentation task. The *first* is that these techniques are changing very rapidly and it is hard to predict what the future holds for rock art recording: 3-D laser scanning appears to be the next mapping and recording technique but it is unlikely to be the final word. That said, the new high-tech approaches typically require substantial funding, equipment, and/or training. It is very likely, for this reason, that our traditional, low-tech, recording techniques will continue to be used on many if not most projects.

The *second* point is that documentation techniques will vary depending upon the nature of the art and the location and condition of the site being studied. As a general (though not invariable) rule, petroglyphs are less fragile than pictographs and direct tracing on engraved panels stands little chance of damaging the motifs, whereas there is a greater potential for damage from direct tracing over pictographs. Where I work in western North America, however, pictographs are commonly covered by mineral skins or coatings and, in these circumstances, there is minimal likelihood for damage from direct tracing. On the Columbia Plateau, similarly, open-air rock art panels are regularly pelted with rain. In this case, the wetting of a panel (e.g., with a spray bottle holding distilled water) may be justified to enhance photography (for professional recording purposes), whereas in other regions this would be an unacceptable practice.

The *third* point, tied to the last concern, pertains to all archaeological research, which is by its very nature destructive (e.g., the excavation of sites destroys them; radiocarbon dating requires the burning of the sample). By widespread consent, the destructive nature of archaeology is considered justified, under proper circumstances. While site destruction by looters is, of course, universally decried, de facto site destruction by archaeologists is acceptable if it occurs for le-

gitimate, officially sanctioned research or management purposes, and if it results in the archival preservation of the artifacts and the dissemination of the data and information contained in the site.

Rock art is no different in this regard, but the key clause here is "legitimate, officially sanctioned research or management purposes." In fact, rock art panels and motifs are probably most commonly recorded for other reasons, usually personal. Eco-tourists, artists, rock art avocationalists, and even archaeologists on a casual visit, for example, may "record" a site, panel, or motif. This ad hoc recording usually includes photography, but it may also involve casting, tracing, rubbing, wetting, and/or chalking. All of these, with the possible exception of simple photography, are definitely or potentially destructive and should be avoided.

There is no hard-and-fast rule about what techniques can or cannot be used for graphic documentation (e.g., see GRAPP 1993) except this one: *ad hoc recording should be entirely and completely nondestructive*. This can be defined as a hands-off approach to the panels and motifs, with recording limited to photography and sketching. Officially sanctioned recording, in contrast, may sometimes occur immediately before the destruction of a site (e.g., by dam flooding). In such cases, cutting out and removing the rock art panels may be justified, as might be the casting of engravings (e.g., Feruglio 2002). These procedures would be considered unacceptable under most other circumstances, including recording for "legitimate, officially sanctioned research or management purposes" where there is no imminent threat of site destruction.

It is important to emphasize this point. One advantage of rock art research over other kinds of archaeological fieldwork, in my opinion, is that it can be conducted nondestructively, with no, or very minimal, impact to a site and its motifs. But to insist that all rock art research, in every circumstance, necessarily must be nondestructive and always must follow a certain narrow set of procedures (as has been suggested in the past) is unrealistic. Extraordinary circumstances may sometimes require extraordinary responses; in this case, documentation techniques that in other circumstances might not be acceptable.

The *fourth* point is that rock art documentation, like map making, invariably involves *generalization*. This is the reduction of the immense amount of empirical detail present at any site to a level that is adequate for management and research purposes, that can be reasonably archived, and that can be documented in a cost-effective manner. Generalization occurs at three stages: the determination of the empirical data to be recorded, the precision and accuracy by which these data are documented, and the precision and accuracy that can be practically achieved in publication.

There is simply no way that every empirical fact can be recorded about a site. (For example, has anyone ever bothered to measure the pigment thickness of pictographs, or the engraved depth of petroglyphs? It may have happened, although no examples come to mind and it certainly is not standard practice. I can, however, envision how such information might be valuable for particular research interests.) Nevertheless, there are some general views about which facts are necessary to record. Because these views are dependent upon research interests and theoretical orientations, they vary somewhat from researcher to researcher, and may change over time. What is important for any given field study is an explicit recognition of and rationale for what is being recorded, at what level of detail, and what may be reasonably overlooked.

A series of standard approaches to site documentation has been developed over the last few decades that balance the needs for adequate and thorough data collection with the desire to ensure the preservation of the art. These are used for the vast majority of professional rock art recording projects, and they can be discussed in terms of two general issues: photography, and drafted or drawn data.

## PHOTOGRAPHY

Photo documentation of a site and its rock art is essential (Aujoulat 1993b). It begins with an overview comprising far, middle, and close shots of the site. It includes shots of each panel in its entirety, with and without a standard color card and a scale. If possible (and at some sites this is impossible), it includes shots of each motif on a giv-

en panel, with and without a scale. It is important to remember that there are data related to the condition of a site that can and should be quickly recorded photographically, and this may involve photography some distance from the rock art panels themselves. This includes especially evidence of vandalism (e.g., graffiti, looters' pits, trash) as well as natural processes of site degradation (e.g., weathering, exfoliation, mineral growths, lichen, animal and bird nesting). These images will provide useful benchmarks for evaluating changes in site condition over time.

For all rock art shots, the camera lens should be held parallel to the panel face to ensure the best focus. This can sometimes be difficult to achieve. Peter Welsh has developed an ingenious solution to this parallax problem: he uses a circular scale in his photos. This scale appears as a circle if the plane of the photo is truly parallel to the panel; otherwise it will be more or less distorted into an oval. Digitized photos can be adjusted with computer software like Adobe Photoshop™ to correct for this parallax distortion. A simpler solution is to control the depth-of-field, the area in front of the camera that is in focus, which can vary from a single spot to a wider area. Set the $f$-stop on your camera to as high a number as possible (e.g., $f$ 22) to improve the depth-of-field and ensure best possible focus. Remember the one-third/two-thirds rule: the in-focus zone of your depth-of-field consists of approximately one-third the distance in front of your focal point and two-thirds behind.

The greatest difficulty in rock art photography is light control. Problems include too much light, partial shadow across a panel, and panels entirely in deep shadow (or, in caves, completely in the dark)—in other words, every lighting problem imaginable! A collapsible cloth sun reflector can be used to throw light across a panel in shadow. A shade cloth held up by assistants can be used to block out unwanted light. (I carry a so-called space blanket, which has a reflective surface that can be used either to throw light on a panel or as a shade. The space blanket has the advantage of serving both purposes, and it is cheap, lightweight, and folds small.) A circular polarizing filter is another essential accessory for eliminating glare off a panel.

A camera flash is usually necessary for photography in most rockshelters and caves. Many cameras now have built-in flashes, and these are often adequate to even out minor differences in shading across a panel. The best flash results for panels in full shadow are obtained with a separate flash attached to an off-camera hot-shoe cord. Optimal results occur when the flash is held by an assistant 8 to 10 feet *to the left* of the photographer, with the flash pointed at the center of the planned shot. This side lighting illuminates the texture of the rock panel face as well as the motifs, yielding the most dramatic but still empirically accurate images.

The digital photographic revolution is rapidly changing rock art photography and promises to continue doing so. Although there is still a significant difference in purchase price, 35-mm *digital* single-lens reflex cameras (dSLRs, *not* fixed-lens digital point-and-shoots) are now every bit as good as standard 35-mm *film* SLRs. Moreover, the digitals are more convenient and versatile, and they have much lower operating costs (since there is no film or developing). But print and slide images can be adequately digitized with a relatively cheap scanner, thereby providing the image-enhancement opportunities of the digital camera.

Regardless of the type of equipment used, some digital enhancement is now standard, especially for pictographs where motifs are faded (or where field conditions result in parallax distortion). Figures 2-3 and 2-4 illustrate this point with respect to fading. These were taken, with 35-mm color slide film, at the Texas Canyon, California, pictograph site, then digitally scanned and enhanced with Adobe Photoshop™ by Joe Simon. A few faint rock art motifs are visible in the standard film image. Importantly, field tracings of this panel by an experienced crew yielded a recording that was only slightly better than the original color slide in terms of what it showed on the panel. The enhanced image demonstrates how much was lost—and what can be recovered—with digital manipulation, including a substantial amount that could not be seen by the human eye in the field.

Regardless of how lightly or heavily a rock art digital image is altered, all should be clearly marked, on the front, as digitized and enhanced. This ensures that the improved visibility and changed color

**FIGURE 2-3** Photo of red-painted panel at the Texas Canyon site, near Agua Dulce, California. Very little of the art is visible in this photo, but this is not because of black-and-white reproduction. Very little of the panel can be seen even in a color image, or with the naked eye (including by experienced rock art recorders). Compare to Figure 2-4.

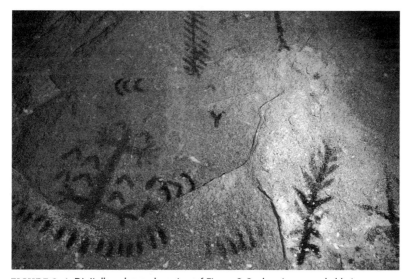

**FIGURE 2-4** Digitally enhanced version of Figure 2-3, showing remarkable improvement in visibility resulting from digital manipulation. This has revealed a number of motifs that had not previously been recognized; the effect is even more dramatic when seen in color. *Digital enhancement courtesy of Joe Simon.*

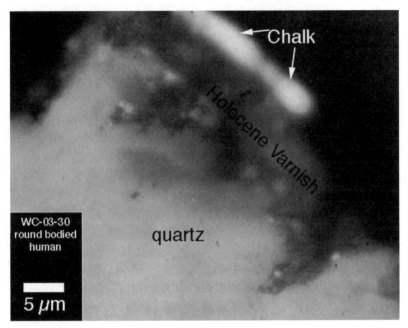

**FIGURE 2-5** Micrograph of a petroglyph, showing chalk embedded in rock varnish, illustrating the permanent damage that results from chalking petroglyphs for photography. *Photo courtesy of Ron Dorn.*

of the motif is never, in the future, assumed to have been its true condition at the time the photograph was taken.

Digital photography raises a corollary topic that has figured prominently in rock art photography. This is the "enhancement" of motifs by chalking to make them more visible for field photography. Unfortunately, chalking destroys the potential for petroglyph varnish dating (Dorn 2001; see Fig. 2-5) and it obscures and degrades pictograph panels. I can think of no circumstance where its use might be justified, partly for these reasons, but also because digital enhancement can serve the same purpose in an entirely nondestructive fashion.

In the past, rock art researchers took color slides and black-and-white prints at rock art sites, often with two cameras in simultaneous use. Given the ease and affordability of digitizing slides, and the fact that high-quality black-and-white prints can now be made from color digital files on an ink-jet printer, black-and-white film photog-

raphy is no longer as important as it once was. High-quality black-and-white prints, suitable for publication in professional journals, can also be obtained by making a black-and-white laser photocopy of a color print. If true black-and-white film is employed, however, it is useful to include a standard gray-scale card in the photos.

All film negatives, slides, and prints will fade and/or degrade over time, yet one goal of rock art documentation is to create a permanent record of the art. For now the best we can do is to employ the most archivally stable products available and store our materials in the safest way possible. (Bear in mind that, given the very rapid pace that computer technology changes, there is no guarantee that digital data archived today, using existing technology, will be accessible or usable in even a decade or two, without regular updates and translations into the latest formats.) The National Register of Historic Places (NRHP), an office within the U.S. National Park Service, is particularly concerned with the archival stability of photographic imagery. Their photo policy provides useful guidelines for anyone concerned with the long-term preservation of rock art data. This can be found on their website (www.cr.nps.gov/nr/), which also includes a series of links to related resources.

Film and digital technology will continue its rapid change. It is essential to keep abreast of this change in order to guarantee the optimal preservation of your rock art data.

## DRAFTED AND DRAWN DATA

Photography alone is not typically adequate for graphic rock art documentation. This is partly because some details may not be observable using standard photographic lenses; in part because careful observations at the panel face are necessary to understand and record the minimum information necessary about a panel; and often because written annotations about aspects of a panel and its motifs are important to record (e.g., which motif is superimposed over another, a fact that may not be apparent by looking at photographs or even from superficial examination of the panel). These annotations are usually placed on the panel recording sheet.

The goal in graphically documenting a rock art panel is to obtain a precise and accurate drafted image of the motifs, as well as to show their relationships to one another and to the natural features and conditions of the panel itself. It is not to "reconstruct" the images by creating idealized copies of them (e.g., with lines straightened, widths regularized, missing parts filled in). Such recordings are impressions of the art, the quality of which will vary dramatically depending upon the skills of the copyist. While rock art sketches of this kind may have aesthetic uses, they are almost invariably inadequate for research and documentation.

Similarly, a skilled artist may be able to draw an accurate depiction of a rock art panel on graph paper using a string grid or measurements as a guide. But the average archaeologist or student has no such skill. Worse, when sites are documented by field crews drawing motifs using string grids, it is impossible to determine confidently, after the fact, which panels are accurately depicted and which are highly inaccurate, even though some are almost certain to be. (Even accomplished artists are likely to make errors because of the parallax effect created by string grids that do not hang perfectly straight against panels that are not perfectly horizontal or vertical.) Although there may be certain circumstances where drawing with grids and/or direct tape measurements are the only acceptable approach, as a general rule this kind of drawing fails the 20-year test: the collected data will be of unknown quality once it is out of the field and its creator is no longer around to attest personally to its accuracy.

## DIRECT TRACING

There are two standard approaches to graphic documentation. The first is the direct tracing of rock art panels; the second is photographic recording with tracing added, which will be discussed in the next section. Direct tracing is appropriate in circumstances where the motifs are stable and are unlikely to be damaged by a slight amount of pressure resulting from tracing over them. This includes almost all petroglyph sites, pictograph sites coated with mineral skins, and pictograph sites with pigment that is otherwise stable and well-fixed to

the panel surface. (Again, we assume that the documentation is occurring for "legitimate, officially sanctioned research or management purposes," with responsible archival storage of the resulting data—that is, that this is not an ad hoc recording of a site or panel.)

Two different sets of material are used to directly trace rock art panels and motifs, depending upon the degree of detail in the rock art itself. Most common is the use of clear plastic sheeting, which is placed over the panel and temporarily affixed with painter's masking tape. This sheet should be labeled with the site name/number, panel number, date of fieldwork, and the recorder's name. An up-arrow is included to orient vertical or approximately vertical panels. Various brands of felt-tipped permanent markers are used to write on the plastic sheet and trace the rock art data. In the United States, Sharpie™ pens come in different colors and line thicknesses and have proven to be good permanent markers for rock art recording purposes. Because it is sometimes hard to determine all of the potential issues that may arise during fieldwork at a site, I usually include several kinds of tape, a variety of pens, and two or three thicknesses ("mil thickness") of plastic sheeting in my field supplies to select for specific field conditions. A small bottle of denatured alcohol and a rag can be used for "erasures" on the plastic sheets for most permanent ink markers.

The panel outline is usually traced onto the sheet and labeled. Cracks and other superficial irregularities are included. The motifs are likewise traced, following their existing edges as precisely as possible, and recording exactly where lines, pecking, or infilling stop and start. Because the panels are rock surfaces, they are invariably not perfectly flat or planar, and even a seemingly straight line will in fact be far from truly straight. Every effort should be made to trace the edge of the motif as accurately as possible, rather than "improving" and regularizing it.

The very fine graphic detail found in some corpora of rock art may require an accuracy in tracing that cannot be obtained using plastic sheeting and felt-tip markers. It is this same fine detail that makes standard photographic recording alone inadequate. The San (or Bushmen) cave paintings of southern Africa are a case in point.

San artists used paint brushes that apparently were just a few hairs thick to add almost minute iconographic details, like upraised hairs along the back of an eland antelope, and these seemingly minor details have in fact proven very important for the interpretation of this art (e.g., see Lewis-Williams 1981). Tracing in these cases requires drafting film, not plastic sheeting, and the use of mechanical (engineers' or "clutch") pencils to depict these minuscule iconographic attributes. Drafting film is not nearly as transparent as plastic sheeting, making this tracing process much more difficult, but there is at present no other way to record these panels adequately.

There are two important reasons for accurately tracing the edge of the motif, with all of its minor irregularities and gaps, rather than generalizing its form. The first is a question of control (and the 20-years rule): there is no way to gauge the degree of generalization employed in documenting a motif once away from the site itself, when it is admitted that generalization has occurred. As with sketched motifs using string grids, there can be no real confidence in the accuracy of the resulting sketch, because accuracy in this case reduces to a question of the skill of the archaeologist recording the motif, and typically this is unknown. The second reason, which is equally important, concerns potential future uses of the recorded data. Almost certainly it will be important to know the dimensions and outlines of many motifs, recorded on a particular date, as accurately as possible, in order to determine in the future the rate at which they may be deteriorating or the degree to which they have weathered away.

I avoid recording motifs by *stippling* (filling in the motif area on the plastic sheet with small dots or stipples, rather than following the motif edge with a line) for this same reason. While stipple recording is certainly more accurate than sketching (even with a string grid), it represents a loss of data that, in the future, may be very desirable to know. (Any future determination of the edge of the motif requires estimating from the already-generalized stippled edge to the presumed real motif edge, and thus is another generation of idealization.) Worse, the loss of important data when stippling, combined with the fact that it is much slower than simple line tracing, makes it both less accurate and less efficient. Admittedly, the motif recorded

Wet Black Pigment

Faint Black Pigment

Red Wet Pigment

White Pigment

Dry Black Pigment

Scratched/ Abraded

Pecked

Dot Underneath Line

Dot on Top of Line

Crack

Edge (≤90°)

Ridge (≥90°)

Mineral Accretion

Dot on Crack

**FIGURE 2-7** Graphic conventions used for recording and re-drawing Lava Beds National Monument pictograph panels, developed by Jannie Loubser (see Loubser and Whitley 1999). Consistent use of conventions such as these clarifies the traced and re-drawn panels (cf. Figure 2-7), and illustrates the complexity of the graphic problems confronted when illustrating rock art with line drawings.

by stippling is aesthetically more attractive than the accurately line-traced motif, but the goal is accuracy, not an attractive result.

With larger sites and field crews, it is useful to systematize the graphic conventions used for the tracings (e.g., Lorblanchet 1993b). Dashed lines, for example, may be used to indicate panel edges; underlying (petroglyph) motifs may be traced in red, whereas overlying petroglyphs are depicted in black; and so on. What is important here is consistency rather than (specific) form, along with the clear and permanent recording of the conventions that are employed in any given project. Figure 2-6 depicts the graphic conventions (developed by Loubser) that we used for tracing pictograph panels during our Lava Beds National Monument project (Loubser and Whitley 1999). Figure 2-7 shows one of the more complicated polychrome panel tracings, after it was cleaned up, reduced to page size, and inked by Loubser.

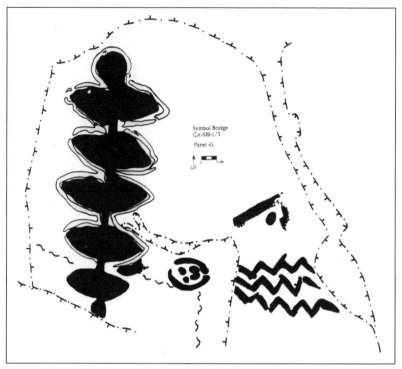

**FIGURE 2-7** Re-drawn tracing from the Symbol Bridge site, Lava Beds National Monument (Loubser and Whitley 1999). This employs the graphic conventions seen in Figure 2-6 in order to depict different colors (dark black and white paints) along with a series of natural cracks on the panel face and mineral accretions. *Redrawn from field tracing by Jannie Loubser.*

Although this last figure provides a good page-sized illustration of the panel, it is obvious that the reduction in size and the need to use graphic conventions (e.g., in depicting the superimposition of one motif on top of another) have yielded a very generalized image of the panel's art. While this is adequate for classifying and tabulating motifs, motifs associations, and the relationships of motifs to natural panels features (such as cracks), it is probably inadequate for any fine-grained analysis of motif condition. For this reason, it is essential to archive the original tracings as well as the final, reduced illustrations of them.

## PHOTOGRAPHIC RECORDING
## WITH TRACING ADDED

Direct tracing may be inappropriate at certain sites (Martin 1993), especially pictograph sites where exfoliation may have destabilized the painted areas, causing motifs to begin flaking off. Similarly, some site contexts (e.g., the ceiling of a cave containing a complex panel of motifs) may be physically difficult to trace directly. A safe and accurate way to record sites or panels such as these—the second approach to graphic documentation—combines photographic recording with tracing over the photo. This starts with a hard-copy photo enlargement of the panel (or a given motif), ideally as close to true size as possible. Next, an accurate tracing is made of this photo enlargement on a clear overlay. The creation of this tracing can be facilitating by digitally manipulating the underlying photo image, maximizing its visibility.

Both the photo enlargement and tracing overlay are then taken into the field, where the combination of the two is field-checked and corrected and augmented as necessary while examining the panel and motifs themselves. Though this approach requires multiple site visits, it reduces the total amount of time that must be spent in the field, and can provide very accurate documentation of the art, essentially giving the researcher the advantages of digital enhancement combined with direct field tracing.

## RECORDING ROCK ART SITES
## AS ARCHAEOLOGICAL SITES

While the art may be the focus of a field recording process, it is always important to recognize that rock art sites are more than just locales with preserved motifs (e.g., Clottes 1993a; Loendorf 1994; Morwood and Hobbs 1995). Whether it is obvious or not, the art at these locations is usually only one component of a larger archaeological phenomenon. This may include midden and other kinds of deposits, structural remains, or just the faint traces of the rituals involved in the creation and subsequent use of the art. In far western

North America, for example, rock art was created in ritual activities, usually by shamans and ritual initiates, who may have left traces of their ceremonies at the sites. Some of the rock art and its attendant rituals was created or occurred at remote, "private" locations; other art in the midst of large villages. Many sites were recognized as sacred places that were subsequently used by many people in what might be termed "folk" rituals (e.g., praying for good health). Elsewhere in the American Southwest, rock art is commonly found in association with Pueblo cliff-dwellings and small structures like granaries.

There are at least four implications of these circumstances. The *first* is that, when you initially visit a rock art site, think about it as an archaeologist in general terms rather than just as a rock art researcher. It is important to record as much archaeological information about a rock art site as reasonably possible, and not to treat the rock art as if it occurs in a vacuum. For example, it is clearly useful to know whether a habitation deposit is present and, if so, what kind of temporally diagnostic artifacts exist on site. A holistic interpretation of rock art, in other words, requires a deep understanding of the archaeological record, of which the rock art is just one part. The tacit implication is that other kinds of archaeological evidence must be included in your interpretation.

The *second* point is that rock art sites sometimes contain archaeological remains related specifically to the creation and use of the rock art. These kinds of remains should be carefully identified and recorded, partly because of what they may reveal about ritual behavior (and thus the functional and social origin and use of rock art), and also because of their potential value for dating. At Apollo 11 Cave in Namibia, for example, Wendt (1976) dated rock paintings to 27,000 YBP based on the discovery of exfoliated, painted pieces of the rock ceiling in a stratified subsurface deposit. In the far western United States, the ritual use of rock art often involved the deposition of offerings at sites, sometimes in cracks, other times at the panel base, and sometimes, apparently, at the foot of the slope leading up to the site.

Typically these offerings involved seemingly small and (to us) insignificant items, such as debitage, twigs, feathers, and quartz rocks and crystals—objects that we might, in fact, easily overlook as arti-

factual (Whitley et al. 1999a). Similar offerings are present at certain European Upper Paleolithic sites, such as Les Trois Fréres (cf. Bégouën and Breuil 1958), where flint, animal teeth, and a seashell have been left in cracks in a small chamber of engraved art (Bégouën and Clottes 1981). Alternatively, remnants of the tools or materials used to make the rock art may have been left on or deposited in the site and even plant pollen used ceremonially may be recovered (Loendorf 1994). These artifacts and specimens should be identified and recorded, if possible. Sometimes this requires controlled excavations at the base of rock art panels.

The *third* implication is a corollary of the last point. Given the presence of rock art panels in association with other kinds of archaeological remains, excavations and other kinds of research are likely to occur at these sites (e.g., Morwood and Hobbs 1995). Sometimes this will be conducted by archaeologists interested in the art, other times by researchers with little concern for it. Regardless of who conducts these studies, it is important to recognize that excavations themselves have the potential to affect rock art adversely (Morwood 1994). Perhaps the biggest potential problem is the generation of dust, which can coat, and become fixed to, the rock art panels, obscuring the motifs. As Mike Morwood (ibid.) has sagely observed, screening *away from* the art (e.g., outside of a rockshelter and downwind from it) and loosely covering the rock art panels with plastic sheeting during excavation are simple ways to avoid this kind of problem.

The *fourth* implication is that the best-preserved ritual deposits associated with rock art will often be found at smaller and more obscure rock art sites. These kinds of sites typically have not attracted the attention, and thus experienced the visitor pressure, of the more spectacular and better-know localities. Needless to say, visitor pressure can easily destroy the small and very fragile ritual offerings that may be associated with the art.

A good example of this was provided by Sally's Rockshelter, a very small and remote site (containing a single, faint panel of petroglyphs) located within the U.S. Army's Fort Irwin training facility in the central Mojave Desert of California. We documented this site

as part of the fort's archaeological management program, but it was included in our project almost as an afterthought, when all of the larger and more spectacular rock art sites had been studied. In fact we found a very well-preserved ritual deposit at the site (Whitley et al. 1999a). This contained intentionally broken quartz cobbles along with quartz hammerstones that had been used to engrave the motifs. This assemblage helped clarify aspects of the vision quest, the ritual involving the creation of rock art; it gave us an independent line of empirical evidence useful for considering continuity and change in the art; and it contributed to our explanation for the near-universal inclusions of quartz crystals in shamans' ritual kits.

Ultimately rock art recording is just another form of archaeological fieldwork. It obviously differs in techniques from the excavations conducted at other kinds of sites. The kinds of questions that rock art studies allow us to address are, in some respects, different from those commonly answered with data related to subsistence or technology. It remains the aim of rock art fieldwork to understand, interpret, and explain the prehistoric past. This will always be best achieved when multiple kinds of archaeological evidence are fully integrated into a field project, and not by the study of rock art alone.

CHAPTER 3

# CLASSIFICATION

Classification—the ordering of collected data in a fashion intended to facilitate analysis—is a basic component of all scientific research, including archaeology generally and rock art research specifically. For rock art research, classification has emphasized the concept of art *style* (Francis 2001). Meyer Shapiro's (1953:287) definition of this term is the most widely cited in rock art research, at least in North America (e.g., Heizer and Baumhoff 1962; Hedges 1982; Schaafsma 1985):

> By style is meant the constant form—and sometimes the constant elements, qualities and expression—in the art of an individual or a group. . . . For the archaeologist, style is exemplified in motive or pattern which helps him to localize and date the work and to establish connections between groups of works or between cultures: style here is a symptomatic trait, like the non-aesthetic features of an artifact (Shapiro 1953:287)

Shapiro's definition seems straightforward and clear. But its use in rock art research has proven difficult because it entails a series of important theoretical and methodological implications that are too often overlooked. Perhaps the most fundamental of these is that all

research, including data collection and classification, is guided by a scientist's theoretical interests and biases. These interests and (especially) biases may be implicit and unrecognized, resulting in unreliable analyses and interpretations. Conscious and critical examination of the implications of all steps in a research program is the best safeguard against this problem. The way a corpus of rock art is classified is at least partly based on the interests, biases, and concerns of the archaeologist. With this in mind, it is useful to consider the problem of rock art classification in terms of three general issues: motif typologies, stylistic evolution, and cultural-historical styles.

## MOTIF TYPOLOGIES

Most analysis begins by placing rock art motifs into particular types (Francis 2001). *Types* are individual designs, patterns, or elements that are repeated in the corpus of the art under study. The implication of typological classification in rock art is that each type matches a mental iconographic category in the culture of the responsible artist. Types, in this sense, include *motifs* (e.g., anthropomorphic or human-like figures), and *motif attributes* (e.g., differing arm positions on different anthropomorphic figures). The difficulty lies in distinguishing between inconsequential variations of specific motif attributes and variations consciously introduced by the creator. Here it is useful to consider frequency (whether specific attributes are common or rare) and range of variation/continuity (e.g., is there a continuous range of variation in the use of a particular attribute, or does this range fall into seemingly obvious clusters?).

Defining distinct motif types may in some cases be relatively easy but in others quite difficult. Simple, clearly distinct, and commonly repeated geometric patterns (circles, grids, zigzags), for example, may appear to be obvious distinguishable types. Yet many rock art corpora also include similar designs such as flecks and dots (that is, a filled-in circle), concentric circles, and spirals. Whether circles and dots had the same iconographic value for the original artist or whether they symbolized entirely different things may be difficult to determine. It is often easiest initially to distinguish each of these different geometric

patterns as distinct motif types—to split them up—and then look to independent theory or evidence to guide the final classification, which might require regrouping some of them into a single type.

It is appropriate here to mention briefly a few examples in which theoretical interests or independent data can influence or guide a motif typology of seemingly simple geometric patterns. The so-called neuropsychological model, to cite one case, was developed by David Lewis-Williams and Thomas Dowson (1988) to illustrate the kinds of mental images (e.g., visions, dreams) that commonly occur during a shaman's trance, and thus can be expected in shamanistic rock art. One component of this model (discussed later in more detail) involves seven geometric light images called *entoptic* designs that are generated in an individual's optical and neural systems during trance. Those interested in testing whether a particular corpus of art was or was not made by shamans to depict visionary imagery can use these seven designs as motif types, each of which itself includes a series of minor variations (e.g., circles, dots, and flecks; parallel lines and tick marks; concentrics and spirals).

Similarly, rock art was often created by cultures that also made ceramic vessels. Pottery has often been much better studied that rock art; in such cases, existing ceramic motif typologies may be useful as a guide for rock art typologies.

So-called representational or iconic images might appear easy to classify. But examining rock art classifications reveals little consistency or replicability. One archaeologist's "phallic human" figure type is another's "tailed lizard" motif. Part of the problem here involves confusing the process of *classification* with the supposed *identification* of the motif. Logically, identification should occur after classification (Panofsky 1983; Lewis-Williams 1990).

An approach that avoids this kind of problem is the use of a typological *key* (see Whitley 1982, 1987). The example in Figure 3-1 was developed to classify pictographs from California's southern Sierra Nevada. Different attributes of each motif (e.g., number and position of appendages) are used to assign a motif to a particular type. The result is a replicable and systematic classification of the motifs, rather than a typology that is impressionistic and ad hoc.

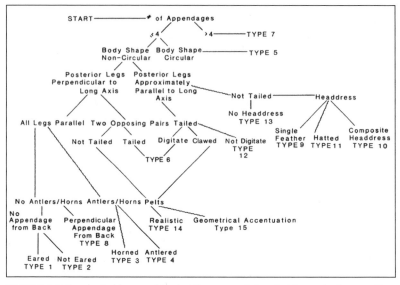

**FIGURE 3-1** Typological key used to classify representational pictographs from south central California (Whitley 1987). Classification begins at the top left and works down the branching decision tree until a motif is assigned to a particular type. Although this particular example is specific to the variety of paintings in the southern Sierra Nevada, similar versions could be developed for other regions, promoting typological replicability among different researchers.

We have seen that attention to the seemingly minor attributes of the motifs can be important in classification—but perhaps even more important for a subsequent analytical step is identification. Rock art motifs in any given region vary with the artistic skills of their creators; some examples of a particular motif type are more carefully and clearly rendered than others, and with greater attention to detail. The examples having greatest detail often provide the clues that clarify a specific identification (e.g., phallic human or tailed lizard?) of the type, and sometimes even its deeper symbolic meaning. Important here is both careful observation of the data set and the exercise of common sense, rather than a mechanistic adherence to self-imposed rules. Methodological rigidity does not necessarily equate with objectivity, as is sometimes assumed. It may simply represent thoughtless analysis.

A good example of these points is provided by the bighorn sheep

petroglyphs that are found in the Coso Range of eastern California (see Fig. 1-6). In this region, smaller sheep are sometimes superimposed on larger sheep, leading to arguments (concerning *identification*) that the motifs portrayed pregnant sheep and therefore that the art was made to enhance the fertility of the herds (Grant 1968). Attention to the iconographic attributes of the bighorn petroglyphs showed first that essentially all of the sheep, big or small, have large and dramatic in-curving horns, along with exaggerated upraised tails. Examinations of the biological literature demonstrated, first, that only sexually active adult male rams have the large in-curved horn racks. Second, the upraised tail is a posture that occurs at the animal's death, due to rigor mortis (Whitley 1994a, 1998c). Instead of pregnant sheep symbolizing concern with fertility, in other words, the Coso bighorns portray dead adult male sheep.

Once the motifs from a site (or series of sites) are classified by type, a higher order of classification can occur. It is now possible to compare the typological assemblage to other sites, regions, and assemblages. Typically, this raises the issue of style.

## STYLISTIC EVOLUTION

The concept of *style* arises in two slightly overlapping fashions in rock art research (Whitley 1982). The first, *stylistic evolution*, has been prominent in studies of the origins of art, especially those focusing on the Paleolithic cave art of western Europe (e.g., Breuil 1952), but it also shows up in other regions, such as western North America (e.g., Heizer and Baumhoff 1962). We will consider the second, *cultural-historical styles*, in the next section.

Stylistic evolution commonly looks at art as exhibiting gradual but directed change over time. This change was thought to run from simple to complex, or from geometric to naturalistic, figurative, or iconic images. Discussions of stylistic evolution provide good examples of the confused inferences that result from the influence of implicit theoretical biases. Stylistic evolution is based on an analogy with human skeletal evolution: since our bodies evolved from simple to complex forms, so too did art, as this thinking goes. But there is,

in fact, no good reason to assume that human artistic skills (and the cognitive abilities they imply) evolved over time, once humans began creating art. Recent chronometric research at certain Paleolithic caves demonstrates this fact. Our earliest known example of rock art, at Chauvet Cave, in France, dates back 33,000 years (see Clottes 2003; Clottes et al. 1995a, 1995b; Valladas et al. 2001). Yet the art at this site is every bit as complex and refined—as *evolved*—as that made by many contemporary figurative artists.

Rock art certainly may have changed over time in any given region. But the word *change* has different implications than *evolution*. Today, the notion of the stylistic evolution of art has been discredited.

## CULTURAL-HISTORICAL STYLES

The primary current use of the concept of style involves the definition of cultural-historical styles—that is, art styles that are thought to be exemplary of a particular culture during a specific time period. This is the definition of style suggested by Shapiro (quoted earlier), and its use in rock art studies has been widespread due to the assumption that style provides a kind of temporal and cultural framework that rock art research (until the advent of chronometric dating) otherwise lacked. Unfortunately, this use of style in rock art studies has been particularly problematic, and for a variety reasons (Whitley 1982).

Primary among these is that, while many researchers have cited Shapiro's (1953) definition of style as their justification for its use, they actually have paid little attention to the way Shapiro defined the concept. Shapiro was careful to state that a specific cultural-historical style involved the sum of the different expressive arts of a particular culture, not simply a single art form or craft, such as a corpus of rock art. The styles defined by rock art researchers, based primarily on rock art motifs, techniques, and motif associations, may or may not represent valid rock art styles—that is, art styles specific to a particular medium or craft.

There is no compelling a priori reason to equate rock art styles with cultural-historical styles, implying specific time periods and ethnic groups. Indeed, ethnographic research has shown that art

styles in general may pertain to tribes, broad regions that cross-cut tribal boundaries, particular crafts or media, specific ritual groups, longer or shorter time periods, initiatory cults, the sexual division of labor, and so on (Whitley 1982). Rock art styles alone are not, in other words, indicative of a particular cultural group or time period, though many rock art studies have made that assumption.

A good example of the potential stylistic complexity that rock art can incorporate, even within one specific cultural group, is found in Native California. In the southwestern portion of the state (roughly, San Diego County), the ethnographic record indicates that, during the historical period, pictographs were made by shamans in certain contexts, by female puberty initiates in other ritual contexts, and, in certain areas, also by boy puberty initiates in yet other contexts (Whitley 2000a, 2005b).

We believe that we can distinguish these three kinds of rock art sites from one another, based on stylistic considerations: colors, motif types, and location or placement. Yet in certain cases these different kinds of rock art—different rock art "styles"—occur in the same villages and appear to be the same ages. The three rock art styles that we find in this region, then, do not reflect cultural-historical distinctions but instead separate ritual styles that were made by different social/gender groups within a single given society during a particular time period.

This first example is hardly unique. The ethnography suggests that the Yuman-speaking tribes, who lived along the lower Colorado River at the southeastern extreme of Native California, made four different kinds of rock art. Shamans, first, created petroglyphs during their vision quests at the foot of their creation mountain. Young boys, next, also made petroglyphs at other locations, when their nasal septums were pierced during their initiations, as apparently young girls did too, during their separate puberty initiations at other locales. And shamans also made large intaglios, at still other locations, which were used by shamans and non-shamans during group ritual pilgrimages (Whitley 2000a).

From the cultural-historical perspective, all of these different forms of rock art contribute to a single (cultural-historical) style.

From the perspective of rock art styles, we might not be able to archaeologically distinguish a shaman's visionary petroglyphs from the boys' or girls' puberty art, even though these were made by different ritual groups. We would, however, differentiate the intaglios from the petroglyphs—although, in fact, these reflect different ritual purposes, rather than art created by distinct cultural-historical groups.

Other examples of similarly complex origins and uses of rock art are found especially in Australia, where substantial rock art ethnography illustrates this circumstance (see Layton 1992; Morwood and Hobbs 1992). That is, the Australian examples point to the fallacy of necessarily and always equating putative art styles with cultural-historical units. In some cases stylistic differences do represent cultural changes but in other cases they may represent differences in the social units or genders involved in making and using the art. The obvious question is, how we can recognize when stylistic differences signal different cultural-historical units? When, in other words, is style usable in the fashion that is so commonly desired by rock art researchers?

There is a rule-of-thumb that is instructive in these kinds of situations. If the regional cultural-historical sequence as a whole contains clear evidence of significant and obvious cultural change over time, such as a transition from hunter-gatherer to agriculturalist societies, it is likely that these changes will be reflected in the rock art. If no such major cultural changes are evident in a region, on the other hand, then changes in art style are less likely.

The rock art of the state of Utah provides an example. This region of the southwestern United States contained hunter-gather cultures for most of its prehistoric past, similar to those in the nearby Great Basin. But between about A.D. 600 and 1250 the Fremont culture developed there. The Fremont were sedentary farmers who represented a northern offshoot of the puebloan Anasazi cultures found to the south and, with their appearance, there was a profound change in regional culture. Fremont rock art is distinct on almost all counts from the hunter-gatherer rock art that preceded it, as well as from what came afterwards (including rock art produced by the pastoralist "horse cultures" that developed in portions of this region). As a num-

ber of researchers have illustrated (e.g., Schaafsma 1971; Cole 1990), there is an obvious stylistic rock art sequence in the region, and it is useful for cultural-historical classification.

In the nearby Great Basin, in Nevada and eastern California west of Fremont territory, no such sequence can be identified. This region witnessed a long-lived "desert culture," characterized by minimal change over time and extending from the end of the Pleistocene into to the historic period (Grant 1968). There is good empirical evidence indicating little if any *stylistic* change for this long-period, with continuities identified in the motifs and the sites used for over 10,000 years, as well as continuities involving specific attributes in the ways the motifs were portrayed and in the tools used to create the art (Whitley et al. 1999a). This is not to suggest that this art was timeless and never changing. Shifts in motif emphasis over time appear to reflect fluctuating social changes (Whitley 1994a; Whitley et al. 1999b). But there is no evidence for the replacement of one iconographic system by another, nor were there consequential changes in the locations or uses of sites, nor in the primary components of the iconographic corpus, which consists of a mix of representational and geometric images throughout the sequence.

The kind of long-term continuity seen in the Great Basin is far from unique. Western Europe, for example, has a number of rock art styles, ranging from the Paleolithic cave art of France and Spain, to the painted Neolithic Levantine art of eastern Spain (e.g., Beltran 1982), to the Neolithic cups-and-rings of the Atlantic province (e.g., Bradley 1997), and the (mostly) Bronze Age engravings of Scandinavia (e.g., Malmer 1975, 1981; Helskog 1996) and Valcamonica, Italy (Anati 1961, 1994; Fossati et al. 1989). Each of these styles (or traditions), is long-lived, but none is more long-lived than European Paleolithic rock art, which was produced for fully 20,000 years with minimal change (Clottes 1994; Valladas et al. 2001). The San (Bushmen) rock art of southern Africa presents a similar case, with 27,000 years of continuity (Lewis-Williams 1984; cf. Whitley and Annegarn 1994).

It is potentially useful to define styles in rock art research, and they can be distinguished based on the types and nature of the motifs, the techniques by which the motifs are made and presented, and the patterns in their association. But what these styles imply in cultural-historical terms needs to be determined through independent analysis, rather than assumed at the outset.

The definition of rock art styles may prove analytically useful, but only when the implications of any style are identified, not assumed. Put another way, stylistic classification does not end with the definition of rock art styles but with analysis that illustrates what these styles imply in cultural-historical and other terms (e.g., Smith 1992, 1994).

CHAPTER 4

# ROCK ART DATING

Despite the central importance of chronology to cultural-historical classification, rock art is rarely easy to date, either in a relative or calendrical sense. That said, great headway has been made in rock art dating in the last two decades. While there is still much to resolve about the new chronometric techniques and approaches, there is every reason to be optimistic that rock art dating will be increasingly common, and accurate. Indeed, any large rock art field project should now have a dating component that includes some effort at chronometric dating.

## RELATIVE CHRONOLOGIES

Relative dating involves analyses that yield internal and relational chronological sequences (e.g., motif type A is older than type B), or that lead to inferences placing a particular motif or set of motifs within a general chronological framework (e.g., motif type X dates to Phase Y; site 1 is older than site 2). Overviews of relative dating techniques for rock art motifs and sites have been provided by Weisbrod (1978), Dewdney (1970), Whitley (1982), Thackerey (1983), Keyser (2001) and, most recently, Morwood (2002). These identify a series of characteristics or qualities of rock art that may provide

clues to age. Relative chronologies, like all chronologies, are best when they are based on a combination of different kinds of evidence (e.g., Wellman 1979a; Whitley 1982; Dorn 1994; David et al. 1997; Chippindale and Taçon 1998).

The types of evidence or approaches to analysis that can yield relative chronological sequences start with *portrayals of datable subject matter*. These commonly may include animal species that either went extinct or were introduced into a region at a particular time; and weapons, tools, and technologies with independently defined chronological ranges. In North America, the introduction of the bow and arrow and, subsequently, the horse, provides key time markers in the rock art of many regions; in the northern Plains changing horse tack and weaponry allows for a more detailed chronology for proto-historic and historical rock art (e.g., Keyser and Klassen 2001). Depictions of extinct animal species were, of course, an important factor in assigning the cave art of the Franco-Cantabrian region to the Paleolithic period, but extinct species have also helped date rock art in Australia and southern and northern Africa (Thackeray 1983; Muzzolini 2001; Morwood 2002). Wagons, types of chariots, plows, ards, and even sailing ships are among the various additional kinds of technologies, tools, and weapons that are sometimes shown in rock art and that provide valuable chronological information about it (e.g., Lee and Stasack 1999; Betts 2001; Rozwadowski 2004). Despite the substantial list of potentially useful kinds of subject matter, depictions datable on this basis are unfortunately rare at most sites.

A conceptually similar approach involves *comparisons between rock art motifs and similar designs* found in other, better-dated media in the archaeological record. The similarities between the Franco-Cantabrian cave art and engraved bone, stone, and ivory artifacts found during site excavations further helped confirm the Paleolithic age of this art and continue to be useful in analyses (e.g., Bégouën and Clottes 1987). In a number of regions, well-dated ceramic designs have also been compared to rock art in order to date these motifs (e.g., Khalil 1979).

At large sites with numerous motifs, analyses of the *superimpositions of designs* can be particularly useful for internal site chro-

nologies. It is important to be aware that the superimposition of one motif on top of another may not be solely or primarily a function of age. There can be both symbolic and neuropsychological reasons for this kind of locational association (cf. Lewis-Williams 1974). For example, Wellman (1979b) has identified a statistically significant superimpositional relationship between shaman figures and bighorn sheep motifs in the Coso Range, California, suggesting that the two are conceptually linked. Similarly, superimpositioning is one of the principles of perception in the neuropsychological model of trance imagery (discussed later) and thus may be expected in shamanistic rock art (Lewis-Williams and Dowson 1988). Still, superimpositional sequences can provide a kind of rock art stratigraphy that is useful at many sites and in many regions.

One important consideration in developing superimpositional sequences involves looking beyond the motif types and their art style(s) to the size, location, and fashion in which the motifs are portrayed. Loubser developed a three-phase superimpositional chronology for Chumash pictographs during our work on the Carrizo Plain in California that illustrates this point (Fig. 4-1). The first phase involves small motifs, painted in the art style characteristic of the Chumash region of the California coast, generally placed at lower and relatively inconspicuous locations on the panel.

The second (later) phase involves the same motif types and art style but with designs that are larger, placed in higher and more visible locations on the panel, and nucleated or clustered, almost into "scenes." The last phase involves smaller randomly placed motifs corresponding to the art style found in the southern Sierra Nevada. Based on independent lines of evidence, we have correlated the changing nature of the rock art at these sites with demographic and sociopolitical shifts identified in other aspects of the archaeological record; we argue that this illustrates the development of a local Carrizo tribelet run by shamans-headmen, followed by a demographic collapse and regional abandonment, allowing for "foreign" shamans to use the local sites at the end of the sequence (Whitley et al. 2005a).

More detailed superimpositional studies can be formalized through the use of a Harris Matrix, which was originally developed

**FIGURE 4-1** A three-phase chronological sequence for the Carrizo Plain pictographs of California by Jannie Loubser (see Whitley et al. 2005a).Loubser developed this sequence by considering superimpositional relationships along with other characteristics of the art, such as size, placement, and style.

to order complex excavated stratigraphic sequences (Loubser 1997). In a Baja California example (Fig. 4-2), Loubser was able to distinguish two major painting episodes. The first of these involved grid designs, which were covered with a natural oxalate coating prior to

**FIGURE 4-2** Harris Matrix diagram showing superimpositional sequence for El Raton Cave pictographs, Baja California, as identified by Jannie Loubser. This sequence suggests two major painting episodes, starting with grids. These were coated by a natural mineral skin and representational images were later painted on top. The intervening mineral skin suggests that some time passed between the two primary painting episodes (Loubser 1996).

the painting of representational images, thereby suggesting a significant separation in time, with eight separate painting episodes involved in the creation of the representational art at the end of the sequence.

The *relative condition of motifs* may also provide some indication of relative age, although this seemingly simple approach is in fact more difficult that it may appear. Differences in the condition of the motifs on a single panel should reflect their relative ages—the worse condition representing the older, all things being equal. But therein lies the catch, because all things are rarely equal. Indeed, even minor differences across a single panel can result in significant apparent differences in the condition of different motifs, and these may not be related to the true age of the art.

This is especially true with respect to *rock* (or "desert") *varnish,* which is the dark coating that develops over time on rocks in arid regions (Dorn 1998a). For example, minor variations in context and position, such as the aspect of the motif or the amount of water that reaches a panel, can greatly affect the speed of weathering and the rate of varnish growth (even on a single panel, let alone across a site or region). But the problem also exists for pictographs, where water and exposure to sun and wind can vary significantly on a single panel face. Relative condition thus should only be used grossly (in a chronological sense) and carefully, and it requires a clear understanding (if not control) of the circumstances or conditions being analyzed.

Probably the most common of these kinds of analyses involves the degree to which petroglyphs in desert settings have been revarnished. This may seem straightforward and relatively simple, but any analysis of revarnishing is predicated on the archaeologist's ability to distinguish varnish growth from color variations in the heartrock of the engraved boulder or cliff face, or from the simple weathering of the rock. This requires practice. I recommend spending some time carefully examining samples with a hand lens in order to develop an understanding of when the specimens are revarnished and when they are not. This distinction is not always obvious to the untrained naked eye. Darkness alone is not always a sign of the presence of varnish, nor of the degree of varnish growth and, thus, of the age of the underlying motif (Whitley et al. 1984). Complicating matters even more, the darkness of a fully rock varnish–covered surface is a function of its geochemistry, not its age.

Still, relative condition has its uses, and it is best employed with large comparative data sets, combined with independent additional sources of chronological information. An example of the potential utility of this approach is provided by a study of the relative degree of revarnishing in approximately 750 human and bighorn sheep petroglyphs from the Coso Range, California, undertaken to identify general patterns in motif production over time for the western Great Basin (Whitley 1994a). I defined three categories of revarnishing for this analysis: little or no revarnishing; moderate revarnishing; and complete revarnishing. About two-thirds of these motifs had little or no revarnishing. This included all humans with bows which, in this region, are less than 1500 years old. This finding suggested that the majority of the petroglyphs in the western Great Basin were made roughly in the last 1000 to 2000 years. The inference was confirmed by a subsequent systematic chronometric analysis that yielded similar results, supporting the idea that there was an intensification in rock art production in the last few thousand years (Whitley et al. 1998, 1999b).

Another example of condition analysis was provided by David et al. (1997) for pictographs in a northeastern Australian region. They observed that white and brown paintings, made with clay and mud, are very unstable and prone to rapid deterioration in their region. The large proportion of their corpus that is painted with exactly these types of "pigments" led them to argue that most of the pictographs are relatively recent (hundreds rather than thousands of years old). They combined this information with superimpositional studies, relative patination and weathering, stratigraphically excavated (and independently dated) fragments of ochre found below the panels, and subject matter (fauna) of known age. The purpose of this exercise was partly to establish relative ages for the pictographs as an aid in testing subsequent accelerator/mass spectrometer (AMS) radiocarbon dating on the art, resulting in a particularly sophisticated and rigorous dating project.

*Ethnographic knowledge* of the making and meaning of rock art is also used to date sites within the ethnographic or historic period. More commonly, archaeologists have used the putative absence of

ethnographic data to argue that rock art is necessarily prehistoric, not recent, in age. Ethnographic analysis is a key topic for rock art research, and will be discussed later in detail. Here it is important to emphasize two facts. *First,* substantial ethnographic data have been identified during the last two decades in many regions of the world where, previously, such evidence was categorically denied by archaeologists. The early archaeologists' claim that no relevant ethnography existed in a given region may prove to be incorrect, and these kinds of claims need to be re-examined. *Second,* it is important to recognize that an apparent absence of evidence does not always equate with evidence of absence (i.e., of ethnographic rock art); discussion of ritual topics, such as rock art, were sometimes avoided by ethnographic informants, not due to ignorance, but because of the sensitivity of the subject matter.

In more limited circumstances, temporal changes in the *relative access to the art* has been used for relative chronological placement, especially in the cliff-dwellings of the American Southwest, where some rock art appears to have been made from the roof-tops of multi-storied pueblos. (That certain Paleolithic caves had been sealed by natural rock falls for thousands of years similarly supported the idea that they dated to the Pleistocene.) Changes over time in the *materials used* to manufacture pictographs have been identified at certain Paleolithic sites (Clottes 1993b, 1994), with different pigment ingredients diagnostic of different time periods. Some regional studies have included a *seriation of motif assemblages*—ordering different site assemblages into a temporal sequence based on the frequency in which different motif types are present in each assemblage—to establish a relative sequence of site ages (King 1978). Subject to the principles and caveats raised above, *stylistic analysis* may also prove useful for relative dating although there is no good reason to assume at the outset that a given rock art style will necessarily equate with a cultural-historical period.

One approach to relative dating is often overlooked but can be particularly useful. This involves looking at the *associated archaeological materials* found at a site, reflecting the fact that rock art panels may represent a single component of a larger and more complex archaeological phenomenon. Ideally, this type of research includes

excavation below rock art panels (e.g., Wendt 1976; Loendorf 1994; David et al. 1994, 1997; Morwood and Hobbs 1995). In such cases, the discovery of stratigraphically buried remnants of the tools and materials used to make the art, or spalled fragments of the rock art panel itself, may yield useful minimum ages for the art based on the age of the stratigraphic layer where they are recovered. Although much less certain, associated surface artifacts may also provide some indication of the age of the site (e.g., Turner 1963, 1971). In this last case, the strength of your chronological inference is improved if the associated materials consistently date to a single time period or phase.

The applicability of these different approaches and kinds of evidence obviously will vary and depend upon conditions specific to a particular site or region. Nonetheless, the best relative sequences result when multiple independent lines of chronological evidence are developed for any given case.

## CHRONOMETRIC CHRONOLOGIES

One of the most significant advances in recent rock art research involved the development and application of chronometric techniques that yield numerical, calendrical, or calibrated ages. Because the chronometric problems presented by petroglyphs and pictographs differ markedly in this regard, they can be considered in turn.

Note that chronometric techniques were traditionally said to provide *absolute* dates, and the term *absolute dating* is sometimes still used by archaeologists. This is a misnomer, in part because the results derived from this kind of analysis, such as radiocarbon dating, are just statistical estimates, providing a probability range for the most likely age of the dated specimen. The terms used here have been developed by chronometricians to clarify the misperceptions surrounding the old "absolute dates" (see Colman et al. 1987).

## PETROGLYPHS

The three primary techniques for chronometrically dating petroglyphs were developed by Ronald Dorn (see Dorn 2001 for a detailed

review). All involve analyses of the rock varnish coating that develops in drylands on rock surfaces (including the engraved-out portion of petroglyphs) over time. *Rock varnish* is a thin natural coating, derived from clay-sized particles of wind-borne dust, that is fixed by microbes onto rock surfaces. As Dorn has shown, the bulk chemistry of rock varnish changes over time; it is deposited in microstratigraphic laminations whose morphology is determined by major regional climatic regimes and it can encapsulate small bits of organic matter. Each of these three conditions provides a potential avenue for chronometric analysis and age control.

The first chronometric technique is *cation-ratio (CR) dating,* which was developed and introduced in the early 1980s (Dorn 1983, 1989; Dorn and Whitley 1983, 1984). Cation-ratio dating is based on the fact that cation exchange processes in the varnish result in changes in the ratio of relatively mobile to immobile cations over time; that is, certain major trace elements (e.g., potassium and calcium) are leached out of the varnish by capillary water more rapidly than others (e.g., titanium). Using independently dated control surfaces, this rate of change can be regionally calibrated, thereby allowing for chronometric age determinations for specific samples for individual motifs. Typically, an electron microprobe is used to measure the chemical constituents of samples of rock varnish that are roughly pin-head in size.

Although CR dating has been criticized (e.g., Reneau and Raymond 1991; Bierman and Gillespie 1991; Watchman 2000), it has been successfully replicated by seven different research groups worldwide, independent of Dorn's lab (Bull 1991; Dragovich 1998; Glazovskiy 1985; Pineda et al. 1990; Whitley and Annegarn 1994; Whitney and Harrington 1993; Zhang, Liu and Li 1990). Furthermore, CR blind tests have convincingly replicated previously existing chronological petroglyph sequences (Loendorf 1991; see also Faris 1995).

Cation-ratio dating is actually relatively imprecise (i.e., relative to radiocarbon dating results) and its proper application requires considerable expertise. But its advantage is that, once regionally calibrated, CR dates are significantly less expensive than those provided by other chronometric techniques. Moreover, CR dates certainly are

as precise as the temporal phases and periods commonly defined by the projectile point and ceramic typologies routinely used to date many sites. Cation-ratio thus provides chronological assays appropriate for most kinds of archaeological research. When properly conducted and applied, it is a very useful tool for rock art researchers.

A second approach to petroglyph dating is the *varnish microlamination (VML)* technique (Dorn 1990, 1998a, 2001; Liu 1994, 2003; Liu and Dorn 1996; Liu and Broecker 1999, 2000; Liu et al. 2000). This is a correlative (or relative) technique that places a particular sample within a previously defined time period rather than assigning it a specific age in calendar years. The VML technique involves a thin-section analysis of the microstratigraphy of rock varnish coatings, and it is analogous to dendrochronology in two ways. First, varnish develops over time in layers and (on appropriate varnish samples) the sequence of these layers is constant across a region. Second, this differential layering is caused by major, datable changes in climate; for example with shifts from wet to dry regimes that result in relative manganese-rich (wet) versus manganese-poor (dry) micro-stratigraphic units. These units are visible in thin sections under transmission light microscopy as either black or orange-yellow bands, respectively. Similar findings have been obtained in South America (Jones 1991) and Africa (Cremaschi 1996), and recent blind testing against cosmogenic dating results (Liu 2003; Phillips 2003) have verified the technique (Marston 2003).

Initial applications identified a series of micro-stratigraphic layers that could be used to constrain the ages of rock varnish samples from the Great Basin of the western United States during the Late Pleistocene for samples >10,000 years in age (Liu 1994; Liu and Dorn 1996; see Fig. 4-3). Ongoing research by Tanzhuo Liu (Liu and Broecker 1999, 2000; Liu et al. 2000; Liu and Whitley 2001), involving variations on the thickness of the thin sections examined microscopically, has resulted in the identification of a series of 12 micro-stratigraphic units for the Holocene. Once these are fully calibrated, it will greatly enhance the applicability of this promising new technique.

The third chronometric technique is the *radiocarbon dating* of the

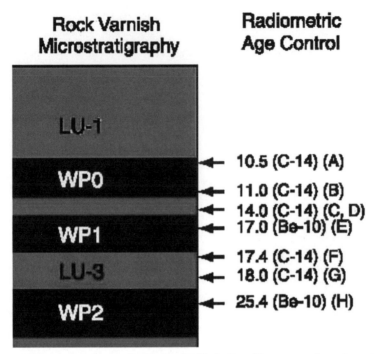

## Rock Varnish Microstratigraphy

## Radiometric Age Control

LU-1

WPO — 10.5 (C-14) (A)

— 11.0 (C-14) (B)

WP1 — 14.0 (C-14) (C, D)
— 17.0 (Be-10) (E)

LU-3 — 17.4 (C-14) (F)
— 18.0 (C-14) (G)

WP2 — 25.4 (Be-10) (H)

**FIGURE 4-3** Varnish micro-lamination (VML) stratigraphic sequence for rock varnish from eastern California, based on the research of Tanzhuo Liu and Ron Dorn. Independent chronometric ages (obtained on geomorphological surfaces), used to calibrate the chronology, are shown on the right. The sequence of dark and light varnish bands results from different climatic regimes. The bands are analogous to tree rings, allowing the assignment of similarly prepared varnish thin sections to specific time periods. *Image courtesy of Ron Dorn.*

very small bits of organic matter that sometimes are trapped in or under rock varnish and other natural rock coatings (Fig. 4-4). Because these organic samples are so small, this requires the use of a nuclear accelerator/mass spectrometer (AMS). Developed by Dorn (see Dorn et al. 1989), the technique was initially seen as having great promise because of the well-developed status and perceived accuracy of AMS radiocarbon dating itself. By 1992, however, discrepancies between pre-existing control ages and the empirical results of the technique suggested that the nature and homogeneity of the organic materials within and under the varnish needed systematic examination (Dorn and Loendorf 1992)—that these organics might include older or

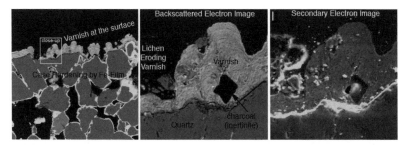

**FIGURE 4-4** Micrograph showing small fragments of carbon trapped under and within rock varnish layers. Various researchers have used nuclear accelerators to radio-carbon date varnish organic fragments and thus, by inference, the onset of varnish formation. But the organics appear to originate in a wide range of sources, with different ages, making the technique currently unreliable. *Image courtesy of Ron Dorn.*

younger contaminants and thus that the bulk samples of carbon used for varnish AMS dating were not providing accurate age constraints. Subsequent analyses demonstrated that these suppositions were correct and that the technique, as then applied, was providing ambiguous results (Dorn 1995, 1997 1998b; Welsh and Dorn 1997).

Two observations about radiocarbon varnish dating need be made. *First,* in some cases the radiocarbon age obtained on varnish organics does appear to estimate correctly the antiquity of the surface being dated. Initial optimism over the technique resulted because its first test yielded results reasonably matching the independently derived ages of the test locale (geologically youthful Hawai'ian basalt flows). But this empirical case apparently was *not* representative of most empirical cases, including the fact that the organics in these samples were homogenous rather than heterogeneous mixes of different types of carbon, as is more commonly true (Whitley and Simon 2002a, 2002b). *Second,* since the technique appears to work in at least some cases, and because the dating of petroglyphs is so important and generally so difficult, it is clear that additional basic research is warranted. This includes determining which carbon type is appropriate for dating, and under what environmental conditions the technique will work. Again, the initial justification for focusing petroglyph dating research on this technique—the well-developed status and general accuracy of AMS radiocarbon dating—continues

to be compelling reasons for research that will make varnish AMS dating a usable technique.

As Dorn (1994) has emphasized, petroglyph dating is most robust when multiple techniques are used, providing a specific example of the general scientific principle which holds that confidence in results increases with each independent analytical technique applied to a problem. Use of multiple techniques for petroglyph dating has resulted in two of the largest regional rock art chronometric data sets (Whitley et al. 1999a; Francis and Loendorf 2002) showing, among other things, that rock art in different parts of the hunter-gatherer North America is both much older and more recent than was originally conjectured.

## PICTOGRAPHS

The chronometric dating of pictographs likewise depends on AMS radiocarbon dating, allowing for radiometric assays on very small samples of carbon (Rowe 2001a)—in this case, carbon extracted from pigment. Although (as with petroglyphs) there is still substantial basic and applied work needed, the application of this technique has already resulted in major revisions to our understanding of prehistoric art, including the fact that art did not evolve from simple to complex; rather, it first appeared in a fully developed and sophisticated form (e.g., Valladas et al. 2001).

Two approaches to AMS radiocarbon pictograph dating have been developed. The first is applicable to charcoal-based pigments; that is, black paint made with charcoal (e.g., Valladas et al. 1990, 1992). Since charcoal dating is common in archaeology, this approach follows standard AMS dating procedures and is subject to the same constraints. Not all pictographs are black, of course, many being made from inorganic pigments such as red ochre. If an organic binder (e.g., blood or saliva) was mixed with the inorganic component to create a liquid paint, AMS dating in theory may be possible, if the organic remnants of the binder can be extracted. This assumes that the organic fraction has neither deteriorated nor chemically exchanged with other carbon sources after painting.

The second approach, developed by Marvin Rowe (2001a), is a plasma-chemical technique that allows for the extraction of the organic component of inorganic pigments, thus expanding pictograph dating beyond charcoal-based motifs. This has been successfully applied to a variety of pigments, including pictographs on limestone surfaces that are particularly hard to radiocarbon date (e.g., Russ et al. 1990, 1992; Chaffee et al. 1994). Perhaps most important, Rowe's plasma extraction system is, in theory at least, nondestructive (see Steelman et al. 2004). That is, it does not destroy the sample being dated (though some chemical change does occur). The implications here are substantial, especially for religious remains that may have intrinsic values (e.g., to Native Americans) that go beyond the scientific importance of a specimen alone. Unfortunately, for rock art dating at least, pigment samples still must be removed from the rock art panel, meaning that some destruction of the art is required.

## OTHER CHRONOMETRIC TECHNIQUES

Certain empirical circumstances may allow for or have prompted applications of other analytical techniques for chronometry. These understandably vary in their success and relevance to different regions, types of rock art, and sites. Although there had long been hope that *micro-erosion analysis* might serve as a chronometric tool for petroglyphs, Pope (2000) has demonstrated that the mineral grains (like quartz) that comprise many rocks already have a history of micro-erosion, before they are consolidated into bedrock. Since micro-erosion dating requires the assumption that fresh mineral grains are exposed when petroglyphs are created, Pope's research indicates that this technique is unlikely ever to be usable. Similarly, *lichenometry* was once thought to have promise for rock art dating. This requires measurements of the area of motifs (usually petroglyphs) covered by lichen, along with a time estimate for the rate at which the specific lichen grows at the site being studied. But, as Weisbrod (1978:2) has noted, the high sensitivity of lichen growth to micro-environmental factors (like water) requires measurements of areas on the order of 100 square meters in size in order to obtain reliable results.

Lichen-covered areas of this size are certainly present on landforms and perhaps on prehistoric rock structures or statues but not, to my knowledge, on rock art.

More successful, but limited in its applicability, is the *AMS radiocarbon dating of beeswax "paint,"* which is found at some northwestern Australian sites (Nelson et al. 1995). Similarly, natural calcium oxalate coatings sometimes develop over paintings or engravings and the carbon in this mineral can be AMS radiocarbon dated, thereby providing a minimum limiting age for the underlying motifs (e.g., Russ et al. 1994, 1996; Watchman 1991; Watchman et al. 2000). This technique assumes that the carbon mobilized in the mineral skin coating is contemporaneous with that coating; that is, that it does not incorporate older carbon than the coating itself—an assumption that still requires evaluation. Nonetheless, the technique is promising and, because mineral skins can develop over petroglyphs and pictographs, it is not limited to a single kind of rock art.

*Optically stimulated luminescence (OSL)* dating has been used to assess the age of mud wasp nests that cover art at certain Australian sites, thereby providing minimum limiting ages for the motifs (Roberts et al. 1997). The principle behind OSL dating is the length of time that quartz grains incorporated in the wasp nests have been protected from sunlight and thus have built up luminescence. Although cases of wasp nests covering motifs may be relatively rare, in the Americas swallows commonly build mud nests at rock art sites; these too almost certainly contain quartz grains that can be OSL dated, and for this reason the technique may be more widely applicable than heretofore recognized.

Phillips et al. (1997) have used *cosmogenic dating* to obtain maximum ages on the exposed schist panels containing Paleolithic petroglyphs in Foz Côa, Portugal; in this case, an analysis of the build-up of chlorine-36 following the exposure of the rock surfaces to the open air. The rock art panels proved to have been exposed between 16,000 and 136,000 years ago. Although this did not date the petroglyphs on the panels, per se, it provided important maximum ages in light of impressionistic arguments that the art was necessarily recent in age, because the rock art panels themselves were thought too youthful to

contain Paleolithic art. Cosmogenic dating using other radioactive nu-clides (e.g., beryllium-10) may have similar uses in rock art research (cf. Cerling and Craig 1994; Kurz and Brook 1994).

A final chronometric technique for petroglyphs is *lead-profile (LP) dating*. This is based on the fact that the iron and manganese in rock varnish "scavenge" lead. When the geochemical profile of a chip of rock varnish is analyzed, it shows a lead spike in its surface layer (Fig. 4-5), due to the increased lead in the atmosphere as a result of twentieth-century industrial pollution (Dorn 1998a; cf. Fleisher et al. 1999; Thiagarajan and Lee 2004). This circumstance provides an independent check for the age of the rock varnish covering the engraved-out area of a petroglyph. If the varnish coating uniformly exhibits a high lead value, we infer that the varnish only started to form in roughly the last hundred years and is, therefore, most likely historical in age. If the varnish under the surface layer exhibits a re-duced lead value, this is independent support for the conclusion that the petroglyph was made before the recent onslaught of industrial pollution. Although this technique is limited in its applicability, it is a useful quick check to determine whether a petroglyph is historical, and of course it is an independent check for other techniques.

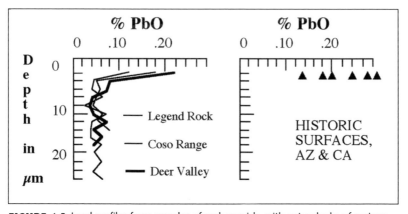

**FIGURE 4-5** Lead profiles from samples of rock varnish, with petroglyphs of various ages on the left and historic surfaces with rock varnish coatings on the right. The Industrial Revolution has increased the amount of lead in the atmosphere. Rock varnish layers that have developed recently, as a result, contain a high proportion of lead. Lead-profile dating is particularly useful for identifying historical motifs. *Image courtesy of Ron Dorn.*

Rock art dating, whether based on chronometric or relative tech-
niques, still requires significant basic research as well as numerous
applied regional investigations. Even though many of the techniques
are still experimental, recent dating research has already profound-
ly changed our understanding of the age of rock art, especially
in France and Spain (e.g., Valladas et al. 1992, 2001), Australia (e.g.,
Chippindale and Taçon 1998), and the western United States (e.g.,
Whitley et al. 1999a, 1999b; Francis and Loendorf 2002), where the
majority of this research has been conducted. One can only be opti-
mistic that, despite difficulties with certain techniques and the high
costs of analyses, our understanding of rock art chronologies will
continue to improve.

# SCIENTIFIC METHOD AND ROCK ART ANALYSIS

Regardless of an archaeologist's specific research interest in rock art, analytical rigor is essential. This is true whether the research problem is cultural-historical (e.g., the chronological placement of the site), interpretive (e.g., the identification of the symbolic meaning of the motifs), or overtly scientific (e.g., attempting to explain this aspect of human social life). Our best guide to analytical rigor is always provided by scientific method. Indeed, scientific method provides a model for problem-solving in all areas of our lives. A quick refresher on scientific method and some related topics can be extremely useful because the careful use of scientific method provides our best means for studying rock art.

## SCIENTIFIC METHOD

In strict philosophical terms, *scientific method* is simply a means for selecting one hypothesis over possible competitors. These hypotheses could concern the age and cultural affiliation of a site, the

symbolic meaning of the site, or its sociopolitical functions. Pre–World War II scientific method was commonly called *positivism*. Different manifestations of it emphasized falsification (i.e., the search for evidence and tests that disproved a hypothesis) or confirmation (evidence and tests proving a theory). But positivism generally ascribed to rigid, unrealistic, and extreme philosophical beliefs about the nature of scientific knowledge and the outcome of scientific testing. The result of testing was thought to be definite "proof," in essence making established scientific knowledge infallible and unequivocal. Many people (including some scientists) retain these positivist ideas about the nature of scientific knowledge and the way research should be conducted.

Since about 1960, many philosophers of science have realized that these positivist beliefs were unrealistic, that scientific knowledge isn't generally that certain, and that scientific tests are often somewhat ambiguous. (Indeed, when research involves statistical analyses, the results are probabilities and probability ranges, and not "proof" at all.) An alternative approach to science has arisen that is generally referred to as *post-positivist* scientific method (Whitley 1992a, 1998a).

One of the key positions of this approach is the acknowledgment that interpretive hypotheses (e.g., about the origin and meaning of rock art) are as amenable to scientific evaluation as physical hypotheses (e.g., about the nature of the universe). The old belief that some subjects are intrinsically "more scientific" than others stems from confused Enlightenment notions (e.g., see Midgley 2003). All that is required for an interpretation or hypothesis to qualify as "scientific" is the ability to evaluate it with empirical data. Put another way, a scientific hypothesis makes a claim about the real world that can be checked ("The earth is round"), whereas a nonscientific assertion cannot be checked ("Given your behavior, you will not go to heaven"). In this sense, rock art hypotheses ("This motif symbolized its creator's clan") are potentially as scientific as the hypotheses developed by chemists.

Equally important, many philosophers now acknowledge that scientific tests are rarely final and thus do not provide absolute proof. (Indeed, philosophers now restrict the concept of proof to two non-

empirical intellectual endeavors: mathematics and logic.) Thus we have three practical principles of this post-positivist kind of scientific method:

- Hypotheses are accepted or rejected based on *inference to the best hypothesis,* not through falsification nor by singular critical tests. (Kelley and Hanen 1988)

- The evidence used to infer to the best hypothesis is similar to *intertwined cables,* not to logical chains (which are only as strong as their weakest link). That is, the best hypotheses involve multiple lines of evidence, thereby avoiding the dangers of both weak logical links and "inverted pyramids of inference." (Wylie 1989)

- Inference to the best hypothesis is most usefully based on *convergent methodologies.* This requires independent data sets, obtained in different ways, leading to the same inference or conclusion. Confidence in a conclusion, in fact, increases geometrically with each added independent technique and data set. (Lakoff and Johnson 1999)

Alternatively, use of a single data set and collection technique potentially yields a result that is a predetermined outcome of the assumptions of that approach.

The ideal rock art analysis thus begins with a set of competing hypotheses. It involves the systematic collection of a series of different kinds of data, using different techniques, and then, based on the analysis and interpretation of the data, selects the best hypothesis among the competitors.

Selecting the best hypothesis or interpretation is an important process. It relies on comparing a number of qualities, characteristics, and attributes of the competing hypotheses. These include:

- The amount of data explained by each

- The diversity of different kinds of data explained

- The ability of the hypothesis to fit within previously accepted larger theories, models and explanations

- Internal consistency and logical coherence

- Ability to generate new insights and avenues for research

- The ease of accommodating new and unexpected data and re-
sults (cf. Newton-Smith 1981)

Three comments about this list are necessary. The concurrence
of a hypothesis with previously accepted theories is an important (in
some cases critical) attribute of the plausibility of that interpretation.
Darwinian evolution is one such previously and widely accepted the-
ory and, as is clear, any biological hypothesis that runs counter to evo-
lution can probably be dismissed, on this point alone, at the outset.

The second issue involves the well-known quality of simplicity,
which many scientists view as a preferred characteristic of good hy-
potheses, in some cases referring to the principle of Occam's Razor in
selecting one hypothesis over another. In fact, simplicity is at best a
problematic quality (Newton-Smith 1981). Its putative importance,
inherited from Enlightenment ideas, has been overplayed (Midgley
2003), and probably should not be overemphasized in selecting a
preferred interpretation. The world is a complex place; there is no
reason why good explanations should not also be complex.

The last issue is the sub-text of this list of qualities. This is that
*some* empirical evidence will support most reasonable hypotheses.
The discovery of empirical support for a preferred hypothesis is
alone inadequate for the acceptance of any hypothesis; it is instead
necessary to demonstrate that the sum of the evidence supports one
hypothesis over its competitors. The flip side of this point is the fact
that any argument based solely on a single line of evidence is intrin-
sically weak.

A good example of an evaluation of competing hypotheses in-
volves two contrasting interpretations of Great Basin rock art (Whitley
1994a, 1998b): whether the art originated in hunting magic (Heizer
and Baumhoff 1962), or whether it was created by shamans to depict
the trance imagery of their vision quests (Whitley 1992b). Empirical
evidence supporting the hunting magic hypothesis includes:

- Depictions of game animals in the art

- Depictions of killed game and hunters shooting game

- Presence of stone cairns, walls and talus pits, which are interpreted as dummy hunters and hunting blinds

The competing hypothesis includes the following lines of evidence:

- Direct ethnographic commentary that ties the art to shamans' vision questing and their supernatural experiences, and that categorically denies hunting magic rock art

- Close correlation between the depicted imagery and independent neuropsychological research on the nature of art intended to portray trance imagery (discussed below; cf. Lewis-Williams and Dowson 1988)

- Ritual use of quartz by shamans during vision quests, and discoveries of quartz at rock art sites, as well as foreign materials analyses showing that quartz hammerstones were used to peck the petroglyphs (Whitley et al. 1999a)

- Ethnographic evidence for the creation of stone cairns, alignments, walls, etc., during vision questing (for purposes of physical exertion)

- Absence of any artifactual evidence at these same features (such as hunting tools or butchery remains) that would be expected if they were hunt-related

Clearly there is some logical empirical support for the hunting magic interpretation of Great Basin rock art and, over the years, many have felt that it was compelling evidence. But the major problem with this interpretation was the denial of hunting magic by Native Americans.

The alternative hypothesis, in contrast, resolves the empirical inconsistencies presented by hunting magic and is supported by three different lines of evidence, involving independent data collection techniques: ethnographic analysis, universal neuropsychological principles, and foreign materials analyses. Simply put,

this hypothesis is more robust than its competitor and, for this reason, is the preferred interpretation.

Interpretive hypotheses, including the kinds involved in rock art research can be treated scientifically, with selection of the best among a series of competing hypotheses. This requires not only careful attention to scientific method but also systematic data collection at the front end of a study.

## AVOIDING ANECDOTAL EVIDENCE

This Great Basin example is useful for a second reason: because it illustrates the difference between anecdotal versus systematic data collection and analysis, and inductive versus deductive research. As should be clear, any strong scientific inference necessarily must be based on systematic, and therefore representative, data collection and study. Yet one central weakness of many rock art studies is their reliance on anecdotal evidence, often resulting from what could be termed a "weekend warrior" approach to fieldwork: develop an inductive hypothesis that explains one particular bit of empirical evidence and, from this single fact, conclude that you have explained the art. Meanwhile, the majority of the evidence, pro or con, is ignored.

In the Great Basin case, Heizer and Baumhoff (1962) justified their hunting magic interpretation, noted earlier, partly based on the presence of putative game animals and hunters in the art. This was problematic for a couple of reasons, the first of which was their conflation of what they identified in the art ("game," "hunters") with its symbolic meaning; that is, they assumed that the symbolic meaning of the motifs for prehistoric Native Americans was necessarily what they themselves, as mid twentieth-century Euro-American academics, saw in these same motifs. This is no different from arguing that stylized Christian fish emblems on cars necessarily mean that the driver is a fisherman, or is obsessed with eating fish. Obviously the emblem does depict a fish, but what it *depicts* and what is *symbolizes*—Christian faith—are two very different things.

Heizer and Baumhoff then compounded this first problem by their use of anecdotal data: the logic of their argument rests, analyti-

cally, on the so-called game-and-hunter motifs (i.e., the kinds of mo-
tifs one would make for purposes of hunting magic). Yet, in fact, over
80 percent of the petroglyphs from their Nevada sites are instead
geometric images (Whitley 1998b). This is what I call "counting the
hits and ignoring the misses." This is to say that their argument cited
the anecdotal evidence that supported their claim and ignored every-
thing else, including the preponderance of the available data.

Rock art studies that focus on single panels or specific motif
types, divorced from some larger interpretive model or theory, often
suffer from this same problem. Although the studies may result in in-
teresting suggestions or interpretations, they are inferentially mean-
ingless until it is demonstrated that the interpretation can be gener-
alized beyond the single case. (This problem is particularly common
in archaeoastronomical studies of rock art.) Archaeology, as a social
science, is necessarily concerned with patterns of behavior, not ran-
dom, isolated, or idiosyncratic acts. The empirical data analyzed
must be representative of the population as a whole, and analysis
must be systematic, not anecdotal, for any inferential confidence to
result.

Scientific method is useful for all rock art analyses and interpreta-
tions, regardless of whether the proposed research is (strictly speak-
ing) cultural-historical, humanistic, or scientific in intent—a fact that
has been poorly understood by many archaeologists in the last few
decades. This is because scientific method is simply a means for eval-
uating evidence and deciding which theory is the stronger and what
(inferentially speaking) is the weaker. Put another way, humanistic
research often looks for the meaning or intent of prehistoric actions,
whereas scientific research seeks cross-cultural laws and generaliza-
tions. But scientific method is only a tool: a method for decision
making, not a commitment to one or the other of these contrast-
ing intellectual goals. Humanists may use scientific method properly,

and I know from personal experience that many hard-core scientists practice poor scientific method. Incorporating scientific method into your rock art research will prove extremely useful, whatever kind of research you to plan to conduct. And it is also a great method for decision-making in your everyday life.

CHAPTER 6

# SYMBOLIC AND ETHNOGRAPHIC INTERPRETATION

Paul Taçon and Chris Chippindale (1998) divide rock art analyses and interpretations into informed versus formal approaches. *Informed approaches* generally are those based on the use of ethnological or ethnographic evidence. They employ an *emic* perspective, or insider information, to understand the art. *Formal approaches,* in contrast, typically use quantitative or locational data, or biological models of some kind, in their analyses. They are *etic,* or outsider's interpretations, of the art, and for this reason often concern implicit social function more than symbolic meaning. In practice, much good rock art research combines elements of both approaches (and uses scientific method to evaluate competing interpretations). But Taçon and Chippindale's distinction is nonetheless useful for conceptualizing different approaches to rock art analysis.

Symbolic and ethnographic interpretations are discussed here, including an overview of the ethnography of world rock art. These are usually linked (e.g., Layton 2001) because both seek an understanding of the meaning of rock art, and both are informed approaches.

A consideration of these approaches necessarily starts with a basic (and often raised) question: Can rock art be interpreted?

## INTERPRETING ROCK ART

Anyone who has had an introductory anthropology course should know that rock art can be interpreted, even in the absence of the artist. Like all symbolic systems, rock art had a social function; part of that function was to communicate ideas and concepts to other people in the absence of its creator (Layton 2001). All symbols have multiple levels of meaning, and identifying the social meaning of rock art is the goal of interpretation. (For example, any Christian, regardless of native language or country of origin, can likely provide a reasonable interpretation of the symbolism and meaning of Michelangelo's frescos in the Sistine Chapel without any input from the long-deceased artist.) That certain rock art sites in a given region share similar motif assemblages or are stylistically equivalent demonstrates their shared social origin and nature. Put another way, if shared meanings, conventions, and norms did not exist, then each rock art site should be unique and unlike all others in the same region. More than a century of international research has shown that this is rarely the case.

The belief that rock art cannot ever be interpreted also reflects confusions about how anthropological research is conducted. As Geertz (1973:17) and Sperber (1982:161) have been careful to note, the meaning of symbols is inferred from human action—behavior, in other words—and not solely from what people say. The archaeological record is in fact a record of human behavior and there is no reason why meaning cannot be derived from archaeological analyses.

Rock art interpretations require an understanding of the way a particular symbolic system operated; with this kind of knowledge, detailed interpretations of rock art can be obtained. The level of detail varies among cultural regions and time periods, depending upon the available evidence. But we can no longer argue that an interpretive understanding of all rock art is beyond our reach.

# SYMBOLIC ANALYSIS

Understanding how a particular symbolic system operated implies conceptual concern at two distinct levels. The first involves how symbols, in general terms, function in human communication systems; the second, discussed later, concerns the analysis of symbolism in specific ethnographic cases.

Perhaps the first general operating principle is that, because symbolic systems have social functions, they are internally consistent, coherent, and logical. Although it is sometimes argued that symbols are arbitrary, it is rarely true. (Some have attempted to generalize based on linguistic studies, where the form of words may be arbitrary, but that is not the case with symbols.) Among traditional peoples, many symbols are in fact based on *natural models*:

> These are natural phenomena, like animal behavior, that served to structure the logic underlying aspects of religious symbolism and ritual, usually by some form of analogical reasoning. In this sense, the thought underlying these models is rational and systematic. When natural models are based on phenomena that themselves involve invariant principles, uniformitarian laws, or timeless characteristics, the models have the potential to inform our understanding of truly prehistoric religious phenomena, without benefit of informants' exegesis, and sometimes even without ethnohistorical connections. (Whitley 2001: 132–33)

Natural models might include dangerous animal predators as symbols of bravery, power, and fighting prowess (Whitley 1994b). In Native California, for example, the grizzly bear was associated with the male shaman, who was thought dangerous and sometimes malevolent. Alternately, avian imagery and symbols were associated with shamans because shamans were believed able, like birds, to fly. This perceived trait was itself based on a natural model. The sensation of flight is one of the bodily reactions to altered states of consciousness used by shamans for supernatural communion (in New Age terms, an

out-of-body experience). In southern Africa, to cite another example, Hollman (2002) illustrated how San knowledge about bristling hair on animals served as a natural model for their beliefs about supernatural potency. The subtext in each of these cases, as Sahlins (1985) has emphasized, is that symbolism is "highly empirical."

A second aspect of symbolic systems is that all aspects of human social life, including behavior, artifacts, and art, not only have symbolic meaning but also have multiple levels of meaning. To cite a trivial example, a stop sign can be *identified* as just that: a sign broadcasting a command: "Stop your car." But its *function* as a symbol includes more than its identification. It can also be used as a landmark (e.g., "Turn right at the first stop sign"). Its potential social functions, in this sense, may go beyond its primary purpose. Indeed, the *potential* symbolic meaning of the stop sign is even greater: it demonstrates the existence of a central authority attempting to control traffic on the road, using a standardized symbol that is shared by the population; it illustrates the fact that this authority has the funds to pay for this kind of public improvement; and, given that stop signs differ in language and form in different countries, it reflects the ethnolinguistic community and/or governmental body where it is found.

As noted earlier, the distinction between identification and meaning is fundamental to any symbolic analysis. Sometimes, as Sigmund Freud famously stated, "A cigar is just a cigar." But when we are concerned with ritual behavior and art—and this is generally the case in rock art research—we have every reason to assume that the intended symbolism involves deeper levels of meaning, much more than mere identification. Yet this raises an important methodological problem. Assuming we have identified a series of potential meanings for a rock art symbol, how can we determine which one (or ones) were intended by the artist?

The answer lies in context and association; different kinds of symbols play different roles in any symbolic system. Victor Turner (1967), for example, usefully distinguishes between *dominant symbols,* which are pervasive, common, and may hold multiple meanings, and *instrumental symbols.* Instrumental symbols are paired with, and signal the specific meaning intended for, a given dominant symbol.

A good example of the interplay of dominant and instrumental symbols is provided by the rock art in the southern Sierra Nevada of California (Whitley 1992b, 2000a). Animals in this region had multiple kinds and levels of symbolic meaning. (For example, society was divided into two major social groups, known as *moieties,* and each of these had specific animals associated with it. Animals were also the main actors in myths. Moreover, certain animal spirits served as shamans' spirit helpers and thus had particularly strong associations with those individuals.)

Despite this diversity, we can confidently interpret animal pictographs as the spirit beings that the shaman saw in the supernatural for an important reason. The rock art site was not a neutral canvas or backdrop upon which the art was painted. It was instead an important instrumental symbol that represented the shaman's portal into the supernatural world, which itself was inhabited by animal spirits but not mythic actors. It is this associational context—the painting of the motif at a site with its own symbolic meaning—that helps clarify the specific meaning intended in this particular case: mythic actors and moiety groups were not associated with the supernatural, whereas spirit helpers and other kinds of spirit beings were closely connected to this realm.

While symbolic systems are logical and coherent, this does not mean that they are in all respects straightforward, literal, and simpleminded. One potentially confounding characteristic of symbolic systems involves the use of inversions. These emphasize the importance or significance of a particular ritual, trait, or circumstance through contrast. In contemporary American culture, Halloween provides a good example of ritual symbolic inversion. For one evening social roles are reversed: children are allowed to roam the streets at night while adults stay inside; the youngsters demand treats from their elders; if the adults do not comply, the children may render retribution in the form of tricks. This inversion of social roles serves at a simple level to reinforce the roles themselves. Children are reminded of the existing hierarchy of authority and control by, on this occasion, inverting it.

Although Halloween is increasingly a secular and commercialized

holiday, only a generation ago its ritual elements continued to emphasize its Christian symbolic roots, with children impersonating devils, ghosts, witches, goblins, and the like. All of these are spirits or beings conceptually opposed to the "positive" aspects of Christian belief and life. (Some fundamentalist Christian groups continue to object to Halloween because of this symbolic connection.) The implicit symbolic message traditionally delivered was tied to the inversion in social roles: failure to adhere to existing social structure unleashes the unholy, or, put another way, spiritual balance is maintained when the social structure is safeguarded.

The Halloween example shows how these symbolic principles operate, often subconsciously, even in what are typically considered very mundane circumstances. This demonstrates that not all ritual and symbolism is necessarily religious. (Political and military power, wealth and status, and gender are some of the other social phenomena that commonly involve symbolical expressions of various kinds.) Inversion is nonetheless a potentially important aspect of the symbolism of rock art sites. In far western North America, for example, the caves and rockshelters that served as rock art sites—typically, low places on the landscape—were thought to be entries into the supernatural world, which itself was conceptualized as up-above, in the sky.

Use of a low place on the landscape to gain access to a world above might seem illogical, save for this: in much of Native America, the supernatural was conceptualized as the inverse of the natural world. Shamans commonly went to relatively low places on the landscape to gain entry to the supernatural "upper" world. Further, given that low places were conceptualized as feminine-gendered, whereas high places were thought masculine, male shamans went to feminine-gendered locations to gain entry to the masculine aspects of the sacred (Whitley 1998b; Whitley et al. 2004). The symbolic system, in this example, is certainly structured, logical, and coherent, and not at all irrational (as some critiques of religion would suggest). But it is different from the Western conceptualization of things, pointing to the importance of cultural context in any detailed rock art interpretation.

A final general characteristic of symbolic systems concerns the importance of metaphor, which emphasizes similarities. As recent

research has shown (Lakoff and Johnson 1999), metaphor is one of the building blocks of linguistic symbolism, and it is clearly important in the symbolism of much rock art. To return to a far-western North American example mentioned earlier, much of the rock art in this region was intended to portray the trance experiences of shamans (Whitley 2000a; Keyser and Klassen 2001; Francis and Loendorf 2002). These experiences involved hallucinations, not only visually but also, potentially, through all of the senses.

Yet the altered states of consciousness (ASC) experiences were intrinsically ineffable—that is, very difficult to describe—partly because a key characteristic of trance experiences is the generation of abundant emotions. As we all know, it takes a poet to describe emotional feelings adequately. Thus metaphors, originating in the common bodily hallucinations of trance, became a way to describe supernatural experiences. Although they are discussed in greater detail later, the most common of these trance metaphors are death or dying; aggression or fighting; flight (out-of-body experiences); swimming or drowning; sexual arousal; and bodily transformation (Whitley 1994b, 1998d, 2000a). These same metaphors were used by the southern African San to portray their trance experiences (Lewis-Williams and Loubser 1986; Lewis-Williams and Dowson 1989). That these metaphors originate in the functioning of the human body, and not in specific cultural beliefs, further emphasizes that much symbolism is systematic, logical, and understandable rather than arbitrary or obscure.

## ETHNOGRAPHIC ANALYSIS

Meg Conkey (1997) has stated that the major recent advances in rock art research have been tied to ethnographic analyses. These are important partly because they can yield true informed (insider's) information about the origins and meanings of specific historical corpora of rock art. But they are also important beyond any individual case study. This is because, when seen in aggregate, they give us a general perspective on how and why traditional cultures made rock art and thus provide expectations (or models) for the making and

meaning of rock art, divorced from the contemporary western European preconceptions that we otherwise bring to our research.

It is therefore important to study the ethnography of rock art, even if there is none in your particular region of study, or even if your rock art is truly disconnected from the ethnographic past. This is because rock art ethnography gives us a context within which the plausibility of any particular rock art interpretation can be assessed. Put another way, ethnography provides a series of competing hypotheses that can be evaluated for any empirical case. And, while there is no reason to assume that every prehistoric example will necessarily conform to the origin and meaning of the ethnographic cases, a starting place for analysis is the assumption that a prehistoric case should be reasonably close to the known range of variation in the ethnography. Alternately, if the origin and meaning of a prehistoric case is thought to be significantly divergent from known ethnographic examples, then it is equally important to show how it diverges, why these variances might matter, and what unusual evidence supports this potentially exceptional variation and interpretation.

Ethnographic analysis and interpretation are unfortunately foreign to many archaeologists, even when they claim to be anthropological archaeologists. There are a variety of reasons for this—some historical, some philosophical, and others simply pedagogical. But archaeological and ethnographic data *are* different, and they require different analytical approaches. Indeed, they involve what is best (if loosely) described as a difference in mind-set: archaeologists are trained to count and measure things and analyze the resulting numerical patterns and correlations; in contrast, many sociocultural anthropologists collect verbal or written statements and deduce meaning from them. One approach is not better than the other. But it is perhaps obvious, if under-appreciated, that different kinds of data require different approaches as well as different sensibilities.

The key aspect of ethnographic research—meaning the analysis of published ethnological studies—derives from this last point. As has been emphasized explicitly, at least since Radcliffe-Brown (1964) studied the Andaman Islanders almost a century ago, ethnographic texts are raw data that must be interpreted and analyzed; they do

not normally provide a final exegesis or a complete explication of a symbol, ritual behavior, or religious practice. Indeed, as Layton (2001:321) noted: "All statements obtained in the field are interpreted by the ethnographer, and all ethnography is written within a theoretical framework, even if only unconsciously." Ethnographic interpretations, in other words, are generally *inferred* rather than directly obtained from ethnographic data.

Dan Sperber notes in this regard that:

It is a truism—but one worth keeping in mind—that beliefs cannot be observed. An ethnographer does not perceive that the people believe this or that; he infers it from what he hears them say and sees them do. (1982:161)

The implication of this is important. The ethnographer's and archaeologist's tasks in reconstructing beliefs are in certain respects conceptually no different: both look at patterns of behavior and both infer meaning from these patterns (see also Geertz 1973:17).

The flip side of this has been demonstrated by traditional archaeological examinations of ethnography. They were commonly based on the false notion that the ethnographic record should provide complete explanations of the origin and meaning of the art and, as a corollary, that any statements made about the art were always to be understood *literally* (taken at face value). In the first instance, the archaeologists' unrealistic expectations led to predictable results: since they could not find what they were looking for (a complete explanation), they dismissed the ethnography as essentially valueless. This led to a pernicious inference: because historical Native Americans apparently knew nothing about rock art, these archaeologists assumed, the rock art was obviously older than the ethnographic cultures. This effectively stripped the tribes of an important part of their patrimony and heritage and created a catastrophic cultural disjunction between past and present.

An example of this kind of thinking, stemming from methodological confusion, is provided by Heizer and Baumhoff's (1962) study of Great Basin rock art, discussed earlier. Despite their claim that Great Basin Indians knew nothing about rock art, substantial

data on rock art were collected by Basin ethnologists. But most of this was not in the literal form these archaeologists sought and, lacking any understanding of ethnographic analysis, it was dismissed by them as meaningless and used to further their belief that living Native Americans had no direct connection to Basin rock art.

Numerous informants nonetheless discussed rock art with ethnologists, widely stating that rock art was made by spirits (e.g., Brooks et al. 1979; Driver 1937; Harrington 1950; Irwin 1980; Hultkrantz 1987; Kelly 1932; Laird 1976, 1984; Lowie 1924; Steward 1943; Stewart 1941, 1942; Sutton 1982; Voegelin 1938; Zigmond 1977, 1986). They also acknowledged the recency of the art, arguing that it continues to be made by the spirits to this day (e.g., Harrington 1950; Hultkrantz 1987:49; Irwin 1980:32; Fowler et al. 1995:55; Kaldenberg, personal communication, 2005), directly contradicting any claim that they believe that the art is necessarily ancient. The ethnographic data on Basin rock art are in this sense numerous and consistent, and the historical age of some of the art is confirmed by chronometric dating along with the presence of horse and rider motifs (see Whitley 1992b, 1998c, 2000a).

How can these ethnographic data be appropriately interpreted? Anthropologist Robert Layton addresses this in his Australian rock art studies. Layton notes that attributions of rock art to mythic or religious spirits "must be understood within an Aboriginal ontology in which people are, or can become, the incarnation of ancestral heroes" (Layton 1992:13). Stated more generally, ethnographic statements must be understood within their own cultural context, not taken literally in a kind of Eurocentric (and fundamentalist) approach to religious texts. Understanding and therefore interpreting these texts requires an analysis of their cultural context and symbolic implications.

In the Great Basin case, contextualizing the ethnographic statements provides a straightforward understanding of the origin of this art, including a clarification of what otherwise might appear to be enigmatic statements. Water (or Rock) Baby is most commonly cited as the spirit that makes rock art. This spirit was widely identified as a shaman's helper (e.g., Chalfant 1933; Downs 1961; Miller

1983; Park 1938; Siskin 1983; Steward 1941; Whiting 1950; Fowler 1992). Since the actions of a spirit helper and a shaman are said to be indistinguishable (Gayton 1948; Applegate 1978; Siskin 1983), attri-bution of the art to a shaman's spirit helper is fully equivalent to stat-ing that it is made by shamans, meanwhile avoiding the taboo against naming deceased individuals, as Laird (1976, 1984) first suggested.

Importantly, this interpretation is confirmed by additional eth-nographic data. One of the earliest translations for the indigenous term shaman is "a man who writes" (Fowler and Fowler 1971:144–45), meaning a man who makes rock writing (following the common use of "rock writings" for rock art in the nineteenth century). Mean-while, additional data indicate that shamans went to rock art sites to conduct their vision quests, whereas Numic peoples, to this day, con-tinue to call rock art sites "doctors' rocks" or "medicine rocks," both of which are clear references to shamans (see Whitley 1998c, 2000a, 2001).

The point here is an important one. While ethnographic analy-sis involves interpretations, it also requires multiple lines of evidence and independent kinds of confirmation. These can be obtained even within the confines of a true emic (insider's) rock art interpretation. Ethnographic research seeks supportive evidence not only from mul-tiple informants (and, ideally, different ethnographers) but also in different forms, which might include direct statements, metaphoric allusions, linguistic terms, and place names.

That ethnographic data are recorded within a conscious or sub-conscious theoretical framework is also particularly important to recognize. Much of our ethnographic record, in fact, dates to the nineteenth and early twentieth centuries, and this has important implications. The attitudes then commonly held about traditional, non-Western peoples and cultures (sometimes even among anthro-pologists) were quite different from those of today. In some cases, the ethnographies reflect overtly primitivist, if not outright racist, attitudes about the peoples they purport to study, portraying espe-cially hunter-gatherer cultures as childlike and simplistic. Many early ethnographies (particularly those written by males) are also andro-centric, with their male-oriented bias expressed both in how they

portray sex and gender relations and also in a failure to consult with female informants about women's participation in cultural lifeways.

A good example of these kinds of biases ("good" because the biases are easily recognizable and can be quickly separated from the important factual data of the ethnography) is provided by Erminie Voegelin's (1938) study of the Tubatulabal, a hunter-gatherer group who lived in California's southern Sierra Nevada. Voegelin noted that, among the Tubatulabal, "Symbolism [was] apparently entirely lacking" (ibid:58), despite the fact that on the same monograph page she discusses their pictographs. Voegelin further states that pictographs are fairly numerous and that they:

> . . . have always been there; they were painted on the rocks by brownies (*yahi iwal*) who were about the size of a 5-yr.-old child. (ibid)

A quick reading of this comment would suggest that Tubatulabal beliefs about the origin of rock art are dismissive and trivializing, due to the use of the term "brownies" which, for us, connotes a child-like superstition. This appears to equate the creation of rock art with our adolescent notions of fairies. But in fact the significance of this comment is clarified elsewhere in the ethnography, where Voegelin records that the *yahi iwal* were small dwarf-like spirits that were seen in jimsonweed (*Datura wrightii*) trances and were associated with tobacco used ritually by shamans. Moreover, they were one class of the larger category of shamans' spirit helpers who inhabited rocks, including rock art sites (ibid:61).

As becomes clear, Voegelin's data associate the creators of Tubatulabal rock art with shamanistic beliefs and practices, not with childish superstitions. But the ultimate lesson here is that, even while good ethnographers may have operated under strong theoretical or cultural biases, the data they collected are often complete and objective enough to allow us to filter out and correct their interpretive errors. That Voegelin's published data allow us to see through her own interpretive biases is a testimony to her skills as an ethnologist.

The point is that ethnographic analysis can require very detailed immersion in all of the existing data; it is not research that can be

conducted quickly. Critical clues to interpretation may be brief and easily overlooked, yet, when recognized, they may unlock substantial amounts of information that otherwise would be ignored as irrelevant. Normal ethnographic research requires reading, and re-reading, the existing documentation multiple times.

This is illustrated by an example from California's southern Sierra Nevada (Table 6-1). Anthropologist Anna Gayton (1930, 1948) collected a substantial amount of information from Yokuts and Western Mono peoples about so-called shamans' caches, the shamans' primary ritual zones. Ethnographic commentary in two instances revealed that the shamans' caches are pictograph sites. This key point was overlooked by two generations of rock art researchers. Yet a very substantial amount of information on the use and importance of rock art sites, including the ways the sites were utilized during the shaman's acquisition of power, are contained in Gayton's ethnographies.

Obviously, the amount of ethnographic data pertaining to rock art varies widely. As noted previously, archaeologists traditionally took an apparent absence (or near-absence) of ethnographic data as a chronological indicator: if a trait or practice was not discussed in the ethnographic record, or if informants denied knowledge of the topic, it was assumed that the phenomenon did not exist during the recent past. In the case of rock art, this led to the argument that it was all prehistoric, and not potentially ethnographic. But this again reflects a literalist attitude toward ethnographic data, and it may or may not be correct. Like all ethnographic data, so-called negative evidence requires careful interpretation and contextualization.

Some topics were never raised by ethnologists as they followed their own research agendas; material culture, including rock art, was among the topics they commonly ignored. Some informants genuinely knew nothing about specific topics and had little if anything to say, and some informants were simply reluctant to discuss, or had widely varying levels of knowledge about, certain subjects, especially religion, ritual, and belief. Layton (1992:13) understandably discredits the false "archaeological inference. . . that the less Aboriginal people have to say about a body of rock art, the further removed in time its execution must lie. . . ." Sometimes an absence of commentary

**TABLE 6-1** Gayton's Ethnographic Information on "Shamans' Caches"

| | |
|---|---|
| **1948:113** | "The [shaman's] cache would be in a cliff or rock pile; cracks indicated the door, which opened at the shaman's command. The rocks were usually painted; in fact, *any rock with pictographs was thought to be a cache*" [emphasis added]. |
| **1930:391** | Shamans' caches were: "some knoll which was shamans' customary meeting place"; shamans met there with their *taiwan* [ritual trays]; plotted deaths of other shamans; played eagle-bone whistles and danced around fires; got magical airshot from sun, and shoot it; ordinary people were afraid of caches. |
| **1930:393** | Shaman *Wasic's* description of his cache: "I have lots of money and baskets up at *Tawatsanahahi* in a big rock like a house; there is a lot of poison there, too." |
| **1948:33** | "As in foothills, doctors were believed to have private caches where the wealth they accumulated was hidden: such a cache is called *taiwan*. One is located in a little ridge about 800 yards north of the Lemoore Rancheria." |
| | "A *taiwan* is always guarded by some kind of creature. This one [near Lemoore Rancheria] is inhabited by personified fire." |
| **1948:34** | "This *taiwan* is an old one; nobody knows what doctor owned it. *Poso'o* [Tachi shaman Bob Bautista] told J.A. about it and warned her to keep away from it. He said a big sickness *(tau'mai)* like consumption or pneumonia would 'come out' if anyone attempted to disturb the place." |
| **1948:113** | Shamans' caches called *pachki* [color 'red'], where wealth and talismans were kept. One cache is in Drum Valley; another at Hoganu [both are rock art sites]. Large cache near *Gutsnumi* (Terminus Beach) called *Choishishiu*, marked with pictographs [site is Bell Bluff, CA-TUL-2; name confirmed by Latta 1977:185] |
| | "S.G. said there were several inner chambers 'each as big as a house' and that they were filled with native treasures . . . S.G. expressed apprehension lest the hill might some day be dynamited, for if so, 'all kinds of bad diseases would fly out over the country.'" |

may reflect the absence of a connection between ethnographic or living peoples and a rock art corpus, but at other times additional confounding issues may be present.

The final point that needs to be raised about rock art ethnography is one emphasized by Jean Clottes (1997a), who wisely noted that, in our race to record sites before they are destroyed, we should not forget the peoples who created them and the knowledge they may still retain about their origin, meaning, and use.    Rock art is truly imperiled in many parts of the world. But people with direct knowledge of this art are presumably rarer, and their knowledge may be much more endangered than the sites themselves. A comprehen-

**TABLE 6-1** Gayton's Ethnographic Information on "Shamans' Caches" *(continued)*

| | |
|---|---|
| | "M.P. had a frightening experience there . . . *The rocks of the bluff are painted with pictographs,* she said, but she could not accompany me there" [emphasis added]. |
| | Uncle of M.P. saw a "beautiful weird dog there which came out of the rocks to attack investigators . . . the dog which guarded the cache had a snake's body and human hands for feet." |
| | M.P. went there and saw a ghost that "looked like fire." |
| | Common term for shaman's cache is *chosishiu,* "dog place" [i.e., "spirit helper place"]; but "correct" name is *pachki* [confirmed by Latta 1977:600]. |
| 1948: 168-9 | Shamanism ran in families, and son would usually inherit father's wealth and *pachki*. If no son, *pachki* lost forever. *Pachki* always located on hill, with rock for door. No mark of ownership. After shaman's son had gotten supernatural power, could enter at will. Son danced outside & called name of father/ grandfather, & it opened. Within were baskets, money, feathered ornaments, skins—"all valuable things". Son could take what he wanted from left side. Things on right belonged to most ancient ancestors & were too powerful. These served as guardians of place, who killed anyone who touched them. |

*Shaman's Acquisition of Supernatural Power:*

| | |
|---|---|
| 1948: 168-9 | Man awoke after dream & went into hills, "to dream somemore". When man had dreamed sufficiently he went to a cache where his spirit helpers opened the door & stayed inside 4 days. No one knew where he was, while in *pachki*. "Animals" [i.e., spirits] told him what to do, gave him songs, danced with him, gave him talismans. Remained in hills 2 more days (total = 6). Then did debut dance, where he talked about his supernatural experience. |
| 1948:207 | According to one informant, only rain shamans had shaman's caches. Outfit was kept within rock, which the shaman could open but otherwise couldn't be seen. "Each doctor had his own place." |

sive rock art project should, whenever appropriate, look beyond the motifs and the sites to record any available ethnographic or ethnological information so that this important information is preserved.

# ETHNOGRAPHIC OVERVIEW OF WORLD ROCK ART

Bob Layton (2000, 2001) has summarized recent ethnographic rock art research, making some particularly important observations about ethnography and world rock art. Layton notes that, while there are some examples of purely secular rock art, most of it is religious in

origin. Layton further distinguishes two types of religious art: sha-manistic and totemic (to which I will later add a third). I emphasize shamanistic rock art in many of my examples for three reasons: (1) it is the kind of rock art that I know best; (2) Native American religions are so commonly shamanistic that shamanistic rock art is typical of many (though not all) regions and cultures in the Americas; and fi-nally (3) the ethnography of nonshamanistic rock art is currently un-der-studied and under-reported.

It is worthwhile to consider the known ethnographic variations on the origin and meaning of rock art. Clearly not all world rock art is shamanistic or, for that matter, totemic, despite the fact that the majority of ethnographic rock art interpretations focus on these two categories. In any consideration of world rock art, we must first ac-knowledge that not all marks on rocks are, strictly speaking, rock art, at least with respect to engraved or abraded marks. Grooves in rocks, in particular, may have been created to shape or sharpen stone tools. Similarly, pits may have been pecked or ground into rocks to support poles, to grind various kinds of materials, or to crack nuts or shells. Some marks on the rocks, in other words, were created for economic or technological rather than symbolic reasons.

In contrast, some natural features on rock panels or natural out-crops were taken as rock art by indigenous peoples; that is, they were seen as manifestations of supernatural or mythic actors. This is true at the landscape scale where, for example, a rock outcrop may be described as a frozen character from a myth. But it is also true at the scale of the rock art panel, where natural weathering, cracks, and features, which create the appearance of an animal or individual, are interpreted as such. This was demonstrated during a project con-ducted in the Columbia River Gorge, Oregon, by Jim Keyser, in con-junction with a number of local tribal peoples.

A series of cracks and discolorations on a rock face adjacent to the highway created a pattern that looked distinctly like a woman wearing an old-fashioned cloth bonnet. A cluster of wildflowers serendipitously grew alongside this natural pattern, enhancing the illusion that the woman was holding a bouquet. When we stopped to examine and photograph this natural phenomenon (at the sug-

gestion of our Native American colleagues), we discovered that offerings had been left at this location, just as at local rock art sites. This emphasizes the significance of the "natural" rock panel face as a symbol in its own right and as an important component of rock art symbolism.

Second, there is at least some ethnographic evidence for purely secular rock art. Layton (2001), for example, cites Australian cases where rock art apparently was made to show others what horses looked like, and there are a few similar cases worldwide. Yet Layton is careful to note that even this secular rock art resonates with a culture's values and interests. Perhaps more important, secular art is clearly the exception rather than the rule.

The third point is that the vast majority of ethnographic information on world rock art indicates that it is religious in origin, making Layton's distinction between shamanistic and totemic systems important to consider. Yet, as Layton acknowledges (following Rosenfeld 1993), all religious art does not necessarily have iconographic qualities; that is, it may lack the kinds of referential meaning, tied to a corpus of motifs, that we typically associate with symbols, instead emphasizing *instrumental* actions. (Note here the important distinction between instrumental *actions,* resulting from ritual behavior, and instrumental *symbols,* discussed earlier, which clarify the specific meaning of a key or dominant symbol.) In such cases the act of creating the motif is of primary importance, with important symbolic relevance to this action but with little symbolic significance beyond the action per se.

A good example of instrumental rock art is provided by girls' puberty initiations in Native California. This includes cupules in some areas and handprints in others (see Fig. 1-4). Although the resulting art lacks deep levels of iconographic meaning, in both cases important symbolism was involved. This symbolism was linked to place; the ceremonies took place at sacred sites imbued with supernatural power. At another level of meaning, cupules and handprints symbolized the belief that their creators had "touched the sacred," and in so doing had joined a succession of young female tribal members who had previously done the same. Much, if not most, rock art, however,

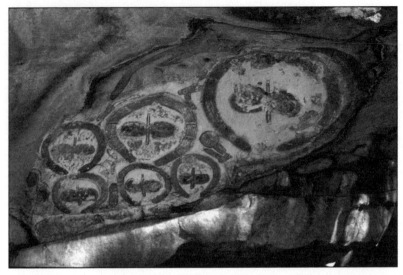

**FIGURE 6-1** In the western Kimberley region of northwestern Australian, Aboriginal totemic clans have ancestral spirits known as Wandjinas that are painted on cave walls. These examples are from the King Edward River Crossing site. *Photo courtesy of Jean Clottes, by permission of tribal custodians.*

has an iconographic reference and meaning that goes beyond the ritual act of production alone.

Three classes of the religious rock art with deliberate iconographic intent can be identified—totemic, shamanistic, and commemorative—along with combinations of these three. In *totemic art,* the right of creation is reserved to members of social groups within a tribe, such as a totemic clan. Among certain Australian aboriginal groups, for example, each totemic clan has an ancestral spirit called a Wandjina; these spirits are described in myths and painted in caves (Fig. 6-1). The Wandjina is painted at the creation point of the clan, along with other spirits and devices described in their origin myth. These images are created during increase rituals in order to ensure access to adequate plant and animal resources (Layton 1992).

The Hopis, an Arizona tribe of farmers living in permanent villages, also create clan symbol petroglyphs, representing another variation on totemic rock art (cf. Michaelis 1981; Schaafsma 1981). These are made at a specific site, Willow Spring, and they represent

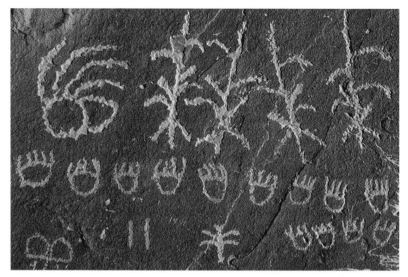

**FIGURE 6-2** The petroglyphs at Willow Springs, Arizona, were created by Hopi Indians during their ritual Salt Pilgrimage. The motifs depict the matrilineal clan symbol of their creator, providing another example of totemic rock art.

the matrilineal clan of their creators (Fig. 6-2). Although a Euro-American academic perspective might suggest that these symbols represent secular social institutions, without religious implications, the Hopi perspective is different. Indeed, it leads us to understand the reluctance of members of traditional cultures to discuss their religious beliefs and practices with outsiders.

The Hopi petroglyphs are created during an important ritual pilgrimage—the Salt Expedition. This pilgrimage was performed by men, as we know from a few very brief early accounts (e.g., Titiev 1937). A recent attempt by a Western linguist to publish the details of this Hopi pilgrimage was prevented by tribal lawsuit, and the attempted publication resulted in a call for a moratorium on all anthropological research within the tribal lands (Whiteley 1998).

The second type of religious rock art is *shamanistic,* where supernatural power is obtained by individuals during visionary experiences, and where the art is intended to portray these experiences. Typically, these visions involved the acquisition of power in the form of a

spirit helper or assistant, generally (though not invariably) manifest as an animal spirit. These spirits were also referred to as dream helpers or guides in North America or, in Mesoamerica, as *naguales* (in Nahuatl, the lingua franca of the region).

The obtained power could be used to heal the ill, for witchcraft, to make rain, to predict the future, to control animals, for good luck, and so on. In some regions (south central California, the Great Basin), vision quests were exclusively restricted to shamans, and only shamans created rock art. In other regions (e.g., southwestern California), youngsters made visionary art at the conclusion of their puberty rituals. In still other regions (e.g., the Columbia Plateau), vision quests and their resulting rock art were made by shamans, by puberty initiates, and by adult non-shamans during life crises (such as the death of a spouse or child). Because of the variety of origins for shamanistic art, Paul Taçon (1983) has made a useful distinction between *shamanic* rock art (made by shamans themselves), and *shamanistic* rock art, made by non-shamans but related to shamanic beliefs and practices.

The San of southern Africa are very well known for their shamanic rock art (e.g., Lewis-Williams 1981, 2002). Eland was the most important spirit helper for the San, and the eland is the most commonly depicted animal in their rock art (Fig. 6-3). Roughly one-third to one-half of the adult San participate in the Trance Dance, during which they obtain visionary experiences. All are shamans, and all could paint pictographs. Commonly in San art the pictographs show combined humans and animals (known as *therianthropes*)—the shaman transformed into his or her spirit helper.

But only about 2% to 4% of the Shoshone Indians of western North America were shamans, almost all of whom were male, and only the shamans made art rock. Petroglyphs showing the shaman himself, often wearing a ritual shirt, are relatively common in this region (Fig. 6-4), as are depictions of spirit helpers. The bighorn sheep, who was associated with rain-making power, is the most frequently portrayed (see Fig. 1-6). Certain sites in this region were reserved for sorcery, or black shamanism, with these sites apparently emphasizing vulva forms (Fig. 6-5). The association between sor-

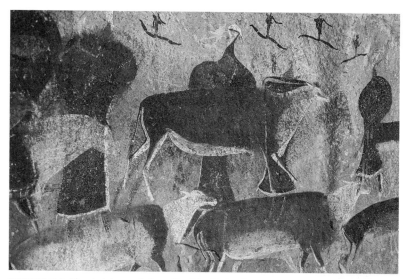

**FIGURE 6-3** Eland pictograph from the Giant's Castle site, Drakensberg Mountains, South Africa, superimposed over human figures wearing skin capes. The San emphasis on the eland reflects its central role in their supernatural world and its close association with shamans.

cery and vulvas in this case was related to the negative connotations of female sexuality which, in this androcentric society, was thought dangerous and therefore highly controlled. In many shamanistic cultures, rock art was also made by puberty initiates. Again, these initiations involved the acquisition of a spirit helper to aid the individual throughout the lifetime, with the art portraying the visionary experience that signaled the receipt of this helper (Whitley 2000a, 2005b).

In addition to totemic and shamanistic art, some religious rock art was made for *commemorative* purposes. Mojave geoglyphs, found along the Colorado River, provide one example. Though Mojave shamans and puberty initiates made visionary rock art, geoglyphs were created at specific locations associated with particular mythic events to portray the mythic actors themselves (see Fig. 1-9; von Werlhof 2004). These were used in a ritual pilgrimage that follows the route of the mythic beings during the creation, with dances, songs, and mythic recitations conducted at each of the sites during the pilgrimage.

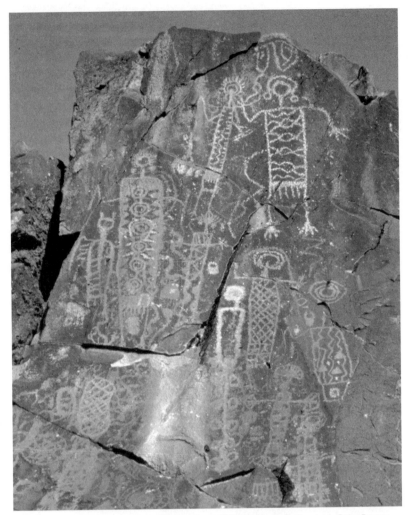

**FIGURE 6-4** A panel of shaman figures from Little Petroglyph Canyon, Coso Range, eastern California. These are shown wearing the painted animal-skin shirts that were part of their ceremonial regalia. Note that none of the figures are shown with faces (see Figure 7-4).

This art is often narrative in nature, in that it attempts to portray a specific event in recognizable graphic form; in a general sense, it is analogous to the Catholics' Stations of the Cross.

Combinations of shamanistic and commemorative rock art also occur in other cultures. One of these is the lowland South American

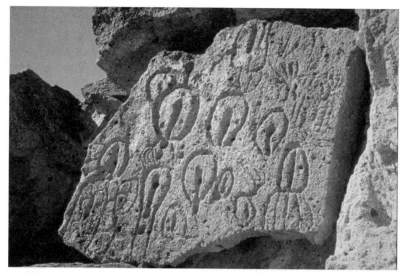

**FIGURE 6-5** Among the Numic speakers in the Great Basin, sorcery power appears to have been symbolized by vulva-form motifs, which are restricted to a few specific sites. This example is from the Chalfant site, Owens Valley, California. *Photo courtesy of Jean Clottes.*

Tukano (Reichel-Dolmatoff 1967), whose shamans created pictograph sites at rock outcrops in the jungle. These replicated visionary images including, especially, the Tukanos' efforts to influence the Master of the Game spirit to the benefit of their tribe. Tukano petroglyphs also exist. They are particularly common along rivers, at cataracts, falls, and deep pools, where spirits associated with myths are said to reside. These motifs apparently commemorate and represent the mythical actors and their acts, which occurred at these same locales.

Another type of commemorative rock art is the so-called biographic art that developed historically among the horse cultures of the North American Great Plains (e.g. Keyser 1987, 2004; Keyser and Klassen 2001; Keyser and Poetschat 2005; Klassen 1998; Sundstrom 2000; Fig. 6-6). This has recognizable narrative structure, composition, and intent, and, initially at least, seems secular in nature, inasmuch as it often records acts of war and bravery. In fact, this kind of art occurs at sites with other types of more directly religious rock art; following Native American theories of causality (which might attribute war success

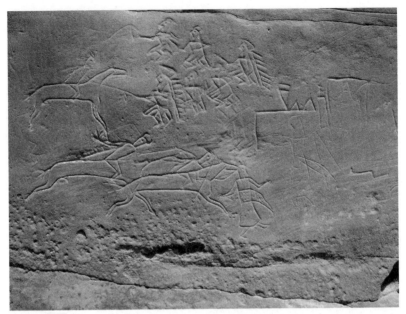

**FIGURE 6-6** The so-called biographic style is a good example of commemorative rock art. It developed historically on the North American plains, and often depicted feats of bravery and war honors. This incised example, showing two raiding parties, with two warriors capturing a woman in the foreground, is from the LaBarge Bluff site, Wyoming. *Photo courtesy of Mike Taylor.*

to the intervention of a spirit helper, for example), it often includes what might best be termed supernatural elements mixed with natural events; and, among some tribes, it was even said to have been created by the spirits themselves, not by the individual depicted in the scene. The secular and religious were so deeply intertwined for many traditional peoples that the distinction is effectively meaningless. While this art commemorates war honors, it cannot be viewed simply as secular because these honors (and the events that led to them) were always seen as intimately tied to the supernatural.

Rock art clearly has a variety of origins and functions. This is true whether the general religious context of the art is shamanistic or totemic. Shamanism and totemism are not, as is sometimes alleged, monolithic explanations for the art, but religious systems that the art expressed in any number of ways. Shamanistic rock art created by a

single culture, for example, can include art made by different ritual and social groups, as well as genders (shamans and non-shamans, adults and/or children, men and/or women). It can include art made for the acquisition of a spirit helper intended generally to promote long life and success, or a spirit helper who yielded specific kinds of powers (healing, rain-making, hunting, sorcery, fighting, gambling), or even specific healing powers (rattlesnake bites, ailing horses). Apparently it could be created both to acquire power and to exercise power. Some shamanistic cultures made different kinds of religious art—visionary and shamanistic, or narrative and commemorative. There is every reason to assume that some cultures may have made both totemic and shamanistic rock art. And certainly some cultures made both shamanistic and commemorative rock art.

Given this picture of ethnographic variability, one final comment needs to be made about ethnographic analysis. This concerns the approach to take when confronting a rock art region and its ethnographic record. The starting point, since most rock art is religious in origin, is straightforward: we need to develop an understanding of the religious system, which most likely provided the cultural context within which the art was made. Through an understanding of the system of beliefs, the nature of rituals, and the kinds of symbolic meanings common to this religion, we can most likely arrive at an interpretation of the culture's rock art. Absent this context as a starting point, the resulting interpretations stand a strong chance of representing little more than projections of Western biases, interests, and concerns onto non-Western traditional art.

## ANALOGICAL REASONING

Not all regions with rock art have a directly relevant ethnographic record, nor is all prehistoric rock art tied to ethnography, even in those areas where a relevant record may exist. For this reason it is useful to consider analogical reasoning in some detail, because it is largely through analogy that we interpret the prehistoric past.

Analogical reasoning plays an important role in all archaeological interpretation, and rock art research is no exception. Though it

needs to be applied carefully and critically, it is one bridge between ethnographic and truly prehistoric corpora of art. Despite its potential interpretive value, ethnographic analogy was widely criticized during the height of the processual archaeology movement and many archaeologists continue to think that it must be avoided. This throws the baby out with the bathwater. Not all analogies are alike; analogies do not all have the same inferential value, nor should they be used as equivalents in interpretive analysis. But all kinds of analogies may have potential value for a given archaeological problem. I distinguish three kinds of analogies that can be usefully employed, in different ways, in rock art interpretations.

## FORMAL ANALOGIES

Formal analogies are based on superficial resemblances: Motif A, from Africa, looks like Motif B, from America, therefore the motifs mean the same thing, or have the same origin. This is a weak analogy, and it is a poor basis for inference or interpretation. Its best use is in the generation of hypotheses to be tested using other lines of data.

## GENETIC ANALOGIES

Genetic analogies are partly based on demonstrable historical or cultural connections: The people that made Site C are linguistically and culturally related to the people that made Site D, therefore equivalent artifacts from the two sites are likely to have the same function, or similar motifs in their arts may have the same meaning or origin; likewise, the descendants of the prehistoric peoples in this region made rock art in such-and-such a context, therefore earlier (prehistoric) examples of similar rock art in this region are likely to have been made in the same context. This type of analogy is good for generating hypotheses. It can also serve in a cable of evidence to support (but not prove) an interpretation.

In the *direct historical approach,* genetic analogies are directed backward in time. Genetic analogies can also be used across space, from one cultural group or site to another, for example, in cases

where less evidence exists about the second group. There is, however, a limit to how far back in time genetic analogies may be extended. Archaeologists who deny the value of analogy sometimes argue that this limit is the divide between the ethnographic and truly prehistoric past, signaling their implicit catastrophist's view of the nature of culture contact and change.

A more reasonable perspective has been suggested by Tom Huffman (1986), who notes that culture change is an empirical phenomenon that is observable in the archeological record. It follows that genetic analogies may be extended back in time until demonstrable change is evident in the archaeological record; for example, the complete or near-complete replacement of one iconographic system by another. Bruno David (2002) has, in essence, used this approach to investigate the time-depth of Australian Aboriginal cultural systems, arguing that changes in rock art signal changes in systems of signification and meaning.

Alison Wylie (1988) points out that we can increase the inferential strength of these types of analogies by bolstering their source-side support. For example, consider a systematic examination of the ethnographic record (our source) directed at two cultural traits. One of these, Trait $x$, involves the use of nonperishable materials and is, therefore, potentially archaeologically visible. Trait $y$, in contrast, involves perishables, and thus would be invisible in the archaeological record. If our systematic study demonstrated that the presence of Trait $x$ was everywhere associated with Trait $y$ and that Trait $y$ only occurred in association with $x$, the discovery of the first trait in an archaeological deposit would provide plausible, if not very strong, support for the practice or use of Trait $y$ by that archaeological culture, even though this cannot be archaeologically seen or "proven."

This kind of analogical reasoning is not an analytical stretch. Indeed, it is the basis for most of our functional artifact interpretations (cf. Wylie 1982, 1985). For example, even though I have excavated about three dozen dry rockshelters, I have never once recovered an arrowhead attached to an arrow shaft. Nor have I ever found a spear point attached to a spear. Yet I have never had any problem inferring that the hundreds—perhaps even thousands—of projectile points

I have found were once parts of arrows or atlatls/spears. Nor do I have any reason to doubt these interpretations. Yet this is fundamentally an example of argument by ethnographic analogy, even if it is implicit in nature. The point is that this type of ethnographic analogy is pervasive in archaeological interpretation. There is no need to shy away from it, especially if it is used in a thoughtful manner.

## FUNCTIONAL ANALOGIES

Functional analogies are based on determining structures, as discussed by David Lewis-Williams with respect to his neuropsychological model (Lewis-Williams and Dowson 1988; Lewis-Williams 1991), and outlined below. They provide testable scientific models and are a form of strong analogy that can result in true scientific explanation.

Functional analogies, based on uniformitarian principles, are the ideal but, unfortunately, they are very rare. More commonly we are faced with the possibility of applying an ethnographic analogy or its analytical cousin, the direct historical approach, to our data in the absence of true, directly relevant ethnographic data about our art. Yet even the applicability of the direct historical approach is limited to regions of the world where long-term cultural change was relatively minimal and where rock art continued to be made into the recent past—which is to say the Americas, Australia, and parts of Asia and Africa.

Ultimately, we confront this question when considering truly prehistoric corpora of art: Is an interpretation of this art more likely correct if based on: (a) comparisons with the origin and function of similar art in other non-Western cultures, i.e., on ethnographic analogies; or (b) on economic and political models that are commonly used in Western academia, i.e., on supposedly universal characteristics of human behavior such as economic rationality? It is critical to recognize that most of these putatively universal characteristics of human behavior are themselves little more than assumptions of late nineteenth- and early twentieth-century theories about specifically Western economies and psychology (Midgley 2001, 2003). That is,

they are unproved assumptions about modern Western cultural be-havior, not universal characteristics of (and thus uniformitarian at-tributes of) the way that humans act—especially humans living in small-scale, non-Western cultures.

In this case, the archaeologist's logical conclusion is obvious. The use of careful ethnographic analogy, at least in the sense of providing a probable range of variation that explains the origin, function, and meaning of prehistoric rock art, is far better than the mechanistic ap-plication of models intended to explain modern Western economic behavior.

Symbolic and ethnographic interpretations are important approach-es to rock art research, even though they were traditionally ignored (or misused) by archaeologists. As noted earlier, a primary problem has been some archaeologists' literalist readings of the ethnography. The results were markedly Eurocentric, empiricist interpretations that confused rather than explicated the art and, as often as not, ef-fectively stripped indigenous peoples from their patrimony. (Con-key [2001:277] has sagely noted, in this regard, "The literalness of a reading must now be shown rather than assumed.") Equally prob-lematic, as Jannie Loubser (2004) observed, are catastrophist views of time. These assume that a massive cultural disjunction necessarily exists between the prehistoric and the recent pasts and, for this rea-son, that ethnography has little to offer us in interpreting prehistory.

While cultural contact with the Western world has ultimately been catastrophic for many traditional societies, it is nonetheless true that religion and belief are commonly the most conservative aspects of cultures. Despite many obvious cultural changes, traditional be-liefs and practices often continued (or, at least, knowledge of them was retained), even into the recent past. Ethnographic studies of rock art are based on this simple fact.

CHAPTER 7

# NEUROPSYCHOLOGY AND ROCK ART

Rock art ethnography, with its associated benefit of informed analysis, is obviously not available in all regions or for all time periods. So we turn to *formal* analyses for their etic (outsider's) insight into the significance of rock art. Formal analyses are more varied in nature and concern than ethnographic analyses because they employ only general data and because they reflect a greater range of theoretical interests and analytical approaches. Despite the great utility of ethnography, it will never be the only data source that archaeologists can or should employ, even in cases where it is appropriate and available, because it is important to use multiple methods and data sets whenever possible.

The subtext of this last point is important. As I have emphasized a number of times, the last two decades have witnessed a revolution in rock art research. This appears to have resulted, first, from a heightened professional archaeological interest in rock art; second, from the development of new chronometric techniques (themselves in fact representing formal analyses of the art); and third, from a dramatic advance in interpretations of shamanistic rock art. These advances have properly involved both informed (ethnographic) and

formal (neuropsychological) research. The conflation of the two approaches as one ("shamanism"), and its tie to ethnographic approaches, is largely due to the intellectual leadership of David Lewis-Williams, whose own studies started with ethnography before adding neuropsychology as another dimension.

It is appropriate to start the discussion of formal approaches with neuropsychology, which considers the form of corpora of art in order to determine their origin, not their meaning (as is sometimes, incorrectly, assumed).

# THE NEUROPSYCHOLOGICAL MODEL

The most frequently used formal analytical approach in rock art research involves the application of the so-called neuropsychological (N-P) model for the mental imagery ("visions") of trance. This was originally developed from clinical and ethnographic data by David Lewis-Williams and Thomas Dowson (1988; see also Lewis-Williams 1991, 2001, 2002, 2003) in order to analyze western European Paleolithic rock art. It has been widely used beyond this period and region, sometimes with ethnographic data and at other times without (e.g., Bradley 1989; Sales 1992; Dronfield 1993, 1995, 1996; Rajnovich 1994; Chippindale et al. 2000; Whitley 1994b, 1994c, 2000a; Keyser and Klassen 2001; Francis and Loendorf 2002). The model is best understood, however, as a formal analytical tool whose purpose is to determine whether a corpus of art portrays hallucinatory imagery.

Because the acquisition of altered states of consciousness (ASC) is a central feature of shamanistic religions, with such experiences thought to represent supernatural communion, the depiction of hallucinatory imagery is itself taken to imply that the art originates in shamanistic beliefs and practices. The N-P model considers the form of rock art motifs, and the mixes of relationships between motifs, in order to infer their origin. Contrary to some assertions, the model itself does not address the meaning of the art: it concerns its origin, not its symbolism.

The cross-cultural applicability of the N-P model is based on a simple fact: all modern humans are neurologically hard-wired in the

same way. Hence, we all react to an ASC (a condition of our brain-mind) in a similar fashion. This is because, as Hobson points out:

[A]lterations of the brain-mind obey reliable and specifiable rules. Whether the states are normal delirium, like dreaming, or an abnormal delirium, like alcohol withdrawal, they always have the same formal features and the same kind of cause. The common features of normal and abnormal delirium are disorientation, inattention, impoverished memory, confabulation, visual hallucinations, and abundant emotions. The common cause of normal and abnormal delirium is a sudden shift in the balance of brain chemicals. (1994:62)

This does not imply that every trance experience will be identical to the next. In fact they vary, even for a single individual. But there are a limited series of potential reactions that occur during most ASC experiences, and it is this range of variation that the N-P model identifies. The model itself has three components (Figs. 7-1 and 7-2):

1. The first consists of seven common *entoptic patterns* (sometimes also called phosphenes or form constants). These are light images that are generated internally in the human optical and neural systems during an ASC. (They also occur during migraine headaches, and they can be generated by staring at a bright light momentarily then closing the eyelids and pressing on them gently.) The seven most common entoptics are: grids; dots, circles and flecks; concentrics and spirals; parallel lines and ticks; zigzags; meanders; and nested curves.

2. The second component involves the fact that ASC often progress through *three stages*. During the first stage, entoptics alone are perceived. Next, they are interpreted or construed as iconic images that are personally or culturally important and/or expected. Finally, the iconics may appear as if projected against the entoptics, and full-blown hallucinations occur.

3. Trance imagery is largely, if not entirely, generated within our brain-minds, thus the resulting mental images do not obey or

**FIGURE 7-1** The first component of the neuro-psychological model for trance imagery consists of the seven most commonly perceived entoptic designs (Lewis-Williams and Dowson 1988). These are light percepts spontaneously generated in the optical and neural systems during the first stage of an ASC. The column on the left illustrates idealized examples; the central and right columns are petroglyphs from the Coso Range, eastern California (Whitley 1994b).

follow the standards of vision in the real world. The third component reflects this fact. It consists of the seven principles of perception that govern the mental display of trance images, regardless of whether the visions involve entoptics or iconics. The seven principles are: simple replication, multiple reduplication, fragmentation, rotation, juxtaposition, superimposition, and integration.

**FIGURE 7-2** The second and third components of the neuropsychological model (Whitley 1994b). An ASC tends to progress through three stages, shown in the three columns, each of which has its own characteristic kinds of imagery. During each stage, images are perceived in a variety of ways that may differ from the constraints of "normal" vision (such as a fixed ground-line and orientation), illustrated in the seven rows. Examples are Coso Range petroglyphs.

Some important issues concerning the N-P model require emphasis. The first is that the value and attention paid to different aspects of trance imagery vary among cultures (as does the larger importance or meaning of trance generally). When our Western culture pays attention to hallucinations, for example, we heed the full-blown iconic images and barely notice (or invest no significance in) entoptic patterns.

But entoptics alone have great significance among the South American Tukano Indians, with specific patterns recognized as particular symbols having well-known names and meanings (e.g., Reichel-Dolmatoff 1978).

The interpretation of a corpus of art as shamanistic in origin is based on a comparison of the art to the expectations of the model. Specific iconic imagery varies from culture to culture and place to place, with San shamans understandably interested in eland antelope while Great Basin Numic shamans favored the bighorn sheep, for example. But the formal characteristics of the arts should be similar if they both portray trance imagery. Two corpora of rock art may be roughly identical on the formal level, even though they may appear quite different from a stylistic perspective or in terms of their (outward) subject matter.

Lewis-Williams and Dowson (1988) were not the first to draw attention to the neuropsychological implications of shamanistic imagery for rock art interpretation (e.g., see Blackburn 1977; Lewis-Williams 2001). But one of their key contributions was the link they noted between the geometric/entoptic and the iconic images, showing how iconics could "emerge" out of entoptics, and demonstrating that both motif classes can occur in shamanistic art. One implication of this concerns traditional stylistic analyses of rock art, many of which made hard-and-fast distinctions between geometric and iconic imagery (e.g., Heizer and Baumhoff 1962). The N-P model shows that, at least in shamanistic imagery, geometric and iconic forms can easily co-occur, and thus the distinction between them may be meaningless in cultural-historical terms.

Determining whether a corpus of art originates in shamanistic beliefs and practices requires comparing the corpus of motifs against the expectations illustrated by the model. This key analytical step is trickier than it sounds. Analysis necessarily involves comparing corpora of art (e.g., an entire motif assemblage from a site, or regional series of sites) against the model, not individual motifs, to determine how well the corpus fits. The analytical problem can be conceptualized by the following questions: How many attributes of the model occur in the corpus of rock art, what proportion of the corpus does

this represent, and how many common characteristics of the art are *not* predicted by the N-P model? Although there is no firm guideline for accepting or rejecting a shamanistic interpretation using this comparative process, generally the model should account for a substantial portion of a rock art corpus, and it should certainly accommodate more than it excludes if the corpus is in fact shamanistic in origin.

A compounding factor is that the N-P model portrays an idealized and standard range of variation for trance imagery. Some, but not all, cultures notice and value this entire range of variation and incorporate it in their art. The art of these cultures will fit all aspects of the model, and we can have confidence in a shamanistic interpretation of their art even without confirmation from independent sources. Other cultures concern themselves with specific aspects of trance imagery, perhaps to the exclusion of others. The Tukano, with their emphasis on the importance of entoptics, provide an example, and we may not be as confident about a shamanistic interpretation of a corpus that is exclusively geometric in nature.

The inferential strength of an interpretation varies somewhat based on the complexity and diversity evidenced in any given corpus of art. But, even in cases like the Tukano's, with exclusively geometric images, analysis of the principles of perception and stages of trance can help guide the final interpretation and signal the inferential strength of the interpretation. Indeed, it is important to emphasize that the formal characteristics of shamanistic art are not limited to the presence or absence of entoptic motifs (as many have erroneously assumed). Entoptics are simply one component of the model, and they are only one class of empirical evidence that the model considers.

## METAPHORS OF TRANCE

The last points further emphasize the importance of independent kinds of data and different analytical approaches in rock art research: while the N-P model can be used inferentially to establish a shamanistic origin for a corpus of art, this interpretation is always stronger with additional kinds of supportive evidence. One such independent

approach concerns the bodily (rather than visual) hallucinations of trance, and the ways these bodily effects are manifest in art.

We have noted a series of cross-cultural metaphors for trance based on bodily hallucinations. These were widely used, in many cultures, to express a visionary experience, at least in part because of the otherwise ineffable nature of ASC. Trance metaphors are common iconographic themes in many corpora of shamanistic art. When all or some of them are present in conjunction with a significant proportion of the other attributes of the N-P model, a confident shamanistic interpretation can result.

There are six common bodily metaphors for trance (Lewis-Williams and Loubser 1986; Whitley 1994b, 1998d, 2000a). The cross-cultural applicability of these is demonstrated by the fact that western Euro-American culture uses some of the same metaphors to describe similar ASC effects (although in verbal form). It is important to note that ASC are often drug-induced in our culture and specific hallucinogens tend to have particular bodily reactions; hence, certain of these reactions and metaphors are commonly associated with certain drugs.

- *Death/killing.* This metaphor results partly from the bodily collapse seen in both real death and entry into an ASC, combined with the grievous emotions ("bummer trip") that sometimes accompany a visionary experience.

- *Fighting/aggression.* Sometimes referred to as the *combative shaman* theme, this relates to the aggressiveness that is sometimes experienced during trance. In our contemporary world, the street hallucinogen PCP (angel dust), which is actually a large-animal tranquilizer, is infamous for leading to aggressive behavior, providing a parallel to the physical origin for this metaphor.

- *Magical flight.* This is caused by a sensation of weightlessness and spinning (e.g., into a vortex), along with a dissociative emotional state. Certain lowland South American tribes and our own 1960s drug culture independently used the metaphor of a *trip* for this ASC reaction. Currently the same reaction is commonly called an out-of-body experience (Turpin 1994).

NEUROPSYCHOLOGY AND ROCK ART

• *Drowning/swimming*. "Leaden" feelings in the arms and legs, difficulty moving, blurred vision, and weightlessness cause some to feel that they are underwater or, if combined with the emotional effects of death, drowning.

• *Sexual arousal/release*. ASC sometimes results in heightened sexual reactions and feelings or, put another way, certain hallucinogens are also aphrodisiacs. The street drug ecstasy is a well-known example; *Datura* spp. (jimsonweed) can have similar effects, although this is much less predictable and, probably more commonly, promotes aggression or violence.

• *Bodily transformation*. A variety of physical effects contribute to the feeling that the body is changing into another form, often wholly or partly animal. These include tingling on the skin, raised hairs, a rush of energy shooting up the spine, and a feeling that the head is elongating (or, similarly, growing horns). These hallucinatory feelings combine with visual hallucinations such that the visionary individual, when looking at his or her own body, links the changing visual impressions with the bodily feelings.

Eastern California petroglyphs illustrate almost all of these, with certain panels incorporating a number of the metaphors, creating particularly potent expressions of trance symbolism. A good example is the so-called hunter-and-sheep panels (Fig. 7-3). This type of scene was traditionally interpreted as a hunter wearing a sheep headdress-disguise to hunt the bighorn, and it was used to argue that the art was related to bighorn sheep hunting magic (e.g., Grant 1968). But there are some empirical problems with this literalist reading of the panel. Native Americans have denied any form of sheep hunting magic, and they also denied use of a bighorn rack as a hunting disguise: it is simply too large and heavy (e.g., Steward 1941:220, 1943:294; Stewart 1941:419; Fowler 1989:19). The panel clearly needs to be understood symbolically, not literally.

The first iconographic point is that the human is not wearing a sheep headdress-disguise, but is himself partly transformed into a sheep. Matched against this bodily transformation is his exaggerated

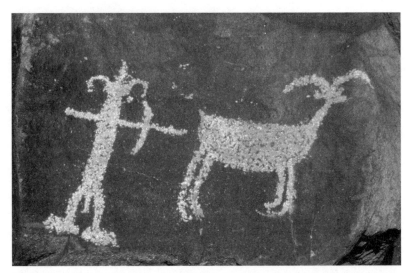

**FIGURE 7-3** "Hunter-and-sheep" petroglyph panel from Sheep Canyon, Coso Range, eastern California. Native American informants consistently denied the use of bighorn sheep racks as hunting disguises or headdresses, citing their weight. They also denied the use of petroglyphs for hunting magic, or of hunting magic for acquiring bighorns (though they frequently admitted and described hunting magic for antelopes, without any associated rock art.) The result is that this "composition" appears to represent a complex metaphor for the shaman's manipulation of supernatural power (Whitley 1994a, 1994, 2000a).

phallus, a physical characteristic common to the human-sheep conflations, but not with human figures more generally. This appears to relate to the sexual arousal metaphor for trance. The human is shown shooting a bighorn, an act of physical aggression. And, in fact, the bighorn is portrayed as already killed: the large upraised tail is a death posture for these sheep. Both aggressiveness and death are thus included. The result is the illustration of the most common metaphor for a shaman's trance: his "death" as an entry into the supernatural, which itself is partly based on the physical similarities between true death and falling into a trance (including collapse and loss of consciousness). Due to the equivalence of the hunter and the sheep established by the human-animal conflation, in other words, this scene is the depiction of a ritual shaman's auto-sacrifice: his own

"death," engendered by his entry into the supernatural world (Whitley 1994a, 1998c).

Flight is also a particularly common shamanic metaphor. It is typically expressed through the use of avian imagery. Shamans' ritual costumes often incorporated bird feathers. The well-known Coso rain shaman petroglyph (Fig. 7-4) illustrates a connection to flight in three ways. The first is the use of bird claws for feet (further signaling bodily transformation). The second is the face as a concentric circle, symbolizing the whirlwind that was thought capable of concentrating supernatural power and carrying the shaman into the supernatural. Third, the shaman is shown wearing a quail topknot feather headdress, another connection to birds, but also the specialized ritual headgear for the rain-maker (ibid.). As in the hunter-and-sheep panels, the metaphors of trance are illustrated in this single engraving in several different, but very coherent, ways.

N-P analysis properly involves an evaluation of the three components of the N-P model: entoptic phenomena, the stages of trance, and the principles of perception. Subsidiary "thematic" evidence, in the form of ASC metaphors, augment the model and provide a potentially additional line of support for a shamanistic interpretation. To these can be added contextual and associational factors (such as independent evidence for the use of hallucinogens by the culture in question). Good N-P analyses consider all these potential lines of evidence, not just one or two of them.

An excellent example of the application of N-P analysis to an ancient rock art corpus with no associated ethnography is David Lewis-Williams and Jean Clottes' studies of the European Upper Paleolithic art of France and Spain (Lewis-Williams and Dowson 1988; Lewis-Williams 2003; Clottes and Lewis-Williams 1998), which they infer to be shamanistic in origin. Entoptic motifs are present in this corpus but not numerically dominant, with the art emphasizing seemingly realistic depictions of animals. This confounded some researchers, who assumed that shamanism was thus an unlikely explanation.

In fact, there is nothing in the N-P of trance that requires visionary imagery to be primarily entoptic in form or that precludes

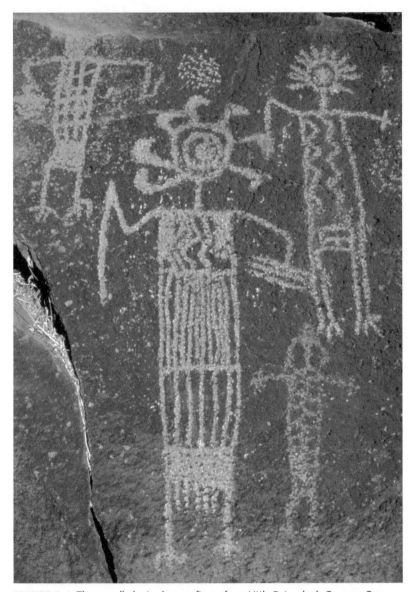

**FIGURE 7-4** The so-called rain shaman figure from Little Petroglyph Canyon, Coso Range, California. The central petroglyph wears a painted skin shirt, used in rituals, and carries a bow and arrows (indicating that the engraving is less than 1500 years old, when these weapons arrived in the region). He also wears a quail topknot feather headdress, identifying him specifically as a rain shaman. His supernatural power is signaled by the concentric circle for his face, representing the whirlwind, which carried the shaman into the supernatural world, and his bird claw feet.

naturalistic representations (or even a dominance of iconic images). Lewis-Williams' and Clottes' shamanistic interpretation results from the fact that the corpus includes some entoptic motifs and that it illustrates all of the principles of trance imagery, as well as the progressive stages of an ASC. Equally important, it includes a small but significant number of human-animal conflations (commonly bison-human), with numerous naturalistic images integrated with natural features on the panels themselves (e.g., the use of a crack as the backline of a horse).

Not incidentally, the context and setting of much of this art supports its relationship to trance. Most of the sites are located in relatively remote, dark zones in caves. Isolation in such environments quickly leads to sensory deprivation and hallucinations that follow the three stages of trance specified in the N-P model (cf. MacLeod and Puleston 1978), which sometimes makes archaeological fieldwork in these caves difficult. Jean Clottes (personal communication, 1994), for example, reported hallucinatory experiences while working alone in the caves long before he conducted any research related to shamanism. The combination of a pre-existing condition that triggers spontaneous entry into an ASC with the nature of the art itself yields a robust interpretation for this very ancient art.

Shamanism was pervasive, even if not universal, in the Americas (LaBarre 1980), and Native American rock art was predominantly (though not exclusively) religious in origin. This underscores the importance of N-P analysis as the first step in the interpretation of any New World rock art corpus. But not all rock art in the Americas is necessarily shamanistic in origin. We know that significant amounts of it are not. Nevertheless, shamanism is a reasonable initial hypothesis and a good starting point for the empirical evaluation of truly prehistoric corpora.

The N-P model is a key tool for formal analysis. Its value lies not solely in the identification of shamanistic corpora of rock art, but equally in its utility for determining which corpora are *not* shamanistic, regardless of place of origin or time of creation. Indeed, if a researcher believes that a particular rock art corpus is totemic or commemorative, an analysis using the N-P model that yields negative results is one way to demonstrate the likelihood of this possibility.

CHAPTER 8

# OTHER FORMAL APPROACHES

Despite the recent prominence of N-P research, not all formal investigations focus on shamanism or employ neuropsychology principles. To the contrary, they include a variety of approaches that address a plethora of concerns from a number of different theoretical perspectives, and employ a wide range of rock art data. In this sense they exhibit (with a few exceptions) a lack of theoretical or methodological cohesiveness, and they stand more as individual case studies rather than as widely followed general approaches to analysis. But they also exhibit notable creativity in their use of rock art data for understanding the past. This is important to emphasize, due to the significance of independent analytical models and empirical data in the support of a preferred hypothesis. In this chapter we look at formal approaches beyond neuropsychology, focusing on those that are most common, if not always successful.

## LANDSCAPE AND DISTRIBUTIONAL STUDIES

Landscape is a particularly common emphasis in formal rock art analysis. It has recently attracted widespread archaeological interest

(e.g., Bender 1992; Tilley 1994; David and Wilson 2002). In rock art research this is an outgrowth of, and conceptually related to, distributional/locational analyses, with the distinction between landscape and distributional/locational being both relative and chronological: it is partly a function of analytical scale and partly a reflection of recent changes in terminology. Landscape studies tend to highlight the relationship of sites to immediate or nearby features of the earth (including the panel itself; cf. Helskog 2004; Keyser and Poetschat 2003), whereas more-traditional distributional studies usually consider sites and motifs in relationship to one another, or relative to abstract geographical space (e.g., using "spatial statistics"). These two approaches are actually on a continuum, with the recent emphasis on landscape as opposed to abstract distributions itself an acknowledgment of the increasing importance of context in all types of archaeological analyses.

This last point is important. *Landscape* is a cultural term pertaining to the earth as it is perceived and conceptualized by a particular culture (cf. Nash and Chippindale 2001). Landscapes are not the physical earth itself, but cultural understandings of the earth. The purpose of landscape studies is to explore the ways that different cultures perceived and used the earth's surface and, for rock art research, the place of rock art in this process. Many landscape studies seek to obtain a deeper understanding (if not the ritual or symbolic meaning) of the art, as well as the logic of its placement in some locations and not others.

As should be clear, landscape research is often closely tied to informed studies (Chippindale and Nash 2004). Numerous publications address the landscape relationships of rock art from an insider's perspective, attempting to relate the symbolism of the art to landscape symbolism and meaning more generally (e.g., Whitley 1988,1998b; Lewis-Williams and Dowson 1990; Taçon 1994, 1999; Tilley 1994; Shepard 1996; Ouzman 1998; Loendorf 2004). Still, formal landscape studies are also common. For sake of discussion, these can be divided into three groups: archaeoastronomical and acoustic approaches, communication studies, and ethnicity and territoriality. Although the distinction is slightly artificial, formal distri-

butional studies are primarily seen in stylistic analyses and histori-cal/relational research.

## ARCHAEOASTRONOMY AND ACOUSTICS

Archaeoastronomical research is not usually included in discussions of landscape archaeology. But, in fact, archaeoastronomy commonly concerns itself with the layout and orientation of sites and how they relate to the earth and the sky (e.g., Freidel et al. 1993). These are exactly the kinds of interests that inform much landscape research—site placement and the logic behind it—and there is a natural link be-tween the two topics. Archaeoastronomical research is probably one of the most common kinds of landscape studies in rock art.

Archaeoastronomical research at rock art sites usually involves one of three approaches: the identification of direct alignments (e.g., between a solstice sunrise, a locally prominent peak, and a site); the discovery of so-called light-and-shadow effects (such as the move-ment of a shadow across a panel or motif at a specific time, usually the equinox or solstice); or the search for star maps, celestial events, or calendrical counts in the iconography. Unfortunately (and regard-less of specific approach), this research is typically anecdotal and un-systematic in the sense that a putative relationship is identified at a single site or panel, and (too commonly) only one panel or site is ex-amined. Despite the recent popularity of archaeoastronomical stud-ies of rock art sites, the vast majority have so far yielded ambiguous results.

That is, given the absence of systematic data collection, it is im-possible to know whether the discovered "relationships" at these sites are anything other than random or coincidental. Regardless of how visually dramatic they might be to the Western visitor (who is looking for these kinds of events), they have little inferential value without some reasonable basis for believing that the phenomena in question is the result of intentional behavior. Dramatic effect alone provides no empirical support on this point. While it is easy, for example, to make a plausible argument about the intentionality of a temple and plaza orientation, given that these are built features,

making the same kind of inference about art placed on an unaltered earth feature is another matter entirely, especially when there are potentially many more examples of similar art at other nearby locations that may not exhibit the same phenomenon or effect.

The standard archaeological approach to this kind of analytical problem is to show that the identified effect or phenomenon is present at a number of sites or on multiple panels (ideally, a statistically significant number). Alternately, we might attempt to demonstrate a correlation between a specific motif type and archaeoastronomically significant locations. Absent this kind of information, archaeoastronomical studies reduce to "counting the hits and ignoring the misses"—selecting the one case that fits the hypothesis while potentially ignoring the preponderance of the evidence, which may contradict it.

Despite the methodological poverty of most rock art archaeoastronomical studies, there are a few archaeologists who have valuable things to say about this topic in their specific regions (e.g., Young 1986; Bostwick 2002). Four points need mentioning. First, it is worthwhile to be mindful of the potential value of archaeoastronomy to rock art interpretation. But, second, it is also necessary to be skeptical about the one-off, anecdotal claims that are the norm for these studies.

Third, an important distinction can be made between unsystematic data collection, resulting in anecdotal evidence, and systematic data collection that can reveal idiosyncratic behavior or unusual cases. There is nothing about systematic research that precludes the discovery and explication of extraordinary cases, or the importance of unusual evidence. But unusual evidence obtained from systematic study differs from anecdotal data collected unsystematically because, at the outset, we know that it is extraordinary rather than representative, and we are therefore better positioned to understand its relevance. Unusual data would generally be recognized as part of the range of empirical variation that occurs in the archaeological record, thereby potentially providing a more nuanced and detailed understanding of an existing interpretation or theory. But a single extraordinary case would not be promoted as proof for a new interpretation or hypothesis. Yet this is what commonly occurs with putative archaeoastronomical discoveries.

A good example of this distinction is provided by Thomas Dowson's (1988) study of certain San motifs. At a general level, these motifs easily fit within the shamanistic framework for the origin of San rock art. But specific idiosyncratic attributes of the motifs (such as a single eland petroglyph combining male and female anatomical characteristics) were used by Dowson to argue for the role of the individual shaman-artist in constructing detailed cultural understandings of the supernatural world.

The results would have been unconvincing, had Dowson attempted to use these unusual motifs alone to demonstrate the validity of the shamanistic interpretation. But his use of them to amplify our knowledge of the variability of this shamanistic tradition, the existence of which had already been established by numerous other studies, was convincing. Moreover, the discovery and accommodation of unusual empirical cases is an important component of research. Recall here that the ability of an interpretation to explain new and previously unexpected kinds of data is one of the criteria we use to "infer to the best hypothesis." Unusual empirical cases are very important to research, but we cannot use them as conclusive evidence in any kind of rigorous investigation.

The fourth, and perhaps most important, point is that there is a general rule-of-thumb concerning the potential existence of archaeoastronomical practices, and therefore the relevance of this kind of research, in any cultural area. Traditional interests in astronomy commonly turn on calendrics—that is, the social regulation of time. In cultures where the regulation of time was (or can be assumed to have been) important, there is a greater likelihood that rock art sites were used in some astronomical or timekeeping fashion. Typically, but not invariably, these would be agriculturalist and/or more complex societies (such as the southwestern cultures discussed by Jane Young and Todd Bostwick, cited earlier). In cultures where time was not presumably important—commonly, among hunter-gatherers—archaeoastronomical practices are less likely. And this is exactly where much rock art is found, making many rock art archaeoastronomical studies questionable from the start.

A counterpoint to archaeoastronomical research are studies of

the acoustical properties of sites (e.g., Reznikoff and Dauvois 1988; Scarre 1989; Waller 1993, 2000; Devereux and Jahn 1996; Devereux 2001), some of which confront and overcome the same kinds of analytical problems seen in archaeoastronomy. A particularly good example is Steve Waller's (2000) analysis of the acoustical properties of the Horseshoe Canyon, Utah, sites (see Fig. 1-5), which contain Archaic pictographs commonly classified in the Barrier Canyon style. Almost everyone who visits these sites notices the seemingly unusual acoustics that are present; speech in even a relatively soft voice at the base of the panels seems to project dramatically across the canyon. It is easy to envision the selection of these locations to enhance rituals where chanting, singing, or drumming might play an important ceremonial role. But the unanswered question had always been whether the acoustics of these rock art sites were in fact a plausible determinant of site location, or whether the dramatic echoing was simply a widespread characteristic of the high-walled sandstone canyons where these sites occur.

The starting hypothesis for Waller's study was the proposition that site locations were selected because they had unusual sonic properties, specifically, strong echoes. Waller digitally measured echo intensity at regular intervals along Horseshoe Canyon to test this proposition. He found that intensity systematically spiked *only* at rock art site locations. And it turned out that, during his study one rock art location was not known to him in advance, yet he had recorded a sonic peak at its location along his sampling transect, giving him a kind of blind test for his analysis. The result is a systematic, scientifically sound analysis that correlates site location with a physical property of the landscape, thereby plausibly supporting the idea that this acoustical property was a determinant of site location.

Waller's study is successful in part because his analysis tested where rock art sites are located and, equally important, where they are *not* located. (This allowed him to avoid the "counting the hits and ignoring the misses" syndrome.) Moreover, Waller also turned to the ethnographic record, and thus to an independent data source requiring a different kind of analytical technique, to illustrate the importance of the acoustical properties of rock art sites to Native

Americans generally. Not only did he demonstrate a correlation be-
tween sites and a specific physical property on the earth but he also
developed an argument using ethnographic analogy to show why
this property was potentially relevant. The result is one of the best
examples of formal rock art analysis: it is methodologically airtight
and, based on his ethnographic comparisons, the relevance of the
findings are clearly demonstrated.

## ROCK ART AS COMMUNICATION: PUBLIC VS. PRIVATE, AND BEYOND

An obvious implication of the Waller acoustical studies is the use of
rock art sites for ritual communication (albeit communication in an
active rather than passive sense). Rock art is often conceptualized as
analogous to a written text or road map, where the symbolic mes-
sage is, in effect, latent: the message is limited to the iconography
and is forever preserved therein. Yet, in at least some cases, rock art
was created in rituals with multiple participants and spectators, and
thus the ceremonial performance itself may have played an impor-
tant communicative role. Girls' puberty initiation pictographs from
southwestern California (see Fig. 1-4) are one example of rock art
created in a ceremony with painters, observers, and ritual officials
(Whitley 2005b). In this case the art was created after a ritual race to
the panel, and the symbolism involved much more than the iconog-
raphy alone (Whitley 2000a).

Interest in the communicative nature of rock art underlies many
analytical approaches, both informed and formal. These formal land-
scape studies consider not so much the iconography (and what it
may symbolize or mean) but the physical properties of the sites
themselves, where they are located, how they may have been seen,
and what this might imply about who may have created and used
them. A common concern involves a basic distinction between the
use of sites for public versus private rituals, evidence for which may
be found in physical aspects of the sites, such as visibility from a dis-
tance and placement and size of the art.

The ethnography of communication provides one analytical

framework for the general problem of formally identifying the characteristics involved in rock art rituals (Whitley 1987). This looks at a series of attributes of "speech events" (Hymes 1972), which include rituals as acts of communication. These attributes are:

- Message form: the way something is said

- Message content: the topic of communication

- Setting: time, place and physical characteristics of the speech event

- Scene: psychological setting (e.g., formal vs. informal)

- Speaker: sender of the message

- Addressor: person verbalizing the message

- Purposes, outcomes: conventionally recognized results (for the participants)

- Purposes, goals: results from the community standpoint

- Key: tone of the speech event

- Channels: medium of communication

- Forms of speech: possible dialects

- Norms of interaction: normative behaviors and proprieties attached to the communicative act

- Norms of interpretation: normative framework for interpreting the speech event

- Genres: the categories of communication (Whitley 1987:166–67)

Not all of these characteristics of speech events are necessarily relevant to rock art rituals or rock art sites. But this list demonstrates the levels of complexity involved even in simple communication, points to the simplicity of rock art perceived solely as a passive text, and implies a series of things about how an analysis of rock art as a kind of ritual performance could be conducted.

I used these concepts in an analysis of the rock art of south cen-
tral California, focusing on message-content groups, message form,
setting, scene, speaker and hearer, and outcomes and goals (ibid.).
Previous analyses had identified two "styles" in this area: a South-
ern Sierra painted style, and a Coso petroglyph style. My analysis
suggested instead the presence of two message-content communi-
ties, one of which corresponds to the Tubatulabal tribal territory.
The second message-content community occurs within Coso Sho-
shone lands, but it consists of two identifiable ritual communities
or subgroups (the first involving petroglyphs and the second picto-
graphs).

Each of these message-content and ritual communities had
slightly different traditions for the placement of their art, with cor-
responding implications for the intended recipients as well as for the
way the messages were received. (For example, the Coso petroglyphs
are on open and visible locations in a wide variety of settings relative
to other site types; the Coso pictographs, in contrast, are often hid-
den and relatively remote; the Tubatulabal pictographs are on open
visible boulders within villages.) In this case, the commonly made
distinction between public and private art, and what this may imply,
is developed at a variety of levels.

Loubser (2002) has looked at landscape settings of rock art in a
slightly different way, directed toward understanding the nature of
communication implied by the sites and what this suggests about
the ritual groups involved. His research was in Hell's Canyon on the
Snake River, a part of the Columbia Plateau that is particularly rich
in rock art sites and rock art ethnography (cf. Keyser 1992; Keyser
and Whitley 2002; Hann et al. n.d.). Because of this, Loubser's ap-
proach was partly based on ethnography, but it is nonetheless instruc-
tive with respect to formal analyses. Recognizing the ethnographic
distinction between shamanic rock art sites (those made by shamans
per se), and shamanistic sites (those made on vision quests by puber-
ty initiates and adults during life crises; cf. Taçon 1983), his concern
was whether he could distinguish public/instructional/shamanic from
private/mnemonic/shamanistic sites. Although approaching the anal-
ysis somewhat qualitatively, Loubser (2002) identified seven criteria

that, based on widespread ethnographic analogy, he argued should help to distinguish these two kinds of arts. These criteria are:

- Visibility of site and/or rock art from a distance, especially from trails and access routes

- Ease of detection of the art within a site, in terms of bodily effort required to view

- Care of execution (i.e., application technique and finish)

- Craftsmanship (uniformity and consistency of execution)

- Recognizability (e.g., of iconic images)

- Integration of art and rock surface (such as incorporation of natural features in the art)

- Degree of effort in creation (especially evidence for group effort)

Loubser then considered the art at three contextual levels, moving from macro to micro. These are, *first,* the landscape setting, which includes the larger geomorphological and cultural context, such as nearby rivers, rapids, occupied shelters and villages, and the terrain surrounding the site; *second,* the site itself, including physical approaches to it and its morphology; and, *third,* the setting of the motifs, especially body movements required to see the art and the arts' integration with rock panel faces.

Perhaps not surprisingly, Loubser's analysis identified more shamanistic than shamanic sites (a predictable outcome given that almost everyone presumably went on a vision quest, whereas only a small number of individuals became shamans). A few sites were mixed, exhibiting characteristics of both types. Unexpected, however, was a variation that he labeled "shamanic entrance" sites. According to Loubser:

> Found closest to the Snake River within individual rock art site complexes (i.e., a site complex comprises two or more neighboring rock art sites), "entrance" sites are typically the most complicated and most carefully executed sites within their particular complex. (2002:92)

As we shall see, the concept of rock art sites serving as a demarcator of ritual space, rather than marking ethnic or tribal territories, is repeated by other authors. Although involving another tribal group, this idea is supported ethnographically by a case study of Numic-speaking peoples in southern Nevada. Rich Stoffle and Nieves Zedeño note that:

> Along most trails are places where a person going on a ceremony will prepare him- or herself. These locales for ceremonial preparation are often marked by the knotted string sign in either rock peckings or paintings. The sites tend not to be near camping places, being more isolated because they are used to prepare for ceremony. Once the designated ceremony is completed, these spots are revisited on the return trip to the major settlement. (2001:151)

The existence of "entrance sites," which Loubser identified inductively in Hell's Canyon, is then supported by analogy with ethnographic data from another region in far western North America. And, though Loubser's study was not a purely formal analysis, one implication of it warrants emphasis. Even in regions like Hell's Canyon that are advantaged by substantial ethnography, formal studies can contribute to our understanding of the art because we may find information not included in the ethnographic record.

The importance of Loubser's examination of the body position and posture required to view sites, panels, and motifs may not be immediately apparent to readers who have not yet recorded sites. But experience reveals that panels and motifs are sometimes in very awkward locations and difficult to view (recording them can be tortuous.) This is no better demonstrated than by the well-known Paleolithic caves of France and Spain, where most of the art is in "dark zone" areas that lack any kind of natural lighting, that may be very difficult to access even with artificial lighting, and where the art is sometimes found in very restricted spaces (e.g., see Clottes 1997b). Visibility (or, more correctly, lack of ready visibility) was obviously an important factor in the placement of this art and it should tell us something about why the art was made and how it was used ritually.

Suzanne Villeneuve and Brian Hayden (2005; Hayden and Villeneuve 2005) have addressed this question directly, using what may be termed a *proxemics analysis*—that is, a study of how people use space. Though independently developed, their approach parallels Loubser's (2002) Hell's Canyon study in many of the variables they examine. They have considered:

> . . . inferred body positions and amount of space available for optimal viewing of individual images or panels in relation to the location of the image, its dimensions, as well as technical aspects of the art relative to effort and quality. (Hayden and Villeneuve 2005:386)

These factors, combined with the requirements for lighting and motif sizes, cause them to concur with other authors (e.g., Clottes 1997b; Lewis-Williams 2002; Loubser 2002) on the likelihood that two different kinds of groups made and/or used this Paleolithic art: large groups involving well-executed art and requiring coordinated efforts at lighting; and individuals or small groups, in restricted spaces, involving cruder motifs and having more limited lighting needs. But to this distinction Villeneuve and Hayden suggest a third use of space. This involved ritual pathways through narrow corridors where the imagery necessarily is seen in sequence. The multidimensional qualities and varied nature of rock art, even within a single culture area and (general) time period, are emphasized again by their study.

Paleolithic rock art is also directly addressed in Bob Layton's (2000) quantitative assemblage analysis, which was intended to determine whether this art originated in totemic, shamanic, or secular practices. He states that:

> In totemism, each social group appropriates animal or plant images as their exclusive emblems. In shamanism, certain species may be favoured vehicles for spiritual encounters for shamans, but they are generally available to anyone throughout the society. I argued that evidence for the deployment of art in different ways may provide clues to its role in cul-

**TABLE 8-1** Layton's predictions about motifs

|  | Each motif concentrated at a few sites | Motifs equally distributed between all sites |
|---|---|---|
| All motifs produced with equal frequency | *Totemic* | *Secular* |
| Some motifs at least 2x as common as mean for remaining motifs |  | *Shamanic* |

ture that do not depend on reconstructions of meaning. . . . [T]otemic, shamanic and secular rock art offer different ways of using motifs drawn from the vocabulary of a cultural tradition. They therefore have different but characteristic distributions within and between sites, and may utilize different styles. Each is symptomatic of a political strategy in which motifs are deployed in appropriate contexts. (ibid:179–80)

Layton used ethnographic cases to develop quantitative predictions about the numbers and distributions of motifs. He then cross-tabulated two axes of variation, each with two states, allowing him to distinguish four possible cultural configurations (ibid.:180). The resulting table, which considers only three of these configurations, is Table 8-1.

Another way of conceptualizing the relationships that Layton outlines is the following:

- Secular rock art is randomly distributed across sites and shows no clear patterning in motif frequency.

- Totemic rock art has a limited range of motifs, and these are concentrated at a few geographically clustered sites.

- Shamanic rock art strongly emphasizes certain motifs, but these are randomly distributed across sites.

Comparing the empirical evidence to this model, Layton concludes that Upper Paleolithic rock art is likely shamanic in origin, whereas the portable art from this same period and place appears to be secular in origin. Layton (like Loubser [2002] and Hayden and

Villeneuve [2005]) is careful to characterize his analysis as provisional, in the sense that additional research is needed to determine whether it may be widely applicable beyond the test cases that he himself considered.

It is worth interjecting that the emphasis on animal spirit helpers and, thus, naturalistic art as characteristic of shamanism, is only sometimes correct. Mojave shamans, for example, received their power by re-experiencing the mythic creation of the world, and animal spirit helpers play little part in their beliefs, with their rock art almost entirely geometric/entoptic in form (Whitley 2005c). But where representational imagery is common, the model appears to have great analytical potential, and certainly warrants additional testing and application.

Many landscape studies take a wider view of site context and setting, addressing (like Waller's [2000] acoustical studies) the general problem of why rock art was placed in one location and not another. A good example is Richard Bradley's (1997) research on the Neolithic rock art of the Atlantic coastal region of western Europe—another case lacking ethnography. This began by dividing his study area into grids, finding and mapping rock outcrops with and without rock art within these grids, measuring distances and angles-of-sight from the various outcrops, and identifying the common patterns. Abstracting from the results, Bradley argued that complex motifs tend to be at the highest locations on the landscape, with more common motifs down below, closer to where everyday activities occurred. The complex motifs also often occur at "thresholds" or natural entrances in the terrain, with rock art sites, in a general way, following ritual routes. The implication here is a nice complement to Stoffle and Zedeños' (2001) and Loubser's (2002) comments about certain rock art sites serving to mark ritual entrances.

Bradley (2001) expanded his analysis in a particularly creative study, providing a model for the interpretive potential of formal analyses. This considered the main concentrations of Neolithic and Bronze Age northern and western Europe rock art, and looked beyond landscape to the nature of the motifs themselves. His concern was the relationship between art that was relatively accessible and art

with restricted access, which provided one axis of variability, plotted against relatively naturalistic versus abstract (geometric) images. Underlying this juxtaposition of what seemed to be two different kinds of variability (landscape versus graphic) is his argument that the potential meanings of naturalistic images are more apparent than those of abstract art.

The identification of naturalistic motifs ("This is a picture of a boat") is straightforward and, while identification certainly does not equate with symbolic meaning, is a starting point for understanding and interpretation. But even the most superficial meaning of abstract motifs may be obscure or ambiguous because, as Layton (1991) has observed, the motifs themselves provide no obvious clue to their meaning. Put another way, as Loubser (2002) likewise implied in his Hell's Canyon study, even the outward meanings of abstract designs must be learned. Because of this, the symbolic meanings, significance, and implications of abstract images are more easily restricted and controlled. Conceptualized in this fashion, abstract motifs in locations with restricted access represent one extreme of a continuum of physical and intellectual accessibility; naturalistic motifs in accessible landscape locations represent the other.

Perhaps not surprisingly, Bradley (2001) found that the art tended to segregate in precisely this fashion. As he notes:

> . . . despite some major exceptions, there does seem to be a relationship between the use of abstract motifs in European rock art and its creation in quite remote locations. Conversely, naturalistic images are usually found in more accessible places. There are many exceptions and yet there is a change from abstract images over time. This took place in conjunction with other changes in the siting of the art. Certain naturalistic images became more widely distributed and were also employed on portable artifacts. This tended to happen towards the end of the sequence. (ibid:239)

Bradley concludes that this suggests a change in the importance of restricted or sacred knowledge over time.

Margarita Diaz-Andreu (2002) has also addressed the problem of

why sites are in certain locations and not others, specifically with re-spect to the so-called Levantine rock art of northeastern Spain, which dates to the Mesolithic. Her analysis starts with a fact that standard studies of rock art styles obscure: while given styles may be associat-ed with particular regional cultures, the sites themselves are often far from uniformly distributed across a regional landscape. Treatment of a particular style as diagnostic of a specific culture (i.e., as if it were everywhere present within that culture's territory) makes problemat-ic any understanding of the functions served by the art in the culture that produced it.

Rock art was not necessarily common in many cultures, and its creation and placement may be as important for what it tells us about internal cultural processes and social divisions as for identifying dis-tinctions with surrounding cultures (such as boundaries or territo-riality). Diaz-Andreu further suggests the importance of what she terms "ritual-depth" in the landscape: recognizing that the Western distinction between sacred and profane may not be applicable to pre-historic populations does not necessarily imply that the two can be entirely conflated, with a sliding-scale then potentially distinguish-ing the degree of sacredness (or intensity of ritual use) for a par-ticular site. She concludes that site location was at least partly con-strained in her study area by outcrops of a distinctive red sandstone and, because there are other geological formations that could have been used, the formation itself had sacral connotations. Further, she identified sites with high visibility, which contained a common motif repertoire, versus sites that were more hidden and contained more idiosyncratic kinds of motifs, considering these contrasting patterns in terms of gender, hunting, shamanism, and ethnic identities.

Ralph Hartley (1992; Hartley and Vawser 1998) has approached the problem from a different perspective: not why a site is in a par-ticular location but what that particular location implies about a site's use. His concern is the measurable information in rock art sites, how this information varies with situational context, what this implies about human behavior, and ultimately the part that rock art played in changing human adaptive strategies in prehistoric southeastern Utah. The amount of information at a site is taken as a quantitative

measure of the number of and variation in motifs present. Analysis of the site positions involved use of a geographic information system (GIS), allowing for precise data on topographic location as well as accessibility and visibility. One of Hartley's conclusions is that the habitation sites used by more stable and smaller populations contained the least differentiated rock art, whereas those sites with longer and more intensive use had greater information content in their associated rock art.

## ETHNICITY AND TERRITORIALITY

Although her research is partly based on Australian Aboriginal ethnographic data, Claire Smith (1992) has provided an analysis relevant to formal landscape studies in her study of the possible territorial implications of rock art. Smith looked at motif distributions, not in terms of art styles but as networks of information. She hypothesized that, in areas that were resource poor, social networks would be extensive and information would be shared across wide distances. Where the environment offered more resources, networks would be smaller and the distribution of individual motifs would be less consistent. Both ideas were supported by her analysis of a large sample of pictographs, with the results paralleling those of Meg Conkey's (1980) conceptually similar analysis of aggregation sites and portable art.

The information content of rock art may potentially provide signals useful in the exploitation of the environment, including the use and manipulation of social networks to gain access to resources. Or—signaling the inherent inferential difficulty of formal analyses—this logic can be turned on its head. The distribution of rock art across the landscape may result more from competition than cooperation, and thus indicate territoriality or contrasting ethnicities. Barton et al. (1994) argue that art is often used to mark sacred places and boundaries. They suggest that, where population densities are low, phenomena like rock art are not much needed because the importance of special places can be transmitted by oral tradition. But, with higher density and larger group size, the importance of the "physical demarcation

of landmarks near important resources and territorial boundaries" (1994:200) emerges. Art in this sense legitimizes group rights to land and resources, and signals these rights to other groups.

Rock art is seen by some as a phenomenon that serves to distinguish different social groups. But it can also be used to trace potential cultural relationships, as Meredith Wilson (1998) has shown. She has analyzed Pacific Islands rock art in order to test archaeological models of the spread and colonization of the region. She notes that:

> . . . continuous colonisation would bear evidence of continuity in rock art traits. A long gap would allow for substantial changes to the rock art sequence. Attributes might be lost and completely replaced. Those that survived might have undergone a process of transformation. . . . (ibid.:181)

Her statistical analysis of motif and attribute similarities failed to support the existing model of cultural continuity across this broad area, causing her to question the current phylogenetic model for Pacific Islands colonization.

These landscape and distributional analyses suggests two conclusions. The first is that analytical approaches vary significantly from study to study, and there is no resulting cohesive body of work that can be said to constitute a well-developed approach (e.g., in comparison to the N-P research, where the analytical technique is well defined and where a large number of applications can be cited, across the world). Chris Chippindale and George Nash commented on this:

> . . . the most formal approaches to landscape are the more analytical techniques, those dealing with spatial distributions as they can be mathematically described and algorithmically expressed. These. . . are not numerous in rock art studies. Indeed, quantitative methods in rock art are not much developed. . . in part because we do not sufficiently grasp what the entities are that are to be counted and statistically explored. (2004:20)

The second conclusion concerns the inferential goals of the analyses. Formal analyses are not often thought to be concerned with

questions of symbolism and meaning, instead considering topics such as social and environmental adaptation. But, as the studies illustrate, a number of the formal analyses are specifically concerned with ritual, sacred places, and *meaning*—even if only indirectly. This suggests that it is difficult to escape the religious nature of most rock art and, having acknowledged that nature, the analytical goal of identifying cultural meaning.

## QUANTITATIVE AND METRICAL STUDIES

As Chippindale and Nash (2004) observed, formal quantitative and statistical analyses in rock art are the exception rather than the rule, in part because it is hard to know what is important to measure or count. Yet there are occasional examples of such analyses that have provided useful information about a couple of interpretive concerns. One of these involves the question of labor and resource expenditures in the creation of rock art, an issue that confronts the general problem of ritual intensification (which itself has implications for interests in changes in sociopolitical complexity). The Coso Range, for example, literally has tens of thousands of petroglyphs. By combining estimates of time expended in making petroglyphs—derived from replicative experiments conducted by Bard and Busby (1974) and Busby et al. (1978)—with chronometric evidence, it was possible to develop estimates of the total time spent yearly in creating the rock art corpus (Whitley 1982). This proved to be relatively small, with only a few hours expended in this ritual activity, on average, in any given year. Although it is likely that substantial yearly fluctuations occurred in production rates, it is clear that the size of the corpus can be explained without recourse to an intensive but short-lived "bighorn sheep hunting" cult, as had been previously hypothesized (see Grant 1968), based on the time-depth of the corpus alone. Similar studies have been conducted for the Bronze Age rock art of Mont Bego in the southern Alps (Chippindale 2001a), and for the Paleolithic site of Lascaux (Geneste et al. 2004). In both cases the time expenditure in rock art production was relatively limited and little evidence for ritual intensification was found.

Another relatively straightforward kind of metrical analysis involves the handprints (or stencils) found in many parts of the world. Anthropometric studies indicate that statistically significant differences exist between male and female hand dimensions within given populations, suggesting the possibility that the sex of the creators of handprints may be reliably determined (Freer 2001). Dean Snow (n.d.) has developed a two-stage analytical approach using digit-length ratios to distinguish adult males, first, from sub-adults of both sexes and adult females, and then the adult females from the sub-adults. Looking at six hand-prints from four French Paleolithic caves, Snow identified four adult females, one adult male, and one sub-adult male.

The ability to determine the sex of the creators of this art is particularly useful, given the interest in gender in archaeology generally, and in rock art research specifically (e.g., Solomon 1992; Diaz-Andreu 1998; Whitley 1998b; Dowson 2001; Hays-Gilpin 2004), Moreover, Snow's approach provides reliable information about the specific makeup of ritual participants, which is always useful but particularly so in the French Paleolithic case, because of long-standing conjectures in the literature about this issue. With the prevalence of these types of motifs worldwide, this approach clearly has widespread utility.

## PHYSICAL ANALYSES OF ROCK ART

Physical (or material sciences) analyses of rock art are critical to rock art conservation and dating. But they may also provide useful information about the technology of rock art manufacture as well as trade in the resources used to make the art (see Rowe 2001b for a useful summary, including technical details of recent analytical methods). Further, they may yield data that relates to, if not amplifies, our understanding of ritual practices. All of these kinds of information are useful for a detailed understanding of the art, including issues that extend beyond the physical nature and chemical constituents of the motifs themselves, thereby providing another kind of formal rock art analysis.

A number of researchers have analyzed rock art pigments to determine their chemical constituents (e.g., Couraud and Laming-Emperaire 1979; David et al. 1993; Scott and Hyder 1993; Ford et al. 1994; Hameau et al. 1995; Hyman et al. 1996; Mawk et al. 1996; Menu and Walter 1992; Taylor et al. 1974; Vialou et al. 1996) and, in some cases, to identify potential patterns of trade or resource acquisition. Following a suggestion proposed by Koski et al. (1973; cf. McKee and Thomas 1973), Whitley and Dorn (1984) found chemical and micro-morphological similarities between red pigment at a pictograph site in the southern Sierra Nevada and natural red ochre at Coso Hot Springs in eastern California. This provides possible confirmation of ethnographic data indicating that hot springs—which, like the rock art sites, were thought to be supernaturally potent places (Whitley et al. 2005b)—served as important pigment sources. Looking beyond rock art pigments alone, Erlandson et al. (1999) have started a database on red ochre pigments in western North America.

Their preliminary analyses suggest that specific ochre quarries can be analytically differentiated and pigment samples thereby sourced, providing an avenue for studies of resource acquisition and trade. This possibility is particularly interesting in light of the fact that, at least in some parts of the far west, pigment trade crossed ethnolinguistic boundaries (e.g., Kelly 1932; Ray 1963). Moreover, while pigment had mundane uses (e.g., for cosmetics and for painting arrow shafts), pigment quarries themselves were considered sacred (Franklin and Bunte 1994). Given that ochre was strongly associated with ritual, this suggests that pigment sourcing could potentially contribute information on the exchange of ritual resources.

The organic binders of pigments have also been examined by a number of scientists, most commonly with an interest in the techniques of paint making. Both Scott et al. (1996) and Rowe (2001; Reese et al. 1996a, 1996b) and his students have identified blood in North American rock art pigments: a mixture of antelope and human blood from a Chumash pictograph, and ungulate blood (bison or deer) in a Pecos River, Texas, case.

Although the technology involved in these studies is still experimental and the results therefore provisional (Rowe 2001b), this kind

of research may ultimately lead to the identification of ritual patterns in the making of pigments and allow us to trace ritual continuity, with physical evidence, in the archaeological record. Among the southern San in the Drakensberg Mountains of southern Africa, for example, eland blood was selectively used as a pigment binder during the ethnographic period, due to the strong association of this antelope with supernatural power (Lewis-Williams 1986). This ethnographic pattern potentially could be investigated through pigment analysis, to determine both the time-depth and the geographical distribution of this practice in the archaeological record.

Pigments have also been chemically analyzed to determine whether motifs of a specific color, found on an individual panel, were created with the same constituents and thus were likely made from the same paint batch (Geneste et al. 2004). The rhinoceros in the famous shaft scene at Lascaux, for example, was apparently created using a different pigment formula than the other motifs of the same color, suggesting that this apparent "composition" was created in a series of discrete episodes, not all at once.

Foreign materials analyses have been conducted on samples of rock varnish that developed, over time, within the pecked-out grooves of western North American petroglyphs (Whitley et al. 1999a, 1999b). This revealed the systematic presence of quartz grains that had been pounded into the underlying (quartz-free) basalt heartrock, indicating the selective use of quartz hammerstones to make the motifs. Because these same petroglyphs had been dated, we were able to identify long-term continuity in this ritual practice, providing an additional avenue of empirical data that could be combined with other lines of evidence, including long-term use of the same sites, the same motifs, and the same iconographic attributes on these motifs. The resulting inference was deep time-depth for the shamanistic ritual that created this art, extending back into Paleoindian times (before 10,000 YBP).

As in all research, one goal should always be the acquisition of independent lines of evidence using different kinds of data collection and analytical techniques. Physical analyses of rock art provide one useful approach. Admittedly, they are usually undertaken by chemists, physi-

cists, and geologists—not archaeologists—and the results are often so technical that they may not appear to have any immediate inferential value to the rock art researcher. But, ultimately, all archaeologists are involved in identifying and studying patterns of continuity and change in the archaeological record, regardless of the kinds of data studied. It is likely that physical analyses of rock art will become increasingly important, as we become more attuned to the kinds of results they yield and the implications of the findings for our archaeological problems.

# STRUCTURALISM AND SEMIOTICS

*Structuralism* is a theory about how the mind is organized and how it operates, specifically the categorization of the world into binary oppositions, such as black:white, good:bad, or hot:cold. Originally derived from linguistics, structuralism was most famously applied to anthropological research by French ethnologist Claude Lévi-Strauss (e.g., 1963). Structuralist analyses of rock art (see Conkey 1989, 1992, 2001 and Chippindale 2001b for reviews) followed shortly thereafter, beginning with Andre Leroi-Gourhan's (e.g., 1958, 1965, 1967) studies of Paleolithic art. These were based on quantitative tabulations of the motifs and an analysis of their placement in the Paleolithic caves. Leroi-Gourhan proposed that this art was laid out in a structured fashion, creating a kind of "mythogram," as he called it, one key component of which was a paired opposition between horse and bison. Initially (at least) he took these two animals to represent male:female, but what he sought was not the deep meaning of the art so much as its structuring principles (Conkey 2001).

Most Paleolithic researchers have retreated from a strict structuralist interpretation (though see Sauvet et al. 1977; Sauvet 1988; Sauvet and Wlodarczyk 1992, 1995), for both empirical and theoretical reasons. More recently, structuralist interpretations have been presented for Namibian (Lenssen-Erz 1989, 1994a, 1994b) and Scandinavian (Tilley 1991) rock art.

The theoretical difficulty with structuralism is that the mind is not exclusively nor even predominantly organized around binary oppositions (Whitley 1993). Binary oppositions do certainly exist, and

they can play important symbolic roles, but duality is not a universal or even a dominant *structural* feature of the mind. I mentioned previously for example the importance of inversions in the symbolism of far western North America (cf. Whitley 1998b). These at least partly reflect a widespread male:female opposition (with, for example, male shamans creating rock art at feminine-gendered places). But our understanding of the existence and operation of this structuring principle derives from informed research (ethnographic analysis), not solely from a formal analysis of rock art motifs or sites, or from an assumed and invariant binary structure of the human mind. Moreover, despite the commonness of the male:female symbolic opposition, it certainly was not universal, even within western Native America (see Whitley 1998b).

The practical problem with structuralist analysis is one that plagues most inductively based quantitative studies and, in fact, many formal analyses. This concerns our ability to understand the empirical patterns that, through analysis, we may discover in our data. Absent a theoretical model or analytical prediction to be tested from the outset (e.g., such as is provided by the N-P model), it is difficult to know how to interpret these patterns, and their inferential importance and meaning often are far from self-evident.

This problem is not unique to formal studies of rock art, of course; it is common in all types of archaeological research. Indeed, it was precisely the recognition of this inferential difficulty that led to the call for Middle Range research in archaeology generally—that is, studies aimed at developing interpretive models for the kinds of empirical patterns that occur in the archaeological record. Though he was writing about an analysis of Mousterian stone tool associations, not rock art motifs, Lew Binford's comments on this issue are particularly illustrative:

> I performed one correlation study after another. . . . I could tell you cross-correlations between any pair of Mousterian tool-types, between tools and bones, between bones and drip-lines in cave sites, between almost any type of data you care to name. What I found, of course, was many new facts

that nobody had seen before. But none of these new facts spoke for themselves, just as the initial facts had not. By generating more and more facts and by detecting more and more patterns, I had simply increased the scope of the problem without reaching any solutions. (1983:98, 100)

The tension between our ability to identify empirical patterns, such as paired motif associations, and the great difficulty in understanding the implications (if any) of the identified patterns, is no better shown than by the structuralist studies of Paleolithic rock art. At about the same time that Leroi-Gourhan developed his interpretation, Annette Laming-Emperaire (e.g., 1962; cf. Laming-Emperaire 1970) independently conducted a similar analysis and found an equivalent associative pattern in the art. But her interpretation of the gender implications were exactly the opposite of Leroi-Gourhan's: what he saw as masculine, she considered feminine, and vice versa. As Binford had discovered in his Mousterian analysis, both Leroi-Gourhan and Laming-Emperaire had identified some seemingly important facts about Paleolithic art. But what the facts implied—beyond their demonstration that this symbolic system was systematic and ordered—was anyone's guess.

Semiotic analyses of rock art are related to structuralist analyses in the sense that they too take their intellectual inspiration from linguistics; in this case *semiotics,* a general theory of signs and symbols. Semiotics has been influential in rock art research, in some cases at the level of theoretical presuppositions about the nature of communication (e.g., Lewis-Williams 1981; cf. Layton 2001; Conkey 2001) and in others more directly at the level of analytical procedures (e.g., Tilley 1991; Rozwadowski 2001; Nash 2002). Chris Tilley (1991:16), for example, argued that material culture, speech, and writing all share the same qualities, although communication through speech is the most direct form. George Nash (1997, 2002) extended these ideas, noting that material culture in general, including rock art, reflects a kind of grammar that can be manipulated for a particular audience.

Andy Rozwadowski (2001) laid out a specific analytical

approach using the principles of semiotics, starting with the distinction between syntactic and semantic analysis. In rock art research, *syntax* refers to the rules by which different motifs are combined, while *semantics* compares communicative patterns in other aspects of the same culture in order to define the characteristics of the semiotic system as a whole. The first step in analysis is the identification of recurring motif associations, followed by a comparison of these patterns within the general culture.

The appearance of semiotic approaches in rock art, like the earlier use of structuralism, is an expression of the "linguistic turn" that social analysis has taken in the last few decades—that is, the increasing influence of linguistic models on and literary approaches to interpretation. While structuralism is based on a cognitive theory about how our minds operate, the use of semiotics in rock art research involves an *analytical metaphor.* Rock art is only a "text" in a loose sense (or, put another way, while some rock art panels may be very similar to texts, others may have qualities that are distinct from the Western idea of a text.) A useful starting point for any semiotic rock art analysis would be a critical analysis of the way a particular corpus of this art may or may not be similar to a text.

## BETWEEN FORMAL AND INFORMED

I was impressed, during the preparation of this chapter, with the relative paucity of formal approaches to rock art analysis (beyond neuropsychology and its relationship to shamanistic interpretations). Certainly there are some researchers who are dedicated to purely formal research—in some cases because their regional interests provide them with no alternative. Others are solely interested in human behavior from the perspective of adaptation and evolution and are not much concerned with symbolism or ritual, beyond the mere fact of its existence. But the subtext of many formal studies remains the definition of the nature of the ritual that created the art and its religious/ social implications (including the communication of meaning), and these topics would be advantaged by the existence of ethnographic data that, in these cases, are not available.

One result is the selection of approaches that fall somewhere between true informed and fully formal. These most commonly appear in western Europe, a research area generally lacking a directly relevant ethnographic record, but boasting many archaeologists interested in symbolism and meaning. The result is tension between what they would like to know and the avenues available to obtain it. Certain of these archaeologists have adopted approaches that, for sake of discussion, can be said to reflect a commitment to phenomenology as a possible resolution to this tension. This is best seen in phenomenological studies relating rock art to landscape (e.g., Tilley 1994; Nash 2002). In some cases phenomenological approaches are used in tandem with some of the analyses already discussed, including semiotics.

At risk of over-simplification, *phenomenology* is a philosophical position that rejects the application of scientific method (derived from the natural sciences) to mental phenomena and embraces consciousness as the only true reality. Chris Tilley (2003) has usefully outlined the kinds of questions that archaeologists should address (and data they should consider) when adopting a phenomenological perspective for landscape rock art research. These include the following:

1. Significant intrinsic characteristics of the rock surface (shape, color, cracks, fissures, etc.)

2. Relationship of the decorated rock to other rocks in the surrounding landscape, and its landscape setting relative to prominent landforms

3. The way your perception of the art changes as you approach it, along with its visibility, accessibility and viewshed characteristics

4. The rock's non-visual physical characteristics (tactile and auditory)

5. The way the motifs relate to the above qualities and characteristics of the rock

6. The way the rock relates to other cultural features on the landscape (ibid: 138)

While these phenomena provide a contextual framework for analysis, the interpretations that result are more akin to an art critique (exploring the emotional and aesthetic qualities of the site) than to empirical research per se, and there seems to be no way to judge the result. Put another way, judgment can be based on three qualities that are rarely considered in other kinds of research: How intuitively convincing is the discussion? How well (in a related fashion) is it written? What truths does it reveal? This kind of research, after all, consists of the production of directed interpretive essays rather than analyses, with the contemporary consciousness of the modern author the driving force.

I leave it up to the reader to decide whether this approach to research is worth pursuing admitting that, if well-executed, it has a particular kind of very specific potential. This is because these kinds of studies are (in my opinion) an exercise in art rather than science, and well-executed art is valuable in its own right. (I like to say that science reveals and explains facts, whereas art helps us uncover truths.) But so far I have yet to see a phenomenological essay on rock art that approaches an artistic level of authorship.

It is worth emphasizing again that formal analyses are important components of any interpretation, regardless of the possible existence of informed sources, because of the value of incorporating multiple methods and independent data in any analysis. The best research results when those primarily using informed kinds of data look to possible checks or tests in formal analyses (e.g., by the incorporation of N-P with ethnography in shamanistic interpretations). The same can also be said for formal analyses (e.g., through their potential use of wide-ranging and systematic ethnographic analogy). The distinction between informed and formal approaches, in this sense, should be understood as complementary, not oppositional.

CHAPTER 9

# MANAGEMENT AND CONSERVATION

Regardless of how an archaeologist documents or analyzes a rock art site, management and conservation must be seen as key issues in any rock art project. This is partly because many sites are intrinsically fragile (often more fragile, and therefore more imperiled, than "dirt" archaeological sites). It is also partly due to the high heritage values of many rock art sites (again, often greater than other kinds of sites). The result is an urgent need for site management and care, yet this can be difficult and expensive, and require specialized kinds of expertise.

The difficulty and expense of rock art site management too often cause the sites to be ignored. But there are some basic principles of site management that every archaeologist should understand. There are also a series of issues involved in site management that archaeologists are well suited to deal with, as well as management problems that they are fully capable of tackling. I discuss these below, loosely following a conceptual guide to management outlined by Jannie Loubser (2001).

# INITIAL ASSESSMENTS

Rock art site management and conservation should be based on a management plan that lays out, in explicit detail, what needs to be done to ensure the long-term survival of the site (cf. Clouse 2000), how and when the identified procedures will be undertaken, and what activities can occur at the site. The management plan is built from a series of components, each of which involves basic data gathering about the art and locality. These are significance, condition, and management assessments of the site (Loubser 2001).

The *significance assessment* is intended to identify the heritage values of a site. These might involve research, spiritual, aesthetic, historical and/or tourist (commercial) interests In the site, and its future use. Professional archaeologists, who are trained to value research above all else, sometimes have difficulty understanding the fundamental point of this assessment. This is that special-interest groups (or "stake-holders") will have varying values, interests, and concerns regarding a site and that these may differ from the research interests of archaeologist—yet they need to be accommodated in the site management process. Archaeologists do not "own" the sites, after all. Research is important, but so are the concerns of the neighbors who reside adjacent to the site and who may benefit from the development of a tourist attraction—which, not incidentally, might also facilitate use of a site for educational purposes by school groups.

The goal of the significance assessment then is to identify *all* of the heritage values of the site, in part by interviewing the concerned parties and special interests. The ultimate goal of the management plan is to accommodate the needs of as many interest groups as possible without compromising the safety of the site.

Also critical is a *condition assessment*. Ideally, this is a technical study conducted by a trained conservator who can identify both the current hazards to the site and possible remedies for them. Conservators will evaluate the status and condition of the rock support or panels, the motifs themselves, and any associated archaeological deposit. They will consider such topics as mineral accretions on the panel and the motifs, lichen and other kinds of biotic growths, ani-

mal and insect effects (wasp or bird nests, bird droppings), weathering and erosion (including cracking and spalling), and human effects. The condition assessment should be part of a detailed documentation of the site. This creates baseline information that can prove useful in evaluating subsequent changes in the site's condition.

It takes specialized training and expertise to conduct a detailed condition assessment., but every archaeologist can complete at least an initial status report on the site. This could include basic site documentation (see Chapter 2), along with information about obvious conditions effecting the panels and motifs (such as lichen or mineral growths). It could also document human impacts, especially in the form of vandalism (such as looting or graffiti).

The final study, which should be completed before writing a management strategy, is the *management assessment.* This considers some of the non-archaeological nuts-and-bolts issues that are pertinent to planning for the site's future. This could include the ownership of the site (and any existing laws or regulations that govern its status or use), the context of the site, and identifiable opportunities and constraints that influence future actions.

# MANAGEMENT PLAN

Once these documents are compiled, a formal *management plan* should be completed. Again, it is important that all interested parties have a voice. In general terms the management plan spells out what will be done to protect, conserve, manage, and use the site. Ideally, any proposed actions at a site should be limited to the bare minimum and should be repeatable and reversible, inasmuch as it is usually impossible to foresee all of their the long-term effects. They should likewise be compatible with the different values the site holds for the different interest groups, and any conservation efforts should be distinguishable from the original site conditions.

The management plan itself includes three components: two different kinds of strategies, and recommendations for the future. The first strategic plan concerns *conservation,* which can be conceptualized in terms of four different levels of activity:

1. *Maintenance* of the site, with minimal intervention, possibly including trash removal and brushing the dust off panels

2. *Preservation,* which involves hands-on intervention (i.e., physical change to the panels or motifs) in addition to maintenance, such as the removal of plants that might be rubbing against a panel or diverting a water flow that might run onto the art

3. *Restoration,* which begins a process of returning a site to its original condition, for example by removing lichen or graffiti

4. *Reconstruction,* an extreme step (usually avoided at rock art sites) that might involve repainting motifs

Archaeologists are often capable of undertaking maintenance and some kinds of preservation. A trained conservator is usually required for any kind of restoration or reconstruction. As a general rule, most kinds of intervention on a panel face are best completed by a conservator.

Given the high interest in rock art and the growing economic importance of eco-tourism around the world, a *public visitation strategy* is likely to be an important (if not controversial) issue in any management plan (see Gale and Jacobs 1986; Sullivan 1995). The tension over this topic derives partly from a deeply entrenched site management precept that governed archaeology for many decades. This was to make all site locations secret, and to keep the public away. For a variety of reasons, this logical (actually, simple-minded) approach has not worked. It has not prevented the public from finding and visiting sites, and it certainly has not kept looters away (who often are as skilled as archaeologists at finding sites).

The Knapp Cave site, in Los Padres National Forest, California, provides an instructive example (McFarland and Horne 1997). This site is located within a fenced shooting range (although the shooting is directed away from the rock art site). Even though visitors must climb over a fence liberally festooned with "Danger–Shooting Range–Keep Out" signs and traverse about a quarter-mile in the direction of the shooting area, it still receives over 800 tourists a year.

Armed and shooting guards, in other words, will not keep visitors away from rock art sites.

Worse, the traditional management approach contributed to the bureaucratic perception that all that is required for site management is secrecy, which costs nothing. This attitude prevented the allocation of essential funds and resources for adequate site management and also contributed to the false perception that the only real concern in site preservation is control of visitor access. Following this passive management philosophy, sites were left to decay, with unofficial or illicit visitation entirely uncontrolled; meanwhile, professional archaeologists felt no obligation or responsibility to do anything constructive to ensure long-term site survival.

Given the overriding goal of guaranteeing long-term preservation, some rock art sites can never be opened to the public. Typically, these are unusual sites, with closure necessary because of their small size, fragility, rarity, or religious importance; the remainder of the sites in a region can potentially be opened for visitation under certain conditions. The first condition is that the sites be thoroughly documented and their condition regularly monitored. Site steward programs, involving trained volunteers who make periodic site visits, noting any problems and collecting trash, are very effective. Second, visitation should be controlled in a fashion appropriate to the condition and nature of the site, and the expected tourist pressure. This might mandate guided tours only, or the construction of infrastructure (e.g., walkways, low "psychological" barriers) that accommodates but controls self-guided tours. The presence of visitor register boxes and signs has proven successful in helping to control behavior at remote sites because it establishes a perceived official presence at these locations (Sullivan 1984).

Third, efforts should be made to minimize the adverse effects of visitation. One of the most common of these is the creation of dust by people walking in front of the panels. Walkways and pavements are two approaches to resolving this problem; these also help prevent people from touching the panels. Fourth, any visitor program should include an educational or interpretive component. People value, and

take care of, things they understand. Whereas the origin and meaning of rock art once may have been a mystery, even to professional archaeologists, we now have a substantial knowledge base that can be used to create an interpretive element for any rock art site. (Indeed, even where such information has not yet been developed, interpretation can be built around already-established information such as local ethnography or the regional prehistoric record. Anthropological and archaeological context, in other words, can be used in place of specific details, if these are lacking.)

It is important to recognize that the way that the sites are presented will affect visitors' perceptions of them and thereby influence their behavior. Clean, trash-free, tidy sites are signs of concern, involvement, and care. Sites marred by graffiti and rubbish broadcast the message that no one cares about them, that they are not important, and that there are no restrictions concerning appropriate behavior and activities.

Reliable rock art education is addressed in part by regional rock art guidebooks, a number of which have appeared recently (e.g., Conway and Conway 1990; Loubser 1993; Deacon 1994; Helskog 1996; Whitley 1996, 1998e; Lewis-Williams and Blundell 1998). There is a long history of guidebooks to many French and Spanish sites, and it is somewhat surprising that it has taken so long for them to appear in other parts of the world (the site secrecy management model was probably responsible). Guides are useful for a number of reasons. Since they are often purchased in advance, they prepare the tourist for the visit both intellectually (what they will see and what it means) and behaviorally (what activities and actions are appropriate at a site, and what needs to be prevented). They also help structure the public's overall rock art experience, partly by promoting visitation to sites that can accommodate tourists, and partly by creating a coherent picture of a series of regional sites.

Ultimately, there are both positive and negative aspects of visitation. On the negative side are the potential degrading effects that visitor pressure can have on a site. From the positive perspective, however, the demand for public visitation (including visitation by avocational rock art "researchers" or enthusiasts) has highlighted the

issue of site management and conservation, forcing professional archaeologists to quit using secrecy as an excuse to do nothing for the sites as they weather away. Even more important, however, is the money that rock art tourism can bring into a local region, and this can be quite substantial.

During the 1990s, for example, tours into the Coso petroglyphs in eastern California generated over $170,000 per year for the Maturango Museum, the local museum, along with an additional $150,000 yearly flowing into the local economy. Although (given its suburban setting) there is no estimate for its economic impact, Petroglyph National Monument, outside of Albuquerque, New Mexico, has had yearly visitation levels of about 100,000 people, with 15% yearly increases. Meanwhile a national survey of public land use indicates that 17% of tourists visiting federal land go to see prehistoric sites, while 50% visit historical sites. Both of these figures are far higher than hiking or off-road vehicle use (Whitley 1999).

Rock art tourism is inevitable, and it is also then potentially beneficial to the regional community. One goal of most management strategies is to find a way to accommodate rock art tourism while safeguarding the sites. A particularly good example of the way these two concerns can be accommodated has been developed by Peter Pilles for the Coconino National Forest, Arizona. Pilles has created a partnership with a local, for-profit tourist company. This company helps fund the conservation and management of the local rock art sites on its tours, recognizing that these sites are the basis for their business. If the sites are degraded, tourist interest in the sites will diminish—and, if the sites are seriously imperiled, the Forest Service potentially could close them to all visitation, eliminating the company's opportunities to run tours. The commercialization of rock art tourism in cases like this may be the best option for the long-term survival of certain sites.

The third component of a management plan involves *recommendations* for the site. It is important that the management plan remain flexible. New conditions and circumstances, or unexpected reactions and results (e.g., especially from restoration and reconstruction interventions) may require alterations to the plan. Regularly

**FIGURE 9-1** Controlling public visitation is an important component of site management. At the Ayer's Rock pictograph site (see Figure 9-2) in the Coso Range, California, a site management plan was developed by the local office of the U.S. Department of Interior, Bureau of Land Management. This involved moving parking away from the site, creating a path from the new parking area to the site, signing the parking area and path, and having a volunteer steward conduct regular site-monitoring visits. A local Boy Scout troop was enlisted to build the car park, path, and signs. The main sign, seen here, serves to establish an official presence at the site as well as to educate the public about the significance of the site.

monitoring site conditions, reassessing the effectiveness of the management strategy, and modifying the approach as necessary should be part of every rock art site management program.

Ayer's Rock (see Figs. 9-1 and 9-2), in eastern California, provides a good example of a simple, relatively inexpensive but effective management program (Whitley 2004). The site consists of three pictograph panels on a large granite monolith, within a surrounding midden deposit (Whitley et al. 2005b). The site was depicted on U.S.G.S. topographical sheets and auto club maps for about a half-century and has always been accessible by a good dirt road so, despite its remoteness, it is very well-known and frequently visited.

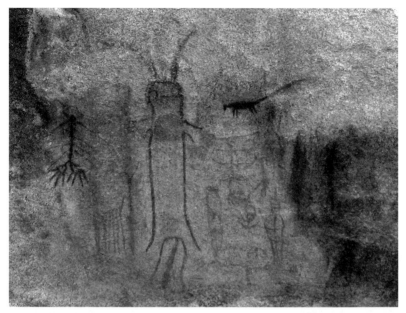

**FIGURE 9-2** The largest pictograph panel at the Ayer's Rock site in the Cosos of eastern California. Motifs are painted in orange, red, black, white, and blue. An x-ray–like figure is seen on the left, with two human figures to the right. These appear to be analogous to the shaman figures seen in the Coso petroglyphs from this same area. Although the evidence is inferential, portions of this site are believed to have been painted by Bob Rabbit, the last known Coso Shoshone rain shaman, in the first few decades of the twentieth century (Whitley et al. 2005b). Despite the fact that this site was depicted on road maps and topographical sheets for more than half a century, it remains in near-pristine condition.

The first documentation of the art (and excavation of the midden) occurred in the 1960s, and it has been recorded a number of times since, making it one of the best-documented sites in California. Yet with the exception of some outline-chalking on one of the panels, the pictographs are still in near-pristine condition.

Originally, a dirt road led immediately up to the pictograph monolith, however, and there was fear that campers' fires might destroy the paintings. Partly because of this threat, as well problems with dust, the Bureau of Land Management developed a management plan and program that began with re-routing the access road so that it terminated in a parking area, with interpretive signs, about a

quarter-mile from the site. A signed dirt path was constructed from the parking area to the site, requiring visitors to hike a short distance to see it. (A local Boy Scout troop was responsible for building these improvements.) A trained site steward was then assigned to the site. This individual is responsible for regular visits to remove trash and document any changes in site condition, and the steward can alert the management agency if any actions needs to be taken to protect the site. With the exception of the parking control imposed during the last decade, unrestricted visitation has occurred at this site for the last half-century. So far this has not resulted in any vandalism or other kinds of problems. Visitation then does not necessarily equate with destruction, as many rock art researchers continue to claim.

Intervention on a rock art panel (e.g., graffiti removal ) certainly may require specialized training, supplies, and equipment, and in certain cases this type of conservation may be required to save a rock art site. But many sites will benefit greatly from simple management plans that accommodate the interests of various stake-holders, and that are primarily oriented toward managing visitors so that future adverse impacts are minimized or eliminated. Any thinking archae-ologist, interested in saving sites and willing to devote some energy to the issue, can develop and implement these kinds of management programs.

Finally, we need to look at heritage values and significance assess-ment. As discussed earlier, many archaeologists view research as the primary if not exclusive value of an archaeological site, prioritizing it above any other value that may be identified. The most common of these other values involves indigenous peoples and their ties to sites (cf. Mowaljarlai et al. 1988; Fourmile 1996; Meehan 1995; Morris and Hamm 1995; Whitley 2001). Almost invariably, contention devel-ops over the religious importance that native peoples place on a site, whether in North America, Australia, or another area of the world. Almost invariably, the initial reaction of archaeologists is the same. It is some variant of denigrating the religious importance of the site by questioning the cultural connection of the group making the claim to the site. This leaves little ground for any kind of compromise solution or management plan, and antagonism understandably results.

A few points must be made. The *first* is that Native Americans (and most traditional peoples) place great importance on their landscape, to a degree that may be difficult for a others to apprehend (Stoffle and Zedeño 2001). *Second,* it follows that traditional sites commonly were invested with religious significance because religion was so commonly intertwined with all aspects of their lives. (Even a "mundane" village may have been used for important rituals, signaling its potential religious qualities.) *Third,* and importantly, a careful review of the ethnographic literature, where available, demonstrates that the claims of religious importance for many sites have been repeated for decades; they demonstrably are not recent inventions promoted for political advantage, as some archaeologists claim.

For example, the religious nature of California's southern Sierra Nevada pictographs has been documented in the ethnohistorical record for more than 150 years; the connection between rock art and shamanic practices in the Great Basin and on the Columbia Plateau has been similarly recorded for over 125 years (Whitley 2000b; Keyser and Whitley 2002). In all three cases, numerous examples illustrate long-term continuity in the indigenous claims about the sites and their importance, extending into our current twenty-first century. The sacred nature of these sites, and their importance to local Native American communities, need to be carefully considered in any management project and plan.

# ARCHAEOLOGY, ANTHROPOLOGY, AND ROCK ART

The last two decades have been a particularly exciting time for rock art research and researchers, with significant changes occurring in all its aspects. Indeed, the 1980s and 1990s witnessed the movement of this traditionally marginalized subdiscipline into the mainstream of research and management, if not to the cutting edge of the discipline. In part, this was because the quality of rock art research improved markedly, proving that we can rigorously study and interpret prehistoric rock art. Its acceptance was also promoted by breakthroughs in technical areas of research, such as chronometric dating. But rock art research is still a work-in-progress, and there are areas that require improvement and problems that need resolution. It is worthwhile to conclude by considering where the need for improvement is greatest, and what research might best be emphasized in the near future.

First, there needs to be more emphasis on incorporating rock art studies and research results into the interpretation of wider archaeological issues. The fact that rock art panels tend to be spatially distinct from archaeological deposits has allowed us to consider the

art separately from the dirt archaeological record. (Indeed, we can conduct most types of rock art fieldwork without any real attention to the remainder of this record.) That rock art has required different analytical techniques also allowed us to address problems specific to rock art alone (such the meaning of an iconographic corpus) while ignoring the site deposit and the problems it suggests about the prehistoric past.

Dirt archaeological research desperately needs rock art, I would argue, if it is to develop a holistic understanding of prehistoric cultures. But rock art research also needs what dirt archaeology can offer, because rock art is always contextualized by the larger material cultural record. Richard Bradley has noted that:

> Rock art research must contribute directly to archaeology if it is to achieve anything of value. It is not a separate discipline, for it is defined by its subject matter and by the techniques that it employs; academic research is defined by its objectives. (1997:8)

Thus it is essential that rock art research be conducted as one aspect of the exploration of a regional prehistoric past rather than undertaken, as has too often occurred, as rock art research for rock art research's own sake.

The second priority is rock art ethnography. As Meg Conkey (1997) has noted, ethnography has been a central impetus behind the recent revolution in rock art research. Perhaps more precisely, there has been a revolution in the ethnographic study of *shamanistic* rock art, but not in ethnographic research on *all* types of rock art. Although there have been important exceptions (e.g., Layton 1992; Morwood and Hobbs 1992), discussions of the ethnography of non-shamanistic rock art are relatively rare, and mostly restricted to Australian Aboriginal rock art. Meanwhile ethnographic research on non–hunter-gatherer rock art is rarer still.

I have emphasized shamanistic rock art partly because this kind of rock art is found where I work, further reflecting the fact that shamanism was pervasive in the Americas (La Barre 1980). But the emphasis also reflects the current status of worldwide ethnographic

rock art research, which is weighted towards shamanistic cultures. More ethnographic research on other kinds of rock art, including art made by settled farming communities, is a significant need. I hope that, if there is a subsequent edition of this book, there will be adequate research material available to develop this important topic in more detail.

My two priorities for future rock art research might seem to be at cross purposes. I am arguing both for more attention to dirt archaeology and for additional ethnographic study. Rock art research is archaeology or it is nothing, but it continues to need ethnography. This is not a contradiction but a recognition of a famous maxim coined by Willey and Phillips (1958) almost a half-century ago: "Archaeology is anthropology, or it is nothing." This is still true in the twenty-first century. Rock art research will flourish to the degree that its practitioners continue to recognize, first, that it is archaeology, and, second, that all good archaeology is anthropology.

# ROCK ART
# RECORDING FORMS

Two recording forms are included here as examples that can be used as models for region- or project-specific forms. Note that both are intended to be employed *in addition to* the standard site record form that is used to record all sites, of all types, in any given state, province or region, or on a specific research project. In the United States, these standard forms are often provided by the state Office of Historic Preservation, or by the governmental agency responsible for managing the region in question (such as the federal Bureau of Land Management or U.S. Forest Service). Alternately, the archaeology department/program at a local university or museum may provide a copy of a standard form that is used in their region. Any of these agencies/programs can advise on where site records are inventoried and archived, and thus where site discoveries can be reported.

It is critical that the standard site record forms be completed before the rock art–specific forms. This ensures that rock art sites are included in the general regional site inventory records. It also guarantees that certain standard types of locational information (e.g., in the United States, the county, township/range/section locations and UTM coordinates) are documented. And it prevents subsequent

confusions over site names and numbers. California, for example, uses a trinomial system for site designations: CA-INY-134 is an example. This indicates that the site was the 134th recorded in Inyo County, within the state of California. In the late 1950s, before this system was standardized in the state, some local museums had their own, very similar, systems. The result is that multiple forms, with different designations, exist for certain sites, leading to endless confusion. Site CA-INY-134, to cite one case, is the official designation for Ayer's Rock (Figure 9.1), but some older records list it as CA-INY-104. It is best, obviously, to avoid this kind of confusion from the start.

As I have emphasized throughout this book, rock art recording is always undertaken with certain guiding biases and interests, whether the archaeologist is aware of it or not. One advantage of rock art recording forms is that they force the researcher to make biases explicit. The two examples that follow reflect this circumstance. Both were developed for work on Fort Irwin, in the central Mojave Desert of California, which has Great Basin petroglyphs similar to those found in the nearby Coso Range. They reflect my pre-existing knowledge of the range of motif types present in the region (following a typology published by Grant [1968]) combined with an interest in looking at the correspondence of this art to the neuropsychological (N-P) model (Lewis-Williams and Dowson 1988) for trance imagery.

The first form is a summary for a site as a whole; the second is a panel-specific form (that is, one of these is completed for each panel at a site). We used these two forms during a documentation program that involved mapping, complete photographic coverage, and panel tracings at a series of sites. The rock art panel record, in other words, complemented the information included on the panel tracings. But both forms could be employed in less-complete recording projects, e.g., where motifs are tabulated on a panel-by-panel basis, not traced, or even where estimates are made.

Each form can be modified as appropriate for the region, kind of art, and research goals of the archaeologist and recorder.

# ROCK ART SITE RECORD

Site Trinomial: _____

Site Temp. Designation: _____

Page_____of _____ .

1. Site Location: [including topo map name] _____

2. Site Type: [e.g., village w/ rock art; rockshelter w/ or w/o midden; isolated rock art panel] _____

3. Rock Art Technique(s): [e.g., petroglyphs, pictographs, combinations] _____

4. Associated Features: [e.g., rock structures, bedrock mortars] _____

5. Associated Artifacts: [especially temporal diagnostics, such as projectile points or ceramics] _____

6. Number of Panels: _____

7. Method of determination: [e.g., counted, estimated] _____

8. Number of Motifs: _____

9. Method of determination: _____

10. Integrity/condition: [consider here especially evidence for weathering and natural deterioration] _____

11. Vandalism: [describe amount, type and specify location] _____

12. Documentation: [e.g., systematically photographed; traced; motifs tabulated using standard typology; etc.] _____

13. Comments: [e.g., styles present] _____

14. Sketches/maps attached? _____

15. Photo log sheet & #: _____

16. Recorder: _____

17. Date: _____

# ROCK ART PANEL RECORD

Site Trinomial: _____

Site Temp. Designation:_____

Page _____ of _____ .

1. Panel No.: _____

2. Panel size: _____ × _____ m.

3. Orientation: _____

4. Inclination: _____

5. No. Motifs/Technique:          Pecking _____

   Scratching _____     Incising _____
   Painting_____      Cupules _____

6. No. Motifs/Type:
   Humans_____        Bighorns _____
   Snakes/zigzags _____     Canids/felines _____
   Birds _____        Cervids _____
   Tracks/prints _____      Shields_____
   UnId'ed animals_____      "Atlatls"_____
   Other Weapons _____        Horns _____
   Medicine Bags _____        Other iconics (desc.) _____
   Diamond Chains _____       Cupules _____
   Grids_____         Spirals/conc's._____
   Dot Patterns _____       Nested curves_____
   Meanders_____         Parallel lines _____
   Complex geometrics _____     Other geometrics _____

7. Revarnishing (petros)/Repainting (pictos):_____
   _____

8. Superpositioning: _____
   _____

9. Condition/vandalism: _____
   _____

10. Comments:_____
    _____
    _____

11. Photo Log Sheet & #:_____

12. Recorder: _____

13. Date:_____

# GLOSSARY

**abstract** A term commonly used for geometric motifs in rock art research, because even the outward significance of these designs are often unknown.

**altered state of consciousness (ASC)** Mental states of trance, hallucinations, visions, or out-of-body experiences. These may be achieved spontaneously or through meditation, fasting, sensory deprivation, isolation, and the ingestion of drugs, among other means. Although ASCs occur cross-culturally and are interpreted differently in contrasting cultures and religious systems, they were central components of shamanism.

**AMS radiocarbon dating** Radiocarbon dating using an Accelerator Mass Spectrometer (AMS), a kind of nuclear accelerator. This permits the dating of very small organic samples, potentially including the small remnants of organic matter that may have been present in rock art pigment.

**analogy** An argument or logical inference based on known similarities between two phenomena, generally holding that if these two phenomena are alike with respect to one attribute, then they are also alike with respect to others.

**anthropomorph** A human-like motif or figure. This term is often used in rock art research instead of "human" because the image may be intended to portray a deity or spirit rather than a real human.

**archaeoastronomy** The study of ancient astronomical beliefs and practices, including calendrical systems.

**archaic** In North America generally, pre-ceramic hunter-gatherer cultures. In some areas the term also applies to a specific time period.

**aspect (of a rock art panel)** The direction (north, south, east or west) the panel faces.

**atlatl** A throwing-board, used to propel a dart. Atlatls were replaced by the bow and arrow roughly 1500 years ago in much of western North America, making both the atlatl and bow and arrows useful time markers in rock art.

**biographic rock art** Painted or engraved rock art common on the northern Plains of North America during the protohistoric and historical periods. This is both iconic and narrative art and it is commemorative in nature, often illustrating war deeds and honors.

**cation-ratio (CR) dating** A chronometric technique for petroglyphs. It is based on chemical analysis of the rock varnish that develops on rock surfaces, including the engraved-out areas of petroglyphs, in arid regions. An electron microprobe, part of an SEM, is used for the chemical analysis.

**cervid** Deer-like mammals of the family *Cervidae*.

**chronometric techniques** Age determination techniques based on scientific analyses, usually yielding age estimates in calendar years.

**Chumash** American Indian tribe living along the coast and coastal mountains of the Santa Barbara region of California. The Chumash are well-known for their polychrome pictographs.

**commemorative rock art** Rock art created to memorialize specific events, such as a battle or a mythic occurrence. Biographic art is one form of commemorative rock art.

**condition assessment** The first step in a rock art site conservation program. It consists of baseline data recording derived from detailed observations on the condition and signs of deterioration at a rock art site or on a panel.

**conservation** Physical or chemical techniques of intervention at a rock art site, panel, or motif, that prevent or retard decay. Conservation is part of the site management process but is not identical to it.

**cultural resource management (CRM)** A sub-field of professional archaeology concerned with the management and protection of archaeological and historical sites.

**cup and ring** Cupule and concentric-circle petroglyphs characteristic of Neolithic and later sites in the British Isles.

**cupules** Also called "cup" marks, these are engraved or pecked pits.

**desert varnish** An older term for rock varnish.

**direct historical approach** An approach to archaeological analysis and interpretation based on broad comparative studies and analogies between the ethnographic and the prehistoric records.

**dirt archaeology** Traditional archaeological fieldwork, which emphasizes the excavation of archaeological deposits ("dirt"), thereby contrasting with rock art research, where no excavation may be involved.

**earth figure** Groundsurface rock art, often monumental in scale. Some earth figures are made by aligning cobbles on top of the existing ground ("rock alignments"); others by scraping away the groundsurface to expose the contrasting soil beneath ("intaglios").

**emic** – See etic.

**entoptic pattern** Geometric light images or patterns created in the optical and neural systems during altered states of consciousness; also called form constants or phosphenes. Motifs made to portray entoptic patterns are common in some shamanistic rock art.

**ethnography** Writing about cultures. The ethnographic record is the written account of cultures and peoples; ethnographic research involves the study of the written accounts.

**ethnology** The study of cultures, requiring primary research involving interviews, questionnaires, and/or participant observations involving informants. Ethnological research often results in ethnography.

**etic** An *outsider's* view or interpretation, e.g., of a cultural belief. Opposed to "emic," which is the *insider's* perspective or knowledge.

**figurative** See naturalistic.

**formal research** Analyses and interpretations that emphasize the formal characteristics of the art rather than any possible artist- or culture-specific knowledge about its origin and meaning. Formal interpretations often seek cross-cultural generalizations or attempt to reconstruct the technology involved in creating the art.

**generalization** Used in reference to graphic reproduction, this is the loss of detail involved in translating primary data, such as a traced rock art panel or a mapping information, into a form and smaller size that can, practically speaking, be printed.

**geoglyph** Alternative term for earth figure.

**Harris matrix** An approach for carefully defining a stratigraphic sequence, particularly valuable in rock art using superimpositional relationships between motifs of particular styles and types.

**hunter-gatherer** Non-farming peoples whose subsistence is based on foraging for plant foods, hunting and, in some cases, fishing.

**iconic** See naturalistic.

**iconography** The ordered set of connections between particular graphic forms and their meaning; a corpus of such forms.

**informed research** Research that is wholly or partly based on "inside" knowledge, such as ethnographic data. Informed analyses commonly seek the symbolism and meaning of rock art.

**instrumental rock art** Motifs that lack any significant iconographic meaning or intent; where the physical act of creating the motifs was primary, rather than any latent symbolism. Examples might include cupules and irregularly shaped rock alignments.

**intaglio** This is an earth figure made through subtraction: by scraping-away the dark surficial layer of the desert pavement to create a negative image. The term is also used for a motif that is so deeply pecked that the design is lower that the original surface of the rock.

**landscape** A cultural understanding or interpretation of the natural earth surface, including the values and symbolism ascribed to different places and different kinds of places. A landscape analytical approach aims to identify the cultural uses of and beliefs about a culture's territory and terrain.

**mineral skin** A natural mineral accretion on a rock surface. While these can obscure rock art, they also serve to seal the art from the elements (especially pictographs) and help to preserve it.

**minimal intervention** A basic principle of conservation holding that direct conservation techniques and strategies should be limited to the minimum actions possible that will yield the desired result.

**naturalistic** Life-like imagery, with a design that is outwardly identifiable, e.g., zoomorphic or anthropomorphic motifs. Sometimes also called *iconic, representative,* or *figurative.*

**neuropsychological (N-P) model** A model of the progressive stages and forms of the mental imagery of trance, and the ways these images are perceived (Lewis-Williams and Dowson 1988). Because shamanistic rock art may be created to portray trance imagery, the N-P model can be used to test whether a corpus is shamanistic in origin.

**neuropsychology** The integrated study of neurology and psychology.

**orientation (of a rock art panel)** The position of a panel relative to a vertical or horizontal plane.

**parietal art** Literally "wall art," another term for rock art.

**Paleolithic** The Stone Age epoch in Old World prehistory, commonly divided into Lower (Early), Middle, and Upper (Later) periods. The last is pertinent to rock art research, and it is generally set at about 40,000 to 10,000 YBP, depending upon region.

**panel (rock art panel)** A natural rock cleavage plain or weathering surface. Rock art is often recorded on a panel-by-panel basis.

**petroglyph** An engraved, incised, pecked, carved or scratched rock art motif.

**pictograph** A painted or drawn rock art motif.

**proxemics** The study of the personal use of space or, in rock art research, the physical constraints on viewing the art and what this implies about the individuals or groups who may have visited sites and the rituals they may have conducted.

**quadruped**  A four-legged animal motif, employed generically or when the intended species in unidentifiable; for example, when a motif may portray an antler-less deer or antelope.

**radiocarbon dating**  A chronometric technique used for organic (carbon-containing) substances.  It is based on the fact that the decay rate of the radioactive component of carbon (14-C) over time is known, relatively constant, and can be measured.  Radiocarbon ages are statistical estimates of the time since the death of the organism whose remnant organic carbon is being analyzed.

**relative dating**  A chronological ordering (e.g., from youngest to oldest) of specific sites, motifs, or styles, or the assignment of a motif or artifact to a general time period, but not a specific calendrical date.

**representative**  See naturalistic.

**rock art**  Images placed on natural landscape surfaces, including cliff and boulder faces, cave walls and ceilings, and the groundsurface.  These images may be painted, drawn, engraved, incised, scratched, pecked, carved, or created with alignments of cobbles.

**rock carving**  Scandinavian term for petroglyph or rock engraving.

**rock engraving**  A petroglyph.  In some cases this term is used generically for all petroglyphs; sometimes the term is used to distinguish pecked petroglyphs from incised or scratched motifs.

**rock painting**  A pictograph or rock drawing.

**rock varnish**  A biogeochemical coating that develops over time on rock surfaces in arid regions and typically causes them to darken with age; also sometimes called "desert varnish" or (incorrectly) "patina."  Rock varnish is derived from clay-sized particles of windblown dust.

**San**  The Bushmen peoples who once occupied all of southern Africa and are now restricted to the Kalahari and Namib deserts of Botswana and Namibia.

**scientific method**  A formal approach to selecting one hypothesis over others.

**SEM**  Scanning electron microscopy; a technique of microscopic examination that enables analysis at the scale of microns and that can be combined with chemical analyses.

**semiotics**  The study of linguistic and cultural signs.

**seriation**  The relative chronological ordering of sites, styles, motifs, or types.

**shaman**  A religious functionary believed to have direct access to the supernatural world and its gods and spirits, achieved through an altered state of consciousness or trance; also sometimes called medicine man/woman/doctor or man of power.  Priests talk to the gods, as the anthropological saying goes, whereas the gods talk to shamans.

**shamanism**  A religious system that emphasizes direct personal interactions with the supernatural, achieved through trance or visionary experiences, and that often includes a multi-tiered cosmological structure with the earth as the middle

tier. Shamanism is commonly but not exclusively associated with hunter-gatherer cultures.

**shamanistic tradition**  Rock art traditions where the right to make art is based on individual ownership of motifs obtained through spiritual communication.

**significance**  A legally defined concept in cultural resource management law in many countries and states, establishing the importance of a specific site, and thereby implying certain legal obligations or guidelines for management or treatment. Generally, those sites that are worthy of management are those that meet certain criteria that establish their significance. Though the criteria for significance vary, in general terms they include research value, aesthetic appeal, sacredness, historical importance, uniqueness, representativeness, and the like.

**site management**  Commonly, along with a conservation rationale, the control of human access to and use of sites, such as regulating visitation; related to but not identical with conservation.

**structuralism**  A theory about the functioning of the human mind, claiming that the mind organizes concepts in terms of binary oppositions, such as good:bad or male: emale.

**style**  A characteristic form or mode of expression. As commonly used in rock art research, style is taken to signify a cultural-historical classification implying a specific prehistoric ethnolinguistic group and time period, equivalent to the general archaeological concept of the prehistoric "culture." In practice, many so-called rock art styles are identified solely or primarily on aesthetic and formal grounds, and have little or no proven equivalence to prehistoric "cultures."

**substrate**  The natural rock surface or support upon which rock art is created, e.g., cave walls or ceiling, cliff face, or boulder surface.

**superimposition/superposition**  One rock art motif placed over another; commonly used to infer relative age or establish relative chronology. However, superimpositions may also result for ritual/symbolic reasons rather than chronological distinctions alone.

**therianthrope**  A combination being, usually a conflation of a human and an animal.

**totemic traditions**  Rock art traditions where the right to make art is based on membership in a particular social group, such as a clan.

**varnish microlamination (VML) dating**  A chronometric technique that yields correlated ages for rock varnished petroglyphs. It is based on the fact that regional environmental changes result in changes in the micromorphology of rock varnish. These changes are visible microscopically and, when calibrated using varnished geological surfaces of known age, provide age control.

**zoomorph**  An animal-like motif or image, often used when the species of the image is unidentifiable.

# REFERENCES

Anati, Emmanuel
1961   *Camonica Valley.* Knopf, New York.
1994   *Valcamonica Rock Art: A New History for Europe.* Edizioni del Centro, Capo di Ponte.
Applegate, Richard B.
1978   *?Atishwin: The Dream-Helper in South-Central California.* Ballena Press, Socorro, New Mexico.
Aujoulat, Norbert
1993a   L'évolution des techniques. In *L'Art Pariétal Paléolithique: Techniques et methodes d'étude,* edited by GRAPP (Groupe de Reflexion sur L'Art Pariétal Paléolithique), pp. 317–329. Ministère de L'Enseignement Supérieur et de la Recherche, Comité des travaux historiques et scientifiques, Documents Préhistoriques 5, Paris.
1993b   L'outil photographique. In *L'Art Pariétal Paléolithique: Techniques et methodes d'étude,* edited by GRAPP, pp. 347–354. Ministère de L'Enseignement Supérieur et de la Recherche, Comité des travaux historiques et scientifiques, Documents Préhistoriques 5, Paris.
2004   *Lascaux: Le Geste, L'Espace et le Temps.* Éditions du Seuil, Paris.
Bard, James, and Colin Busby
1974   The manufacture of a petroglyph: A replicative experiment. *University of California Archaeological Research Facility Contributions* 20:83–102.
Barnett, T., A. Chalmers, M. Diaz-Andreu, P. Longhurst, G. Ellis, K. Sharpe, and I. Trinks
2005   3D laser scanning for recording and monitoring rock art erosion. *International Newsletter on Rock Art (INORA)* 41:25–29.

Barton, C. M., G. A. Clark, and A. Cohen
1994   Art as information: Explaining Upper Palaeolithic art in western Europe.
       *World Archaeology* 26:185–206.
Bégouën, Henri, and Henri Breuil
1958   *Les Cavernes du Volp: Trois Frères—Tuc d-Audoubert, a Montesquieu-Avantès
       (Ariège).* Arts et Metiers Graphique, Paris.
Bégouën, Robert, and Jean Clottes
1981   Des ex-votos magdaléniens? *La Recherche* 132:51–54.
1987   Art mobilier et art pariétal dans les cavernes du Volp. In *L'art des Ob-
       jets au Paléolithique, Tome 1: L'art mobilier et son contexte*, edited by Jean
       Clottes, pp. 157–172. Picard, Paris.
Beltran, Antonio
1982   *Rock Art of the Spanish Levant.* Cambridge University Press, Cambridge.
Bender, Barbara
1992   Theorising landscapes, and the prehistoric landscapes of Stonehenge.
       *Man* (n.s.) 27:735–755.
Betts, Alison V. G.
2001   The Middle East. In *Handbook of Rock Art Research*, edited by D. S. Whit-
       ley, pp. 786–824. AltaMira Press, Walnut Creek, California.
Bierman, P., and A. Gillespie
1991   Accuracy of rock varnish chemical analyses: Implications for CR dating.
       *Geology* 19:196–199.
Binford, Lewis R.
1983   *In Pursuit of the Past: Decoding the Archaeological Record.* Thames and
       Hudson, London.
Blackburn, Thomas
1977   Biopsychological aspects of Chumash rock art. *Journal of California An-
       thropology* 4:88–94.
Bostwick, Todd W.
2002   *Landscape of the Spirits: Hohokam Rock Art at South Mountain Park.* The
       University of Arizona Press, Tucson.
Boyd, Carolyn E.
2003   *Rock Art of the Lower Pecos.* Texas A&M University Press, College Station,
       Texas.
Bradley, R.
1989   Deaths and entrances: A contextual analysis of Megalithic art. *Current
       Anthropology* 30:68–75.
1997   *Rock Art and the Prehistory of Atlantic Europe: Signing the Land.* Routledge,
       London.
2001   The Authority of Abstraction: Knowledge and Power in the Landscape of
       Prehistoric Europe. In *Theoretical Perspectives in Rock Art Research*, edited
       by K. Helskog, pp. 227–241. Novus forlag, Oslo.

Breuil, Abbé H.

1952    *Four Hundred Centuries of Cave Art.* Translated by M. A. Boyle. Centre
        d'Études et de Documentation Préhistorique, Montignac.

Brooks, C. R., W. M. Clements, J. A. Kantner and G. Y. Poirier

1979    *A Land Use History of Coso Hot Springs, Inyo County, California.* NWC Ad-
        ministrative Publication 200, China Lake Naval Air Weapons Station,
        Ridgecrest, California.

Bull, William B.

1991    *Geomorphic Responses to Climatic Change.* Oxford University Press, Ox-
        ford.

Busby, C., R. Fleming, R. Hayes and K. Nissen

1978    The Manufacture of Petroglyphs: Additional Replicative Studies. In *Four
        Rock Art Studies,* edited by C. W. Clewlow, Jr., pp. 89–108. Ballena Press,
        Socorro, New Mexico.

Cerling, T. E., and H. Craig

1994    Geomorphology and in situ cosmogenic isotopes. *Annual Review of Earth
        and Planetary Sciences* 22:273–317.

Chaffee, S. D., M. Hyman, and M. W. Rowe

1994    Radiocarbon Dating of Rock Paintings. In *New Light on Old Art: Recent
        Advances in Hunter-Gatherer Rock Art,* edited by D. S. Whitley and L. L.
        Loendorf, pp. 9–12. Monograph 36, Institute of Archaeology, University
        of California Los Angeles.

Chalfant, W. A.

1933    *The Story of Inyo.* Bishop, privately printed.

Chippindale, Christopher

2001a   Studying Ancient Pictures as Pictures. In *Handbook of Rock Art Research,*
        edited by David S. Whitley, pp. 247–272. AltaMira Press, Walnut Creek,
        California.

2001b   Theory and Meaning of Prehistoric European Rock Art: "Informed Meth-
        ods," "Formal Methods" and Questions of Uniformitarianism. In *Theo-
        retical Perspectives in Rock Art* Research, edited by Knut Helskog,
        pp. 130–157. Novus forlag, Oslo.

Chippindale, Christopher, and Paul S.C. Taçon

1998    The Many Ways of Dating Arnhem Land Rock Art, North Australia. In
        *The Archaeology of Rock Art,* edited by C. Chippindale and P. S. C. Taçon,
        pp. 90–111. Cambridge University Press, Cambridge.

Chippindale, Christopher, and George Nash

2004    Pictures in Place: Approaches to the Figured Landscapes of Rock Art.
        In *The Figured Landscapes of Rock Art: Looking at Pictures in Place,* edited
        by C. Chippindale and G. Nash, pp. 1–36. Cambridge University Press,
        Cambridge.

Chippindale, Christopher, Benjamin Smith and Paul S.C. Taçon
2000    Visions of dynamic power: Archaic rock-paintings, altered states
        of consciousness and "Clever Men" in Western Arnhem Land (NT),
        Australia. *Cambridge Archaeological Journal* 10(1):63–101.
Clottes, Jean
1993a   Contexte archéologique externe. In *L'Art Pariétal Paléolithique:
        Techniques et methodes d'étude,* edited by GRAPP, pp. 317–329. Ministère
        de L'Enseignement Supérieur et de la Recherche, Comité des travaux his-
        toriques et scientifiques,
        Documents Préhistoriques 5, Paris.
1993b   Paint analyses from several Magdalenian caves in the Ariège region of
        France. *Journal of Archaeological Science* 20:223–35.
1994    Who Painted What in Upper Palaeolithic European Caves. In *New Light
        on Old Art: Recent Advances in Hunter-Gatherer Rock Art Research,* edited
        by D. S. Whitley and L. L. Loendorf, pp. 1–8. Monograph 36, Institute
        of Archaeology, University of California, Los Angeles.
1995    *Les Cavernes de Niaux: Art Préhistorique en Ariège.* Éditions du Seuil, Paris.
1997a   *Rock Art: A Universal Cultural Image.* UNESCO/ICOMOC, Verhiles,
        France.
1997b   Art of the Light and Art of the Depths. In *Beyond Art: Pleistocene Image
        and Symbol,* edited by M. W. Conkey, O. Soffer, D. Stratmann, and N. G.
        Jablonski, pp. 203–216. Memoirs of the California Academy of Sciences,
        Number 23.
1998    The "Three Cs": Fresh Avenues Towards European Palaeolithic Art. In
        *The Archaeology of Rock Art,* edited by C. Chippindale and P. S. C. Taçon,
        pp. 112–129. Cambridge University Press, Cambridge.
2003    (editor) *Chauvet Cave: the Art of Earliest Times.* University of Utah Press,
        Salt Lake City.
Clottes, J., J. M. Chauvet, E. Brunel-Deschamps, C. Hillaire, J. P. Daugas,
        M. Arnold, H. Cachier, J. Évin, P. Fortin, C. Oberlin, N. Tisnérat, and
        H. Valladas
1995a   Radiocarbon Dates for the Chauvet-Pont-d'Arc Cave. *International News-
        letter on Rock Art (INORA)* 11:1–2.
1995b   Les Peintures paléolithiques de la Grotte Chauvet-Pont d'Arc, à Val-
        lon-Pont d'Arc (Ardèche, France): Datations Directes et Indirectes par la
        Méthode du Radiocarbone. *Comptes Rendus de l'Academie des Science Paris*
        320:1133–1140.
Clottes, Jean, Jean Courtin, and Luc Vanrell
2005    *Cosquer Redécouvert.* Éditions du Seuil, Paris.
Clottes, J., and J. D. Lewis-Williams
1998    *The Shamans of Prehistory: Trance and Magic in the Painted Caves.* Harry N.
        Abrams, New York.

Clouse, Robert
2000    Sustainability: Towards a comprehensive management plan for rock art
        sites. *1999 International Rock Art Congress Proceedings*, 1:39–46.
Cole, Sally J.
1990    *Legacy on Stone: Rock Art of the Colorado Plateau and Four Corners Region.*
        Johnson Books, Boulder, Colorado.
Colman, S. M., K. L. Pierce, and P. W. Birkeland
1987    Suggested terminology for quaternary dating methods. *Quaternary
        Research* 28:314–19.
Conkey, Margaret W.
1980    The identification of prehistoric hunter-gatherer aggregation sites: The
        case of Altamira. *Current Anthropology* 21:609–620.
1989    The Structural Analysis of Palaeolithic Art. In *Archaeological Thought in
        America*, edited by C. C. Lamberg-Karlovsky, pp. 135–154. Cambridge
        University Press, Cambridge.
1992    L'Approche Structurelle de l'Art Paléolithique et l'Héritage d'André Leroi-
        Gourhan. *Les Nouvelles de l'Archéologie* 48/49:41–45.
1997    Making a mark: Rock art research. *American Anthropologist* 99:168–172.
2001    Structural and Semiotic Approaches. In *Handbook of Rock Art Research*,
        edited by D. S. Whitley, pp: 273–310. AltaMira Press, Walnut Creek,
        California.
Conway, Thor, and Julie Conway
1990    *Spirits on Stone: The Agawa Petroglyphs*. Heritage Discoveries, San Luis
        Obispo.
Couraud, C., and A. Laming-Emperaire
1979    Les Colorants. *Lascaux Inconnu*. XII [Supplément à Gallia Préhistoire]
        pp. 153–69.
Cremaschi, M.
1996    The desert varnish in the Messak Sattafet (Fezzan, Libryan Sahara),
        Age, archaeological context and paleo-environmental implication.
        *Geoarchaeology* 11:393–421.
David, Bruno
2002    *Landscapes, Rock Art and the Dreaming: An Archaeology of Pre-
        understanding*. Leicester University Press, London.
David, Bruno, E. Clayton, and A. Watchman
1993    Initial results of PIXE analysis on northern Australian ochres. *Australian
        Archaeology* 36:50–57.
David, Bruno and Harry Lourandos
1998    Rock art and socio-demography in northeastern Australian prehistory.
        *World Archaeology* 30:193–219.
David, Bruno, Ian McNiven, Val Attenbrow, Josephine Flood, and Jackie Collins
1994    Of lightning brothers and white cockatoos: Dating the antiquity of signi-
        fying systems in the Northern Territory, Australia. *Antiquity* 68:241–251.

David, Bruno, Henry Walt, Harry Lourandos, Marvin Rowe, John Brayer, and
    Claudio Tuniz
 1997    Ordering the rock paintings of the Mitchell-Palmer limestone zone (Aus-
         tralia) for AMS Dating. *The Artefact* 20:57–72.
David, Bruno, and Meredith Wilson, editors
 2002    *Inscribed Landscapes: Marking and Making Place.* University of Hawai'i
         Press, Honolulu.
Deacon, Jeanette
 1994    *Some Views of the Rock Paintings in the Cedarberg.* National Monuments
         Council, Cape Town.
Devereux, Paul
 2001    *Stone Age Soundtracks: The Acoustic Archaeology of Ancient Sites.* Vega,
         London.
Devereux, Paul, and R. G. Jahn
 1996    Preliminary investigations and cognitive considerations of the acoustical
         resonances of selected archaeological sites. *Antiquity* 70(269):665–666.
Dewdney, Selwyn
 1970    *Dating Rock Art in the Canadian Shield Region.* Royal Ontario Museum,
         Art and Archaeology Occasional Paper 24. University of Toronto Press,
         Toronto, Ontario.
Diaz-Andreu, Margarita
 1998    Iberian post-palaeolithic art and gender: Discussing human representa-
         tions in Levantine art. *Journal of Iberian Archaeology* 0:33–52.
 2002    Marking the Landscape: Iberian Post-Paleolithic Art, Identities, and the
         Sacred. In *European Landscapes of Rock Art*, edited by G. Nash and
         C. Chippindale, pp. 158–175. Routledge, London.
Dorn, Ronald I.
 1983    Cation-ratio dating: A new rock varnish age-determination technique.
         *Quaternary Research* 20:49–73.
 1989    Cation-ratio dating of rock varnish: A geographical perspective.
         *Progress in Physical Geography* 13:559–596.
 1990    Quaternary alkalinity fluctuations recorded in rock varnish microlami-
         nations on western U.S.A. volcanics. *Palaeogeography, Palaeoclimatology,
         Palaeoecology* 76:291–310.
 1994    Dating Petroglyphs with a 3-Tier Rock Varnish Approach. In *New Light
         on Old Art: Advances in Hunterer-Gatherer Rock Art Research*, edited by
         D. S. Whitley and L. L. Loendorf, pp. 2–36. UCLA Institute for Archae-
         ology Monograph Series No. 36. University of California, Los Angeles.
 1995    A change of perception. *La Pintura* 23(2):10–11.
 1997    Constraining the age of the Côa Valley (Portugal) engravings with
         radiocarbon dating. *Antiquity* 71:105–115.
 1998a   *Rock Coatings.* Elsevier, Amsterdam.

1998b    Response. *Science* 280:2136–2139.

2001    Chronometric Techniques: Engravings. In *Handbook of Rock Art Research*, edited by D. S. Whitley, pp. 167–189. AltaMira Press, Walnut Creek, California.

Dorn, R. I., A. J. T. Jull, D. J. Donahue, T. W. Linick, and L. J. Toolin

1989    Accelerator mass spectrometry radiocarbon dating of rock varnish. *Geological Society of America Bulletin* 101:1363–1372.

Dorn, Ronald I., and Lawrence L. Loendorf

1992    Assessing Distortion of Radiocarbon Ages of Rock Coatings by Non-Contemporaneous Material. Proposal No. BNS-9204711, submitted to Archaeometry Program, NSF.

Dorn, Ronald I., and David S. Whitley

1983    Cation-ratio dating of petroglyphs from the western United States, North America. *Nature* 302:816–818.

1984    Chronometric and relative age determination of petroglyphs in the western United States. *Annals of the Association of American Geographers* 74:308–322.

Downs, James F.

1961    Washo religion. *University of California Anthropological Records* 16(9):365–385. University of California, Berkeley.

Dowson, Thomas A.

1988    Revelations of religious reality: The individual in San rock art. *World Archaeology* 20:116–128.

2001    Queer Theory and Feminist Theory: Towards a Sociology of Sexual Politics in Rock Art. In *Theoretical Perspectives in Rock Art* Research, edited by Knut Helskog, pp. 312–329. Novus forlag, Oslo.

Dragovich, D.

1998    Microchemistry and relative chronology of small desert varnish samples, western New South Wales, Australia. *Earth Surface Processes and Landforms* 22:445–453.

Driver, Harold E.

1937    Cultural element distributions: VI, southern Sierra Nevada. *University of California Anthropological Records* 1(2):53–154. University of California, Berkeley.

Dronfield, Jeremy

1993    Ways of Seeing, Ways of Telling: Irish Passage Tomb Art, Style and the Universality of Vision. In *Rock Art Studies: The Post-Stylistic Era, or Where Do We Go From Here?*, edited by M. Lorblanchet and P. G. Bahn, pp. 179–193. Monograph 35. Oxbow Books, Oxford.

1995    Subjective vision and the source of Irish megalithic art. *Antiquity* 69: 539–549.

1996    Entering alternative realities: Cognition, art, and architecture in Irish passage-tombs. *Cambridge Archaeological Journal* 6:37–72.

Erlandson, Jon M., J. D. Robertson, and C. Descantes
1999    Geochemical analysis of eight red ochres from western North America. *American Antiquity* 64:517–526.
Faris, Peter
1995    Petroglyph chronology in southeast Colorado. *Southwestern Lore* 61:7–35.
Féruglio, Valérie
1993    La gravure. In *L'Art Pariétal Paléolithique: Techniques et methodes d'étude,* edited by GRAPP, pp. 265–274. Ministère de L'Enseignement Supérieur et de la Recherche, Comité des travaux historiques et scientifiques, Documents Préhistoriques 5, Paris.
2002    *Decloisonner les méthodologies de l'art pariétal et rupestre. Questions pour un devenier de la discipline: techniciens ou théoriciens?* Master's thesis, D. E. A. de Préhistoire, Université de Paris I, Paris.
Fleisher, M., T. Liu, W. E. Broecker, and W. Moore
1999    A clue to the origin of rock varnish. *Geophysical Research Letters* 26:103–106.
Ford, B., I. D. MacLeod, and P. Haydock
1994    Rock art pigments from Kimberley region of western Australia: Identification of the minerals and conversion mechanisms. *Studies in Conservation* 39:57–69.
Fossati, Angelo, L. Jaffé, and M. Saomes d'Abreu
1989    *Etched in Time: The Petroglyphs of Val Camonica.* Valcamonica Preistorica 3, Ceto, Italy.
Fourmile, H.
1996    The Politics of Managing Aboriginal Rock Imagery. In *Management of Rock Imagery,* edited by G. K. Ward and L. A. Ward, pp. 39–41. Occasional AURA Publication 9, Melbourne.
Fowler, Catherine S., editor
1989    Willard Z. Park's Ethnographic Notes on the Northern Paiute of Western Nevada, 1933–1940. *University of Utah Anthropological Papers,* No. 114. University of Utah Press, Salt Lake City.
Fowler, Catherine S.
1992    *In the Shadow of Fox Peak: An Ethnography of the Cattail-Eater Northern Paiute People of Stillwater Marsh.* Cultural Resource Series Number 5, Stillwater National Wildlife Refuge, Fallon, Nevada.
Fowler, Catherine S., and Don D. Fowler, editors
1971    Anthropology of the Numa: John Wesley Powell's Manuscript on the Numic Peoples of Western North America. *Smithsonian Contributions to Anthropology* 14. Smithsonian Institution, Washington, D.C.
Fowler, Catherine S., Molly Dufort, and Mary K. Rusco
1995    *Timbisha Shoshone Tribe's Land Acquisition Program: Anthropological Data on Twelve Study Areas.* Report submitted to the Timbisha Shoshone Tribe, Death Valley, California.

Francis, Julie E.
2001    Style and Classification. In *Handbook of Rock Art Research*, edited by
        D. S. Whitley, pp. 221–246. AltaMira Press, Walnut Creek, California.
Francis, Julie E., and Lawrence L. Loendorf
2002    *Ancient Visions: Petroglyphs and Pictographs from the Wind River and
        Bighorn Country, Wyoming and Montana.* University of Utah Press,
        Salt Lake City.
Franklin, Robert, and Pamela Bunte
1994    When Sacred Land Is Sacred to Three Tribes: San Juan Paiute Sacred
        Sites and the Hopi-Navajo-Paiute Suit to Partition the Arizona Navajo
        Reservation. In *Sacred Sites, Sacred Places*, edited by D. L. Carmichael,
        J. Hubert, B. Reeves and A. Schanche, pp. 245–258. Routledge, London.
Freer, Steven
2001    The handprints at CA-RIV-114: A forensic and anthropometric study.
        *American Indian Rock Art* 27:319–332.
Freidel, David, Linda Schele and Joy Parker
1993    *Maya Cosmos: Three Thousand Years on the Shaman's Path.* Morrow,
        New York.
Gale, F., and J. Jacobs
1986    Identifying high-risk visitors at aboriginal art sites in Australia.
        *Rock Art Research* 3(1):3–19.
Garlake, Peter
1995    *The Hunters' Vision.* British Museum Press, London.
Gayton, Anna H.
1930    Yokuts-Mono chiefs and shamans. *University of California Publications in
        American Archaeology and Ethnology* 24:361–420. University of California,
        Berkeley.
1948    Yokuts and western Mono ethnography. *University of California
        Anthropological Records* 10:1–290. University of California, Berkeley.
Geertz, Clifford
1973    *The Interpretation of Cultures.* Basic Books, New York.
Glazovskiy, A. F.
1985    Rock varnish in the glacierized regions of the Pamirs (in Russian).
        *Data of the Glaciological Studies (Moscow)* 54:136–141.
Geneste, Jean-Michel, T. Horde and C. Tanet
2004    *Lascaux: A Work of Memory.* Éditions Fanlac, Periguex.
Gould, Richard A.
1969    *Yiwara: Foragers of the Australian Desert.* Scribner's, New York.
Grant, Campbell
1968    *Rock Drawings of the Coso Range.* Maturango Museum Publication 4.
        Maturango Museum, China Lake, California.

GRAPP (Groupe de Refléxion sur L'Art Pariétal Paléolithique), editors
1993    L'Art Pariétal Paléolithique: Techniques et méthodes d'étude. Ministère de L'Enseignement Supérieur et de la Recherche, Comité des travaux historiques et scientifiques, Documents Préhistoriques 5, Paris.

Hameau, P., M. Menu, M-P. Pomies, and P. Walter
1995    Les peintures schématiques postglaciaires du sud-est de la France: Analyses pigmentaires. Bulletin de la Société Préhistorique Française 92: 353–362.

Hann, Don, James D. Keyser, and Phillip E. Cash Cash
in press  Columbia Plateau Rock Art: A Window to the Spirit World. In Ethnography and North American Rock Art, edited by D. S. Whitley. AltaMira Press, Walnut Creek, California.

Harrington, Mark R.
1950    "Little Devil So High." The Masterkey 24(5):170.

Hartley, Ralph J.
1992    Rock Art on the Northern Colorado Plateau. Aldershot, Avebury.

Hartley, R. J., and A. W. Vawser
1998    Spatial Behaviour and Learning in the Prehistoric Environment of the Colorado River Drainage (South-Eastern Utah), Western North America. In The Archaeology of Rock Art, edited by C. Chippindale and P. S. C. Taçon, pp. 185–211. Cambridge University Press, Cambridge.

Hayden, Brian, and Suzanne Villeneuve
2005    Review of Lascaux, Le Geste, L'Espace, et Le Temps, by N. Aujoulat, and Chauvet Cave: The Art of Earliest Times, edited by J. Clottes. American Antiquity 70:384–388.

Hays-Gilpin, Kelley
2004    Ambiguous Images: Gender and Rock Art. AltaMira Press, Walnut Creek, California.

Hedges, Ken
1982    Great Basin rock art styles: A revisionist view. American Indian Rock Art 7–8:205–211.

Heizer, Robert F., and Martin A. Baumhoff
1962    Prehistoric Rock Art of Nevada and Eastern California. University of California, Berkeley.

Helskog, Knut
1996    The Rock Carvings in Hjemmeuft/Jiepmaluotka. Alta Museum, Alta, Norway.
1999    The shore connection: Cognitive landscape and communication with rock carvings in northernmost Europe. Norwegian Archaeological Review 32(2):73–94.
2004    Landscapes in Rock Art: Rock Carving and Ritual in the Old European North. In The Figured Landscapes of Rock Art: Looking at Pictures in Place, edited by C. Chippindale and G. Nash, pp. 265–288. Cambridge University Press, Cambridge.

Hobson, J. Allan
  1994   *The Chemistry of Conscious States: Toward a Unified Model of the Brain and the Mind.* Little, Brown, Boston.
Hollman, Jeremy
  2002   Natural models, ethology and San rock paintings: Pilo-erection and depictions of bristles in south-eastern South Africa. *South African Journal of Science* 98:563–567.
Huffman, Thomas N.
  1986   Cognitive studies of the Iron age in Africa. *World Archaeology* 18:84–95.
Hultkrantz, Åke
  1987   *Native Religions of North America: The Power of Visions and Fertility.* Harper & Row, San Francisco.
Hyman, M., S. Turpin, and M. Zolensky
  1996   Pigment analyses from Panther Cave, Texas. *Rock Art Research* 13:93–103.
Hymes, Dell
  1972   Models of the Interaction of Language and Social Life. In *Directions in Sociolinguistics: The Ethnography of Communication*, edited by J. J. Gumperz and D. Hymes, pp. 35–71. Holt Rinehart and Winston, New York.
Irwin, Charles (editor)
  1980   *The Shoshoni Indians of Inyo County, California: The Kerr Manuscript.* Ballena Press Publications in Archaeology, Ethnology and History No. 15. Ballena Press, Socorro, New Mexico.
Jones, C. E.
  1991   Characteristics and origin of rock varnish from the hyperarid coastal deserts of northern Peru. *Quaternary Research* 35:116–129.
Kelley, Jane H., and Marsha P. Hanen
  1988   *Archaeology and the Methodology of Science.* University of New Mexico Press, Albuquerque.
Kelly, Isabel T.
  1932   Ethnography of the Surprise Valley Paiutes. *University of California Publications in American Archaeology and Ethnology* 31(3):67–210. University of California, Berkeley.
Keyser, James D.
  1987   A lexicon for historic Plains Indian rock art: Increasing interpretive potential. *Plains Anthropologist* 32:43–71.
  1992   *Indian Rock Art of the Columbia Plateau.* University of Washington Press, Seattle.
  2001   Relative Dating Methods. In *Handbook of Rock Art Research*, edited by D. S. Whitley, pp. 116–138. AltaMira Press, Walnut Creek, California.
  2004   *Art of the Warrior: Rock Art of the American Plains.* University of Utah Press, Salt Lake City.

Keyser, James D., and Michael A. Klassen
2001   Plains Indian Rock Art. University of Washington Press, Seattle.
Keyser, James D., and George Poetschat
2004   The Canvas as the Art: Landscape Analysis of a Rock Art Panel. In The Figured Landscapes of Rock Art: Looking at Pictures in Place, edited by C. Chippindale and G. Nash, pp. 118–130. Cambridge University Press, Cambridge.
2005   Warrior Art of Wyoming's Green River Basin: Biographic Petroglyphs Along the Seedskadee. Oregon Archaeological Society Publication 15. Oregon Archaeological Society, Portland, Oregon.
Keyser, James D., and G. Rabiega
1999   Petroglyph manufacture by indirect percussion: The potential occurrence of tools and debitage in datable contexts. Journal of California and Great Basin Anthropology 21:124–136.
Keyser, James D., and David S. Whitley
2000   A new ethnographic reference for Columbia Plateau rock art: Documenting a century of vision quest practices. International Newsletter on Rock Art (INORA) 25:14–20.
Khalil, Carol L.
1979   Dating of Mimbres Valley Rock Art by Comparative Methods. M.A. Thesis, Archaeology Program, University of California, Los Angeles.
King, Jr., Thomas J.
1978   A Petroglyph Assemblage from Cerrito de Cascabeles. In Seven Rock Art Sites in Baja California, edited by C. W. Meighan and V. L. Pontoni, pp. 124–177. Ballena Press, Socorro, New Mexico.
Klassen, Michael A.
1998   Icon and Narrative in Contact Transition Rock Art at Writing-on-Stone, Aouthern Alberta, Canada. In The Archaeology of Rock Art, edited by C. Chippindale and P. S. C. Taçon, pp. 42–72. Cambridge University Press, Cambridge.
Koski, R. A., E. H. McKee, and D. H. Thomas
1973   Pigment composition of prehistoric pictographs of Gatecliff Shelter, central Nevada. American Museum Novitiates 2521:1–9.
Kurz, M. D., and E. J. Brook
1994   Surface Exposure Dating with Cosmogenic Nuclides. In Dating in Exposed and Surface Contexts, edited by C. Beck, pp. 139–159. University of New Mexico Press, Albuquerque.
La Barre, Weston
1980   Culture in Context. Duke University Press, Durham, North Carolina.
Laird, Carobeth
1976   The Chemehuevis. Malki Museum, Banning, California.
1984   Mirror and Pattern: George Laird's World of Chemehuevi Mythology. Malki Museum, Banning, California.

Lakoff, George, and Mark Johnson
1999    *Philosophy in the Flesh: The Embodied Mind and Its Challenge to Western Thought.* Basic Books, New York.

Laming-Emperaire, A.
1962    *La signification de l'art rupestre paléolithique.* Picard, Paris.
1970    Système de penser et organisation sociale dans l'art rupestre paléolithique. *L'Homme de Cro-Magnon,* pp. 197–211. Arts et Metiers Graphiques, Paris.

Latta, Frank
1977    *Handbook of the Yokuts Indians,* 2nd ed. Bear State Books, Santa Cruz.

Layton, Robert
1991    *The Anthropology of Art,* 2nd ed. Cambridge University Press, Cambridge.
1992    *Australian Rock Art: A New Synthesis.* Cambridge University Press, Cambridge.
2000    Shamanism, totemism, and rock art: *Les Chamanes de la prehistoire* in the context of rock art research. *Cambridge Archaeological Journal* 10:169–186.
2001    Ethnographic study and symbolic analysis. In *Handbook of Rock Art Research,* edited by D. S. Whitley, pp. 311–332. AltaMira Press, Walnut Creek, California.

Lee, Georgia, and E. Stasack
1999    *Spirit of Place: Petroglyphs of Hawaii.* Easter Island Foundation, Los Osos, California.

Lenssen-Erz, T.
1989    The Conceptual Framework for the Analysis of the Brandberg Rock Paintings. In *The Rock Paintings of the Upper Brandberg. Part I, Amis Gorge,* edited by H. Pager, pp. 361–370. Heinrich Barth Institute, Cologne, Germany.
1994a   Jumping About: Springbok in the Brandberg Rock Paintings and in the Bleek and Lloyd Collection. An Attempt at a Correlation. In *Contested Images: Diversity in Southern African Rock Art Research,* edited by T. A. Dowson and J. D. Lewis-Williams, pp. 275–292. Witwatersrand University Press, Johannesburg.
1994b   The rock paintings of the Brandberg, Namibia, and a concept of textualization for purposes of data processing. *Semiotica* 100(2/4):169–200.

Leroi-Gourhan, André
1958    Répartition et groupement des animaux dans l'art pariétal paléolithique. *Bulletin de la Société Préhistorique Française* 55:515–527.
1965    *Préhistoire de l'Art Occidental.* Lucien Mazenod, Paris.
1967    *Treasures of Prehistoric Art.* Harry N. Abrams, New York.

Lévi-Strauss, Claude
1963    *Structural Anthropology.* Basic Books, New York.

Lewis-Williams, J. David
1972 The syntax and function of the Giant's Castle rock paintings. *South African Archaeological Bulletin* 27:49–65.
1974 Superpositioning in a sample of rock paintings in the Barkly East District. *South African Archaeological Bulletin* 29:93–103.
1981 *Believing and Seeing: Symbolic Meanings in Southern San Rock Paintings.* Academic Press, London.
1983 Science and rock art: Introductory essay. *South African Archaeological Bulletin,* Goodwin Series 4:3–13.
1984 Ideological Continuities in Prehistoric Southern Africa: The Evidence of Rock Art. In *Past and Present in Hunter–Gatherer Studies,* edited by C. Schrire, pp. 225–252. Academic Press, New York.
1986 The last testament of the southern San. *South African Archaeological Bulletin* 41(143):10–11.
1990 Documentation, analysis, and interpretation: Dilemmas in rock art research. A review of *The Rock Paintings of the Upper Brandberg. Part I: Amis Gorge,* edited by H. Pager (1989). *South African Archaeological Bulletin* 45:126–136.
1991 Wrestling with analogy: A methodological dilemma in Upper Palaeolithic art research. *Proceedings of the Prehistoric Society* 57(1):149–162.
1995 ACRA: A Retrospect. In *Perceiving Rock Art: Social and Political Perspectives,* edited by K. Helskog and B. Olsen, pp. 409–415. Novus forlag, Oslo.
2001 Brainstorming Images: Neuropsychology and Rock Art Research. In *Handbook of Rock Art Research,* edited by D. S. Whitley, pp. 332–360. AltaMira Press, Walnut Creek, California.
2002 *The Mind in the Cave: Consciousness and the Origins of Art.* Thames and Hudson, London.
2003 *A Cosmos in Stone: Interpreting Religion and Society Through Rock Art.* AltaMira Press, Walnut Creek, California.
Lewis-Williams, J. David, and Geoffrey Blundell
1998 *Fragile Heritage: A Rock Art Fieldguide.* Witwatersrand University Press, Johannesburg.
Lewis-Williams, J. David, and Thomas A. Dowson
1988 Signs of all times: Entoptic phenomena in Upper Palaeolithic art. *Current Anthropology* 29:201–245.
1989 *Images of Power.* Southern Book Publishers, Johannesburg.
1990 Through the veil: San rock paintings and the rock face. *South African Archaeological Bulletin* 45:5–16.
Lewis-Williams, J. David, and Johannes H. N. Loubser
1986 Deceptive appearances: A critique of southern African rock art studies. *Advances in World Archaeology* 5:253–289. Academic Press, New York.

Lewis-Williams, J. David, and David G. Pearce
2004   San Spirituality: Roots, Expression, and Social Consequences. AltaMira Press, Walnut Creek, California.

Liu, Tanzhuo
1994   Visual Laminations in Rock Varnish: A New Paleoenvironmental and Geomorphic Tool in Drylands Research. Unpublished Ph.D. dissertation, Department of Geography, Arizona State University, Tempe.
2003   Blind testing of rock varnish microstratigraphy as a chronometric indicator: Results of late quaternary lava flows in the Mojave Desert, California. Geomorphology 53:209–234.

Liu, Tanhzuo, and Ronald I. Dorn
1996   Understanding spatial variability in environmental changes in drylands with rock varnish microlaminations. Annals of the Association of American Geographers 86:187–212.

Liu, Tanzhuo, and W. S. Broecker
1999   Rock varnish evidence for Holocene climate variations in the Great Basin of the western United States. GSA Abstracts with Program 31:418. Geological Society of America, Boulder, Colorado.
2000   How fast does rock varnish grow? Geology 28:183–186.

Liu, Tanzhuo., W. S. Broecker, J. W. Bell, and C. W. Mandeville
2000   Terminal Pleistocene wet event recorded in rock varnish from the Las Vegas Valley, southern Nevada. Paleogeography, Paleoclimatology, Paleoecology 161:423–433.

Liu, Tanzhuo, and David S. Whitley
2001   Collaborative Research on Dating Prehistoric Stone Artifacts in the Mojave Desert and the Lower Colorado River Region with Rock Varnish Microstratigraphy, Proposal No. BCS-0131399, submitted to Archaeology Program, NSF, Washington, D.C.

Loendorf, Lawrence L.
1991   Cation-ratio varnish dating and petroglyph chronology in southeastern Colorado. Antiquity 65:246–255.
1994   Traditional Archaeological Methods and Their Applications at Rock Art Sites. In New Light on Old Art: Recent Advances in Hunter-Gatherer Rock Art Research, edited by D. S. Whitley and L. L. Loendorf, pp. 95–104. Institute of Archaeology Monograph 36. University of California, Los Angeles.
2001   Rock Art Recording. In Handbook of Rock Art Research, edited by D. S. Whitley, pp. 55–79. AltaMira Press, Walnut Creek, California.
2004   Places of Power: The Placement of Dinwoody Petroglyphs across the Wyoming Landscape. In The Figured Landscapes of Rock Art: Looking at Pictures in Place, edited by C. Chippindale and G. Nash, pp. 201–216. Cambridge University Press, Cambridge.

Lorblanchet, Michel
1991    Spitting images: Replicating the spotted horses at Pech Merle. *Archaeology* 44:24–31.
1993a   Pochoir et soufflé. In *L'Art Pariétal Paléolithique: Techniques et methodes d'étude*, edited by GRAPP, pp. 257–260. Ministère de L'Enseignement Supérieur et de la Recherche, Comité des travaux historiques et scientifiques, Documents Préhistoriques 5, Paris.
1993b   Les conventions graphiques, In *L'Art Pariétal Paléolithique: Techniques et methodes d'étude*, edited by GRAPP, pp. 369–374. Ministère de L'Enseignement Supérieur et de la Recherche, Comité des travaux historiques et scientifiques, Documents Préhistoriques 5, Paris.
Loubser, Johannes (Jannie) H. N.
1993    A Guide to the Rock Paintings of Tandjesberg. *Navorsinge van die Nasionale Museum Bloemfontein* 9, Part 11. National Museum, Bloemfontein, South Africa.
1997    The use of Harris diagrams in recording, conserving, and interpreting rock paintings. *International Newsletter on Rock Art (INORA)* 18:14–21.
2001    Management Planning for Conservation. In *Handbook of Rock Art Research*, edited by David S. Whitley, pp. 80–115. AltaMira Press, Walnut Creek, Calfornia.
2002    *Tripping on the Snake, or On a Quest for Visions Forgotten: An Assessment of Selected Rock Art Sites in the Hell's Canyon National Recreation Area.* New South Associates Technical Report 963. New South Associates, Stone Mountain, Georgia.
2004    Mountains, Pools, and Dry Ones: The Discontinuity between Political Power and Religious Status Among Venda-speaking Chiefdoms of Southern Africa. Paper presented at the Society for American Archaeology meetings, Montreal, April 2004.
Loubser, Johannes H. N., and David S. Whitley
1999    *Recording Eight Places with Rock Imagery: Lava Beds National Monument, Northern California*, 3 volumes. Report on file, Lava Beds National Monument, Tulelake, California.
Lowie, Robert H.
1924    Notes on Shoshonean ethnography. *Anthropological Papers, American Museum of Natural History* 20:185–314. New York.
Loy, T. H., R. Jones, D. E. Nelson, B. Meehan, J. Vogel, J. Southon, and R. Cosgrove
1990    Accelerator radiocarbon dating of human blood proteins in pigments from Late Pleistocene art sites in Australia. *Antiquity* 64:110–116.
McFarland, J., and S. Horne
1997    The Beaten Path: Visitors and Visitation at Rock Art Sites in Los Padres National Forest, Santa Barbara, California. Paper presented at the American Rock Art Research Association meetings, La Junta, Colorado, May 1997.

McKee, E. H., and D. H. Thomas
1973    X-ray diffraction analysis of pictograph pigments from Toquima Cave, central Nevada. *American Antiquity* 38:112–113.

MacLeod, Barbara, and Dennis E. Puleston
1978    Pathways into darkness: The search for the road to Xibalba. *Tercera Mesa Redonda de Palenque* IV: 71–77. Pre-Columbian Art Research Center, Palenque, Mexico.

Malmer, M.
1975    The Rock Carvings at Nämforsen, Ångermanland, Sweden, as a Problem of Maritime Adaptation and Circumpolar Interrelations. In *Prehistoric Maritime Adaptations of the Circumpolar Zone,* edited by W. Fitzhugh, pp. 41–46. Mouton, The Hague, Netherlands.

1981    *A Chorological Study of North European Rock Art.* Kungliga Vitterhets Historie och Antikvitets Akademien handlingar, ser.32. Stockholm.

Marston, R.A.
2003    Editorial note. *Geomorphology* 53:197.

Martin, Yves
1993    Relevé graphique sur support transparent, In *L'Art Pariétal Paléolithique: Techniques et methodes d'étude,* edited by GRAPP, pp. 343–346. Ministère de L'Enseignement Supérieur et de la Recherche, Comité des travaux historiques et scientifiques, Documents Préhistoriques 5, Paris.

Mawk, E. J., M. F. Nobbs, and M. W. Rowe
1996    Analysis of white pigments from the Olary region, south Australia. *Rock Art Research* 13:31–37.

Meehan, B.
1995    Aboriginal Views on the Management of Rock Art Sites in Australia. In *Perceiving Rock Art: Social and Political Perspectives,* edited by K. Helskog and B. Olsen, 295–316. The Institute for Comparative Research in Human Culture, Oslo.

Menu, M., and P. Walter
1992    Prehistoric cave painting PIXE analysis for the identification of paint "pots." *Nuclear Instruments and Methods in Physics Research* B64:547–552.

Michaelis, Helen
1981    Willowsprings: A Hopi petroglyph site. *Journal of New World Archaeology* 4(2):3–32.

Midgley, Mary
2001    *Science and Poetry.* Routledge, London.
2003    *The Myths We Live By.* Routledge, London.

Miller, Jay
1983    Basin religion and theology: A comparative study of power (*Puha*). *Journal of California and Great Basin Anthropology* 5:66–86.

Morris, G., and G. Hamm

1995    Aboriginal Use of Traditional Rock Painting and Engraving Sites as a
        Means of Cultural Revival. *Management of Rock Imagery*, edited by
        G. K. Ward and L. A. Ward, pp. 63–70. Occasional AURA Publication 9,
        Melbourne.

Morwood, Michael J.

1994    Handy household hints for archaeological excavations at rock art sites.
        *Rock Art Research* 11(1):10–12.

2002    *Visions from the Past: the Archaeology of Australian Aboriginal Art.* Allen &
        Unwin, Crows Nest, New South Wales, Australia.

Morwood, Michael J., and D. R. Hobbs (editors)

1992    *Rock Art and Ethnography.* Occasional AURA Publication No. 5. Melbourne.

1995    *Quinkan Prehistory: The Archaeology of Aboriginal Art in S. E. Cape York
        Peninsula, Australia.* Tempus: Archaeology and Material Culture Studies
        in Anthropology, 3. Anthropology Museum, University of Queensland,
        Brisbane, Australia.

Mowaljarlai, D., P. Vinnicombe, G. K. Ward, and C. Chippindale

1988    Repainting images on rock in Australia and the maintenance of
        aboriginal culture. *Antiquity* 62:690–696.

Muzzolini, Alfred

2001    Saharan Africa. In *Handbook of Rock Art Research*, edited by D. S. Whitley,
        pp. 605–636. AltaMira Press, Walnut Creek, California.

Nash, George

1997    Dancing in Space: Rock Art of the Campo Lameiro Valley, Southern
        Galicia, Spain. In *Semiotics of Landscape: Archaeology of Mind*, edited by
        George Nash, pp. 46–56. BAR International Series 661. Oxbow Books,
        Oxford.

2002    The Landscape Brought Within: A Re-Evaluation of the Rock Painting
        Site at Tumlehead, Torslanda, Göteborg, West Sweden. In *European Land-
        scapes of Rock Art*, edited by G. Nash and C. Chippindale, pp. 176–194.
        Routledge, London.

Nash, George, and Christopher Chippindale

2001    Images of Enculturating Landscapes: a European Perspective. In *Euro-
        pean Landscapes of Rock Art*, edited by G. Nash and C. Chippindale, pp.
        1–19. Routledge, London.

Nelson, D. E., G. Chaloupka, C. Chippindale, M. Anderson, and J. R. Southon

1995    Radiocarbon dates for beeswax figures in the prehistoric rock art of
        northern Australia. *Archaeometry* 37:151–156.

Newton-Smith, William

1981    *The Rationality of Science.* Routledge and Kegan Paul, London.

Ouzman, Sven

1998    Towards a Mindscape of Landscape: Rock Art as an Expression of World-

Understanding. In *The Archaeology of Rock Art*, edited by C. Chippindale and P. S. C. Taçon, pp. 30–41. Cambridge University Press, Cambridge.

2003    Review of *The Art of the Shaman, The Petroglyphs and Pictographs of Missouri* and the *Handbook of Rock Art Research*. *American Antiquity* 68:592–594.

Panofsky, Erwin

1983    *Meaning in the Visual Arts*. University of Chicago Press, Chicago.

Park, Willard Z.

1938    *Shamanism in Western North America: A Study in Cultural Relationships*. Northwestern University Studies in the Social Sciences, No. 2. Northwestern University, Evanston.

Phillips, Fred M.

2003    Cosmogenic 36Cl ages on quaternary basalt flows in the Mojave Desert, California, USA. *Geomorphology* 53:199–208.

Phillips, F. M., M. Flinsch, D. Elmore, and P. Sharma

1997    Maximum ages of the Côa Valley (Portugal) engravings measured with chlorine-36. *Antiquity* 71:100–104.

Pineda, C. A., M. Peisach, L. Jacobson, and C. G. Sampson

1990    Cation-ratio differences in rock patina on hornfels and chalcedony using thick target PIXE. *Nuclear Instruments and Methods in Physics Research* B49:332–335.

Pope, G. A.

2000    Weathering of petroglyphs: Direct assessment and implications for dating methods. *Antiquity* 74:833–843.

Preucel, Robert W., and Ian Hodder (editors)

1996    *Contemporary Archaeology in Theory: A Reader*. Blackwell, Oxford.

Radcliffe-Brown, A.R.

1964    *The Andaman Islanders* (1922). Free Press, Glencoe, Illinois.

Rajnovich, Grace

1994    *Reading Rock Art: Interpreting the Indian Rock Paintings of the Canadian Shield*. Natural History/Natural Heritage, Toronto, Ontario.

Ray, Verne

1963    *Primitive Pragmatists: The Modoc Indians of Northern California*. University of Washington Press, Seattle.

Reese, R. L., M. Hyman, M. W. Rowe, J. N. Derr, and S. K. Davis

1996a    Ancient DNA from Texas pictographs. *Journal of Archaeological Science* 23:269–277.

Reese, R. L., E. J. Mawk, J. N. Derr, M. Hyman, M. W. Rowe, and S. K. Davis

1996b    Ancient DNA in Texas Rock Paintings. In *Archaeological Chemistry V: Organic, Inorganic, and Biochemical Analysis,* edited by M. V. Orna, pp. 378–390. Advances in Chemistry Series, American Chemical Society, Washington, D.C.

Reichel-Dolmatoff, Gerardo

1967    Rock paintings of the Vaupes: An essay of interpretation. *Folklore Americas* 27(2):107–113.

1978    *Beyond the Milky Way: Hallucinatory Imagery of the Tukano Indians.* UCLA Latin American Center, University of California, Los Angeles.

Renau, S. L., and R. J. Raymond

1991    Cation-ratio dating of rock varnish: Why does it work? *Geology* 19:937–940.

Reznikoff, I., and M. Dauvois

1988    La dimension sonore des grottees ornées. *Bulletin de la Société Préhistorique Française* 85(8):238–246.

Roberts, R., G. L. Walsh, A. Murray, J. Olley, R. Jones, M. Morwood, C. Tuniz, E. Lawson, M. MacPhail, D. Bowdery, and I. Naumann

1997    Luminescence dating of rock art and past environments using mud-wasp nests in northern Australia. *Nature* 387:696–699.

Rosenfeld, Andre

1993    The Panaramittee Tradition. In *Sahul in Review: Pleistocene Archaeology in Australia, New Guinea, and Island Melanesia,* edited by M. Smith, M. Spriggs, and B. Fankhauser, pp. 71–80. Department of Prehistory, Research School of Pacific Studies, Occasional Paper 24. Australian National University, Canberra.

Rouzaud, François

1993    Topographie interne: releve topographique, In *L'Art Pariétal Paléolithique: Techniques et methodes d'étude,* edited by GRAPP, pp. 39–48. Ministère de L'Enseignement Supérieur et de la Recherche, é des travaux historiques et scientifiques, Documents Préhistoriques 5, Paris.

Rowe, Marvin W.

2001a    Dating by AMS Radiocarbon Dating. In *Handbook of Rock Art Research,* edited by D. S. Whitley, pp. 139–166. AltaMira Press, Walnut Creek, California.

2001b    Physical and Chemical Analyses. In *Handbook of Rock Art Research,* edited by D. S. Whitley, pp. 190–220. AltaMira Press, Walnut Creek, California.

Rozwadowski, Andrzej

2001    From Semiotics to Phenomenology: Central Asian Petroglyphs and the Indo-Iranian Mythology. In *Theoretical Perspectives in Rock Art Research,* edited by Knut Helskog, pp. 155–174. Novus forlag, Oslo.

2004    *Symbols Through Time: Interpreting the Rock Art of Central Asia.* Institute of Eastern Studies, Adam Mickiewicz University, Poznan, Poland.

Russ, J., M. Hyman, H. J. Shafer, and M. W. Rowe

1990    Radiocarbon dating of prehistoric rock paintings by selective oxidation of organic carbon. *Nature* 348:710–711.

Russ, J., M. Hyman, and M. W. Rowe

1992    Direct radiocarbon dating of rock art. *Radiocarbon* 34:867–872.

Russ, J., R. L. Palma, and J. Booker
1994    Whewellite rock crusts in the lower Pecos region of Texas. *Texas Journal of Science* 46:165–172.
Russ, J., R. L. Palma, D. H. Lloyd, T. W. Boutton, and M. A. Coy
1996    Origin of the Whewellite-rich rock crust in the lower Pecos region of southwest Texas and its significance to paleoclimate reconstructions. *Quaternary Research* 46:27–36.
Sahlins, Marshall
1985    *Islands of History*. University of Chicago Press, Chicago.
Sales, Kim
1992    Ascent to the sky: A shamanic initiatory engraving from the Burrup Peninsula, northwest Australia. *Archaeology in Oceania* 27:22–35.
Sauvet, G.
1988    La Communication graphique paléolithique: De l'analyse quantitative d'un corpus de données: Son interpretation semiologique. *L'Anthropologie* 92 (1):3–16.
Sauvet, G., S. Sauvet, and A. Wlodarczyk
1977    Essai de sémiologie préhistorique: Pour une théorie des premiers signes graphiques de l'homme. *Bulletin de la Société Préhistorique Française* 74(2):545–558.
Sauvet, G., and A. Wlodarczyk
1992    Structural Interpretation of Statistical Data from European Palaeolithic Cave Art. In *Ancient Images, Ancient Thought: The Archaeology of Ideology*, edited by A. S. Goldsmith, S. Garvie, D. Selin, and J. Smith, pp. 223–234. Archaeological Association, University of Calgary, Calgary, Alberta.
1995    Éléments d'une grammaire formelle de l'art pariétal paléolithique. *L'Anthropologie* 99 (2/3):193–211.
Scarre, Chris
1989    Painting by resonance. *Nature* 338:382.
Schaafsma, Polly
1971    *The Rock Art of Utah*. Papers of the Peabody Museum of American Archaeology and Ethnology No. 65. Harvard University, Cambridge.
1981    Kachinas in Rock Art. *Journal of New World Archaeology* 4(2):25–32.
1985    Form, Content, and Function: Theory and Method in North American Rock Art Studies. In *Advances in Archaeological Method and Theory, Volume 8*, edited by M. B. Schiffer, pp. 237–277. Academic Press, New York.
Scott, David A., and William D. Hyder
1993    A study of some Californian Indian rock art pigments. *Studies in Conservation* 38:155–173.
Scott, D. A., M. Newman, M. Schilling, M. Derrick, and H. P. Khanjian
1996    Blood as a binding medium in a Chumash Indian pigment cake. *Archaeometry* 38:103–112.

Shapiro, Meyer
1953 Style. In *Anthropology Today*, edited by A. L. Kroeber, pp. 287–312. University of Chicago Press, Chicago.

Shepard, Richard S.
1996 *Luiseño Rock Art and Sacred Landscape in Late Prehistoric Southern California*. M.A. thesis, UCLA.

Simpson, A., P. Clogg, M. Diaz-Andreau, and B. Larman
2004 Towards three-dimensional non-invasive recording of incised rock art. *Antiquity* 78:692–698.

Siskin, Edgar E.
1983 *Washo Shamans and Peyotists: Religious Conflict in an American Indian Tribe.* University of Utah, Salt Lake City.

Smith, Claire
1992 Colonising with style: Reviewing the nexus between rock art, territoriality and the colonisation and occupation of Sahul. *Australian Archaeology* 34:34–42.

1994 Situating Style: an Ethnoarchaeological Study of Social and Material Context in an Australian Aboriginal Artistic System. Unpublished Ph.D. thesis. University of New England, Armidale, New South Wales, Australia.

Snow, Dean
n.d. Sexual Dimorphism in Upper Palaeolithic Hand Stencils. Manuscript under review.

Solomon, Anne
1992 Gender, representation and power in San ethnography and rock art. *Journal of Anthropological Archaeology* 11:291–329.

Sperber, Dan
1982 Apparently Irrational Thoughts. In *Rationality and Relativism*, edited by M. Hollis and S. Lukes, pp. 149–180. The MIT Press, Cambridge.

Steelman, K. L., M. W. Rowe, S. A. Turpin, T. Guilderson, and L. Nightengale
2004 Nondestructive radiocarbon dating: Naturally mummified infant bundle from SW Texas. *American Antiquity* 69:741–750.

Steward, Julian H.
1941 Culture element distributions: XIII, Nevada Shoshoni. *Anthropological Records* 4(2):209–359. University of California, Berkeley.

1943 Culture element distributions: XXIII, Northern and Gosiute Shoshoni. *Anthropological Records* 8(3):263–392. University of California, Berkeley.

Stewart, O.C.
1941 Culture element distributions: XIV, Northern Paiute. *Anthropological Records* 4(3):361–446. University of California, Berkeley.

1942 Culture element distributions: XVIII, Ute–Southern Paiute. *Anthropological Records* 6(4):231–354. University of California, Berkeley.

Stoffle, Richard W., and M. Nieves Zedeño
2001 American Indian Worldviews II: Power and Cultural Landscapes. In

*American Indians and the Nevada Test Site: A Model of Research and Cooperation,* edited by R. W. Stoffle, M. N. Zedeño, and D.B. Halmo, pp. 139–152. U.S. Government Printing Office, Washington, D.C.

Sullivan, H.

1995   Visitor Management at Painting Sites in Kakadu National Park. In *Management of Rock Imagery,* edited by G. K. Ward and L. A. Ward, pp. 82–87. Occasional AURA Publication 9, Melbourne.

Sullivan, K. M.

1984   Monitoring Visitor Use and Site Management at Three Art Sites—An Experiment with Visitors' Books. In *Visitors to Aboriginal Sites: Access, Control, and Management,* edited by H. Sullivan, pp. 43–53. Australian National Parks and Wildlife Service, Canberra.

Sundstrom, Linea

2000   Rock art studies and the direct ethnographic approach: Case studies from the Black Hills country. *1999 International Rock Art Congress Proceedings* 1:105–110.

Sutton, Mark

1982   Kawaiisu mythology and rock art: One example. *Journal of California and Great Basin Anthropology* 4:148–154.

Taçon, Paul S. C.

1983   An analysis of Dorset art in relation to prehistoric culture stress. *Inuit Studies* 7(1):41–65.

1994   Socialising landscapes: The long-term implication of signs, symbols and marks on the land. *Archaeology in Oceania* 29:117–129.

1999   Identifying Ancient Landscapes in Australia: From Physical to Social. In *Archaeology of landscapes: contemporary perspectives,* edited by W. Ashmore and B. Knapp, pp. 33–57. Blackwell, Oxford.

Taçon, Paul S. C., and Christopher Chippindale

1998   An Archaeology of Rock Art Through Informed Methods and Formal Methods. In *The Archaeology of Rock Art,* edited by C. Chippindale and P. S. C. Taçon, pp. 1–10. Cambridge University Press, Cambridge.

Taçon, Paul, Meredith Wilson, and Christopher Chippindale

1996   Birth of the Rainbow Serpent in Arnhem Land rock art and oral history. *Archaeology in Oceania* 31(3):103–124.

Taylor, J. M., R. M. Myers, and I. N. M. Wainwright

1974   Scientific studies of Indian rock paintings in Canada. *Bulletin of the American Institute for Conservation* 14:28–43.

Taylor, Michael W., and James D. Keyser

2003   The Columbia Plateau scratched style: A preliminary interpretation. *American Indian Rock Art* 29:11–20.

Thackerey, A. I.

1983   Dating the Rock Art of Southern Africa. In *New Approaches to Southern African Rock Art,* edited by J. D. Lewis-Williams, pp. 21–26. Southern

African Archaeological Society, Goodwin Series 4. Cape Town, South Africa.

Thiagarajan, N. and C.T.A. Lee
2004    Trace element evidence for the origin of desert varnish by direct aqueous deposition. *Earth and Planetary Science Letters* 224: 131–141.

Tilley, Christopher
1991    *Material Culture and Text: The Art of Ambiquity.* Routledge, London.
1994    *A Phenomenology of Landscapes, Places, Paths and Monuments.* Berg, Oxford.
2003    Landscape and rock art. (Review of *European Landscapes of Rock Art.*) *Cambridge Archaeological Journal* 13:138–139.

Titiev, Mischa
1937    A Hopi salt expedition. *American Anthropologist* 37:244–258.

Turner, Christy G., II
1963    Petroglyphs of the Glen Canyon region. *Museum of Northern Arizona Bulletin* 38, Flagstaff, Arizona.
1971    Revised dating for early rock art of the Glen Canyon region. *American Antiquity* 36:469–471.

Turner, Victor
1967    *The Forest of Symbols: Aspects of Ndembu Ritual.* Cornell University Press, Ithaca, New York.

Turpin, Solveig A.
1994    On a Wing and a Prayer: Flight Metaphors in Pecos River Pictographs. In *Shamanism and Rock Art In North America*, edited by S. A. Turpin, pp. 73–102. Rock Art Foundation, Inc., Special Publication 1. San Antonio, Texas.

Utemara, D., with P. Vinnicombe
1992    North-Western Kimberley Belief Systems. In *Rock Art and Ethnography*, edited by M. J. Morwood and D. R. Hobbs, pp. 24–26. Australian Rock Art Research Association, Melbourne.

Valladas, H., H. Cachier, and M. Arnold
1990    AMS C-14 dates for the prehistoric Cougnac cave paintings and related bone remains. *Rock Art Research* 7:18–19.

Valladas, H., H. Cachier, P. Maurice, F. Bernaldo de Quiros, J. Clottes, V. C. Valdes, P. Uzquiano, and M. Arnold
1992    Direct radiocarbon dates for the prehistoric paintings at the Altamira, El Castillo, and Niaux caves. *Nature* 357:68–70.

Valladas, H., J. Clottes, J.-M. Geneste, M. A. Garcia, M. Arnold, H. Cachier, and N. Tisnérat-Laborde
2001    Palaeolithic paintings: Evolution of prehistoric cave art. *Nature* 413:479.

Vialou, A. V., H. Badu, F. d'Errico, and D. Vialou
1996    Les colorants rouges de l'habitat rupestre de Santa Elina, Mato Grosso (Brazil). *Techne* 3:91–97.

Villeneuve, Suzanne, and Brian Hayden
  2005    Nouvelle Approche dans l'Analyse du Contexte du Images dans les
          Grottes. Paper presented at the conference Restituer la Vie Quotidienne
          au Paléolithique Supérieur. Université de Lyon III, France.
Voegelin, Erminie W.
  1938    Tubatulabal ethnography. *Anthropological Records* 2(1):1–90. University of
          California, Berkeley.
von Werlhof, Jay
  1987    *Spirits of the Earth: A Study of Earthen Art in the North American Deserts,*
          *Volume 1: The North Desert.* Imperial Valley College Desert Museum
          Society, El Centro, California.
  2004    *That They May Know and Remember, Vol. 2: Spirits of the Earth.* Imperial
          Valley College Desert Museum Society, Ocotillo, California.
Waller, S.
  1993    Sound reflection as an explanation for the content and context of rock
          art. *Rock Art Research* 10(2):91–101.
  2000    Spatial correlation of rock art and acoustics exemplified in Horseshoe
          Canyon. *American Indian Rock Art* 24:85–94.
Walsh, G. L.
  1979    Mutilated hands or signal stencils? *Australian Archaeology* 9:33–41.
  1983    Composite stencil art: Elemental or specialized? *Australian Aboriginal*
          *Studies* 1983(2):34–44.
Wallace, Henry D., and J. P. Holmlund
  1986    Petroglyphs of the Picacho Mountains, South Central Arizona. *Institute*
          *for American Research Anthropological Papers*, No. 6, Tucson, Arizona.
Waslewicz, T., D. Staley, H. Volcker, and D. S. Whitley
  2005    Terrestrial 3D laser scanner: A new method for recording rock art.
          *International Newsletter on Rock Art (INORA)* 41:16–25.
Watchman, Alan
  1991    Age and composition of oxalate-rich crusts in the Northern Territory,
          Australia. *Studies in Conservation* 36:24–32.
  2000    A review of the history of dating rock varnishes. *Earth-Science Reviews*
          49:261–277.
Watchman, Alan, B. David, I. J. McNiven, and J. M. Flood
  2000    Micro-archaeology of engraved and painted rock surface crusts at Yiwar-
          larlay (Lightning Brothers site), Northern Territory, Australia,
          *Journal of Archaeological Science* 27:315–325.
Weisbrod, Richard
  1978    Rock art dating methods. *Journal of New World Archaeology* 2(4):1–8.
Wellman, Klaus
  1979    A quantitative analysis of superimpositions in the rock art of the Coso
          Range, California. *American Antiquity* 44:546–556.

1979    A Survey of North American Indian Rock Art. Akademische Druck und
        Verlagsanfalt, Graz, Austria.

Welsh, Peter H., and Ronald I. Dorn

1997    Critical analysis of petroglyph radiocarbon ages from Côa, Portugal, and
        Deer Valley, Arizona. American Indian Rock Art 23:11–23.

Wendt, W. E.

1976    "Art mobilier" from the Apollo 11 cave, south west Africa: Africa's
        oldest dated works of art. South African Archaeological Bulletin 31:5–11.

Whiteley, Peter M.

1998    Rethinking Hopi Ethnography. Smithsonian Institution, Washington, D.C.

Whiting, Beatrice B.

1950    Paiute Sorcery. Viking Fund Publications in Anthropology, Number 15.
        New York.

Whitley, David S.

1982    The Study of North American Rock Art: A Case Study from South-Central
        California. Ph.D. dissertation, Anthropology Department, UCLA.

1987    Socioreligious context and rock art in east-central California. Journal of
        Anthropological Archaeology 6:159–188.

1988    Bears and Baskets: Shamanism in California Rock Art. In The State of the
        Art: Advances in World Rock Art Research, edited by T. Dowson, pp. 1–8.
        University of the Witwatersrand, Johannesburg, South Africa.

1992a   Prehistory and post-positivist science: A prolegomenon to cognitive
        archaeology. Archaeological Method and Theory 4: 57–100.

1992b   Shamanism and rock art in far western North America. Cambridge
        Archaeological Journal 2:89–113.

1993    The raw and the half-baked: Structuralism and archaeological
        interpretation (review of Material Culture and Text: The Art of Ambiguity,
        by C. Tilley). Cambridge Archaeological Journal 3:118–121.

1994a   By the hunter, for the gatherer: Art, social relations, and subsistence
        change in the prehistoric Great Basin. World Archaeology 25:356–377.

1994b   Shamanism, Natural Modeling, and the Rock Art of Far Western
        North America. In Shamanism and Rock Art in North America, edited by
        S. Turpin, pp. 1–43. Rock Art Foundation, Inc., Special Publication 1.
        San Antonio, Texas.

1994c   Ethnography and Rock Art in Far Western North America: Some
        Archaeological Implications. In New Light on Old Art: Recent Advances in
        Hunter-Gatherer Rock Art Research, edited by D. S. Whitley and
        L. L. Loendorf, pp. 81–94. Monograph 36, Institute of Archaeology.
        University of California, Los Angeles.

1996    Guide to Rock Art Sites: Southern California and Southern Nevada. Mountain
        Press, Missoula, Montana.

1998a   (editor) Reader in Archaeological Theory: Postprocessual and Cognitive
        Approaches. Routledge, London.

1998b    Finding Rain in the Desert: Landscape, Gender, and Far Western North American Rock Art. In *The Archaeology of Rock Art*, edited by C. Chippindale and P.S.C. Taçon, pp. 11–29. Cambridge University Press, Cambridge.

1998c    Meaning and Metaphor in the Coso Petroglyphs: Understanding Great Basin Rock Art. In *Coso Rock Art: A New Perspective*, edited by E. Younkin, pp.109–174. Maturango Museum, Ridgecrest, California.

1998d    Cognitive neuroscience, shamanism, and the rock art of native California. *Anthropology of Consciousness* 9:22–36.

1998e    *Following the Shaman's Path: A Walking Tour of Little Petroglyph Canyon.* Maturango Museum, Ridgecrest, California.

1999    Issues in the Commodification of the Past. Paper presented at the annual meeting of the Society for American Archaeology, Chicago, April, 1999.

2000a    *The Art of the Shaman: Rock Art of California.* University of Utah Press, Salt Lake City.

2000b    Use and abuse of ethnohistory in the far west. *1999 International Rock Art Congress Proceedings* 1:127–154. American Rock Art Research Association, Tucson, Arizona.

2001    Science and the Sacred: Interpretive Theory in U.S. Rock Art Research. In *Theoretical Perspectives in Rock Art Research*, edited by K. Helskog, pp. 130–157. Novus forlag, Oslo.

2004    Management Plan for Rock Art Sites on BLM Lands in California. In *The Human Journey and Ancient Life in California's Deserts: Proceedings from the 2001 Millennium Conference*, edited by M. W. Allen and J. Reed, pp. 225–228. Maturango Museum Publication No. 15. Maturango Museum, Ridgecrest, California.

2005a    The Archaeology of Religion. In *Handbook of Archaeological Method and Theory*, edited by H. Maschner and A. Bender (in press). AltaMira Press, Walnut Creek, California.

2005b    Rock Art and Rites of Passage in Far Western North America. In *Talking to the Past: The Ethnography of World Rock Art*, edited by J. Keyser and G. Poetschat (in press). Oregon Archaeological Society.

2005c    Re-Experiencing the Creation: Mythic Landscape and Ritual Pilgrimage Along the Colorado River. In *Landscapes of Origin in the Americas*, edited by J. J. Christie and J. E. Staller (in press). University of Arizona Press, Tucson, Arizona.

Whitley, David S., and Harold J. Annegarn
1994    Cation-Ratio Dating of Rock Engravings from Klipfontein, Northern Cape Province, South Africa. In *Contested Images: Diversity in Southern African Rock Art Research*, edited by T. A. Dowson and J. D. Lewis-Williams, pp. 189–197. University of Witwatersrand Press, Johannesburg, South Africa.

Whitley, D. S., J. Baird, J. Bennett, and R. G. Tuck
1984    The use of relative repatination in the chronological ordering of petroglyph assemblages. *Journal of New World Archaeology* 4(3):19–25.

Whitley, David S., and Jean Clottes
  2005    In Steward's Shadow: A History of Rock Art Research in the Far West.
          In Discovering North American Rock Art, edited by L. Loendorf,
          C. Chippindale, and D. S. Whitley (in press). The University of Arizona
          Press, Tucson, Arizona.
Whitley, David S., and Ronald I. Dorn
  1984    Chemical and micromorphological analysis of rock art pigments from the
          western Great Basin. Journal of New World Archaeology 6:48–51.
Whitley, D. S., R. I. Dorn, J. M. Simon, R. B. Rechtman, and T. K. Whitley
  1999a   Sally's rockshelter and the archaeology of the vision quest. Cambridge
          Archaeological Journal 9(2):221–247.
Whitley, David S., Johannes H. N. Loubser, and Don Hann
  2004    Friends in Low Places: Rock Art and Landscape on the Modoc Plateau.
          In The Figured Landscapes of Rock Art: Looking at Pictures in Place, edited
          by C. Chippindale and G. Nash, pp. 217–238. Cambridge University
          Press, Cambridge.
Whitley, D. S., J. M. Simon, and R. I. Dorn
  1999b   The vision quest in the Coso Range. American Indian Rock Art 25:1–32.
Whitley, David S., and Joseph M. Simon
  2002a   Recent AMS radiocarbon rock engraving dates. International Newsletter on
          Rock Art (INORA) 32:10–16.
  2002b   Reply to Huyge and Watchman. International Newsletter on Rock Art (IN-
          ORA) 34:12–21.
Whitley, David S., Joseph M. Simon, and Ronald I. Dorn
  1998    Rock Art Studies at CA-SBR-2347, the Paradise Bird Site, Fort Irwin
          N.T.C., San Bernardino County, California. Report on file, Archaeological
          Information Center, San Bernardino County Museum.
Whitley, D. S., J. M. Simon, and J. N. H. Loubser
  2005a   The Carrizo Collapse: Art and Politics in the Past. In Collected Papers in
          Honor of the Achievements of Archaeologist Jay von Werlhof, edited by
          Russell L. Kaldenberg (in press). Maturango Museum Press Number 20.
          Maturango Museum, Ridgecrest, California.
Whitley, David S., Tamara K. Whitley, and Joseph M. Simon
  2005b   The Archaeology of Ayer's Rock, Inyo County, California: The Archaeological
          Survey Association Excavations at CA-INY-134. Maturango Museum
          Publication No. 19. Maturango Museum, Ridgecrest, California.
Whitney, J. W., and C. D. Harrington
  1993    Relict colluvial boulder deposits as paleoclimatic indicators in the Yucca
          Mountain region, southern Nevada. Geological Society of America Bulletin
          105:1008–1018.
Willey, Gordon R., and Phillip Phillips
  1958    Method and Theory in American Archaeology. University of Chicago Press,
          Chicago.

Wilson, Meredith
1998    Pacific Rock Art and Cultural Genesis: A Multi-Variate Exploration. In
        *The Archaeology of Rock Art*, edited by C. Chippindale and P. S. C. Taçon,
        pp. 163–184. Cambridge University Press, Cambridge.
Wylie, Alison
1982    An analogy by any other name is just as analogical: A commentary on
        the Gould-Watson dialogue. *Journal of Anthropological Archaeology* 1:382–
        401.
1985    The Reaction Against Analogy. *Advances in Archaeological Method and
        Theory, Volume 8*, edited by M. B. Schiffer, pp. 63–111. Academic Press,
        New York.
1988    Comment on "The signs of all times: Entoptic phenomena in Upper
        Palaeolithic art," by J. D. Lewis-Williams and T. A. Dowson. *Current
        Anthropology* 29:201–245.
1989    Archaeological cables and tacking: The implications of practice for
        Bernstein's "Options beyond objectivism and relativism." *Philosophy of the
        Social Sciences* 19:1–18.
Young, M. Jane
1986    The interrelationship of rock art and astronomical practice in the Ameri-
        can Southwest. *Archaeoastronomy* 10:S43–S47.
Zedeño, M. Nieves, and K. Hamm
2001    The Ethnoarchaeology of the Pahute and Rainier Mesas. In *American
        Indians and the Nevada Test Site: A Model of Research and Cooperation*,
        edited by R.W. Stoffle, M.N. Zedeño, and D. B. Halmo, pp. 98–121.
        U.S. Government Printing Office, Washington, D.C.
Zhang, Y., T. Liu, and S. Li
1990    Establishment of a cation-leaching curve of rock varnish and its
        application to the boundary region of Gansu and Xinjiang, western Chi-
        na. *Seismology and Geology (Beijing)* 12:251–261.
Zigmond, Maurice
1977    The Supernatural World of the Kawaiisu. In *Flowers of the Wind: Papers
        on Ritual, Myth and Symbolism in California and the Southwest*, edited by
        T. C. Blackburn, pp. 59–95. Ballena Press, Socorro, New Mexico.
1986    Kawaiisu. In *Handbook of North American Indians, Volume 11, Great Basin*,
        edited by Warren D'Azevedo, pp. 398–411. Smithsonian Institution,
        Washington, D.C.

# INDEX

Baumhoff, Martin, *see* Heizer, Robert
bedrock mortars, 11
beeswax dating, 68
Big Petroglyph Canyon site, California, 12, *12*
Bighorn sheep, 12, *12*, 46–7, 55, 59, 98, *113*, 114, 117–8, *118*, 141
Binford, Lewis, 146–7
biographic rock art, *see* commemorative rock art
bison, 121, 143, 145
blood (in pigment), 4, 11, 13, 66, 143–4
Blythe, California, intaglios, 14, *14*
bodily transformation metaphor, 85, 98, 117–8, *118*, 119, *119*, 120, *120*
(*see also* therianthrope)
bow and arrow, 54, 59, 105–6, 118, *118*, 120, *120*
(*see also* projectile point)
Bradley, Richard, 136–7
Bronze Age period, Europe, 51, 136–7, 141
Bushmen, *see* San

California, 5, 6, 7, 8, 9, 10, 11, 12, 13, 14, 15, 20, 21, 22, 23, 30, 31, 37, 38, 41, 44–5, 47, 51, 55–6, 59, 83, 91–2, 95, 98, 99, 100, 101, 112, 113, 118, 119, 120, 131, 141, 154, 157, 158, 159
Carrizo Plain National Monument, California, 5, *5*, 55–6, *56*
catastrophism, 87, 105, 107
cation–ratio (CR) dating, 62–3, 172
(*see also* Chronology)
ceramics, 45, 54, 63
Chalfant site, California, 101, *101*
chalk, chalking, 4, 6, 27, 32, *32*, 159
Chauvet Cave site, France, 48
Chippindale, Christopher, 79, 140
chronology, 2, 40, 48, 59, 70, 71, 120, 128, 144, 163, 172
chronometric chronology, 61–9, 172, 176

relative chronology, 53–61, 172, 176
(*see also* dating techniques)
Chumash Indians, 55–6, 143, 172
classification, *see* typology
Clottes, Jean, vii, viii, 92, 119, 121
Coconino National Forest, Arizona, 157
Colorado River, 14, 49, 99
Columbia Plateau, 13, 15, 26, 98, 131–2, 161,
Columbia River Gorge, 94
"combative shaman" metaphor, 85, 116, 117–8,
commemorative rock art, 99–102, *102*, 172
communication studies approaches, 81–5, 124, 129–40, 147
Conkey, Margaret (Meg), 85, 107, 139, 164
condition (of a site or panel), 17–18, 23, 25, 29, 33, 58–9,152–3
condition assessment, 25, 152–3, 172
(*see also* conservation)
conflation, *see* bodily transformation, therianthrope
conservation, 3, 17–18, 19, 142, 151, 152, 153–4, 172, 174, 176
(*see also* site management, preservation)
context, 55–6, 58, 60–1, 82–4, 91, 101, 103, 104, 119, 121, 124, 132, 150, 153, 156, 163
convergent methodologies, 73
(*see also* scientific method)
Copper Rock Cavern site, California, 21, *21*
cosmogenic dating, 63, 68–69
(*see also* chronology, dating techniques)
Coso Range, California, 12, *12*, 13, 15, 23, 47, 55, 59, *69*, 100, *100*, 112, *112*, 113, *113*, 118, *118*, 119, *119*, 131, 141, 157, 158, 159, 168
cross-dating, 54
cultural boundaries, *see* territoriality
cultural affiliation, *see* ethnicity

# ABOUT THE AUTHOR

**David S. Whitley** is one of the leading North American experts on rock art. A former member of the Council of Directors of the ICOMOS Committee on Rock Art and head of a contract archaeology firm, he has published extensively on the subject both at an academic and more popular level. He is author of *Art of the Shaman* and editor of *Handbook of Rock Art Research,* among his many other works. Whitley has done fieldwork in the U.S., Guatemala, France, and South Africa, and has taught at the University of Witwatersrand and UCLA.